DITAROD

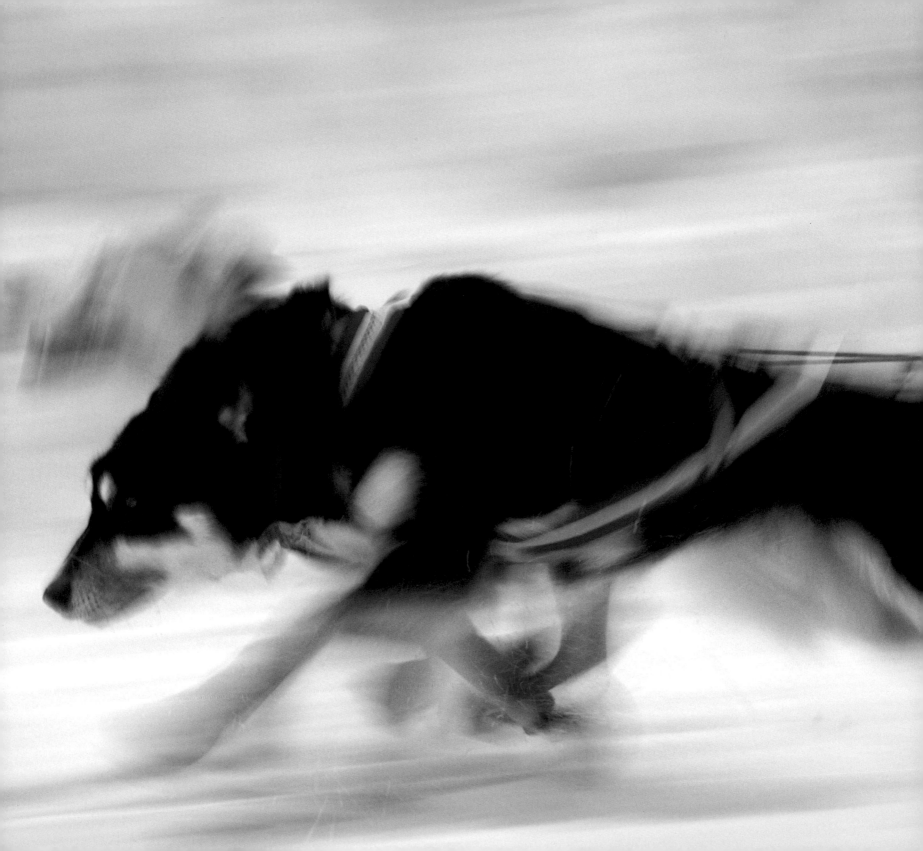

IDITAROD

The Great Race to Nome

Text by Bill Sherwonit
Photography by Jeff Schultz

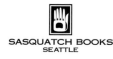

SASQUATCH BOOKS
SEATTLE

ALASKA

Bering Sea

Norton Sound

Kuskokwim Bay

Yukon River

Nome
Safety
White Mountain
Golovin
Elim
Koyuk
Shaktoolik
Unalakleet
Eagle Island
Grayling
Anvik
Shageluk
Iditarod
Nulato
Galena
Ruby
Cripple
Ophir
Takotna
McGrath
Nikolai

Kuskokwim River

Kuskokwim

Mountains

Yukon River

Tanana
Manley
Fairbanks
Nenana
Denali Park
Cantwell

Mt. McKinley (Denali)

Susitna River

Talkeetna

Farewell Burn
Rohn
Dalzell Gorge
Rainy Pass
Finger Lake
Skwentna
Yentna
Knik
Wasilla
Anchorage
Eagle River

Alaska Range

Bethel

Cook Inlet

Kenai Peninsula

Seward

Homer

Gulf of Alaska

Kodiak Island

Iditarod Trail

▲ N

— ·· — ·· — Northern/Even-Year Route

· · · · · · · · · Southern/Odd-Year Route

············· 1925 Serum Run Route

CONTENTS

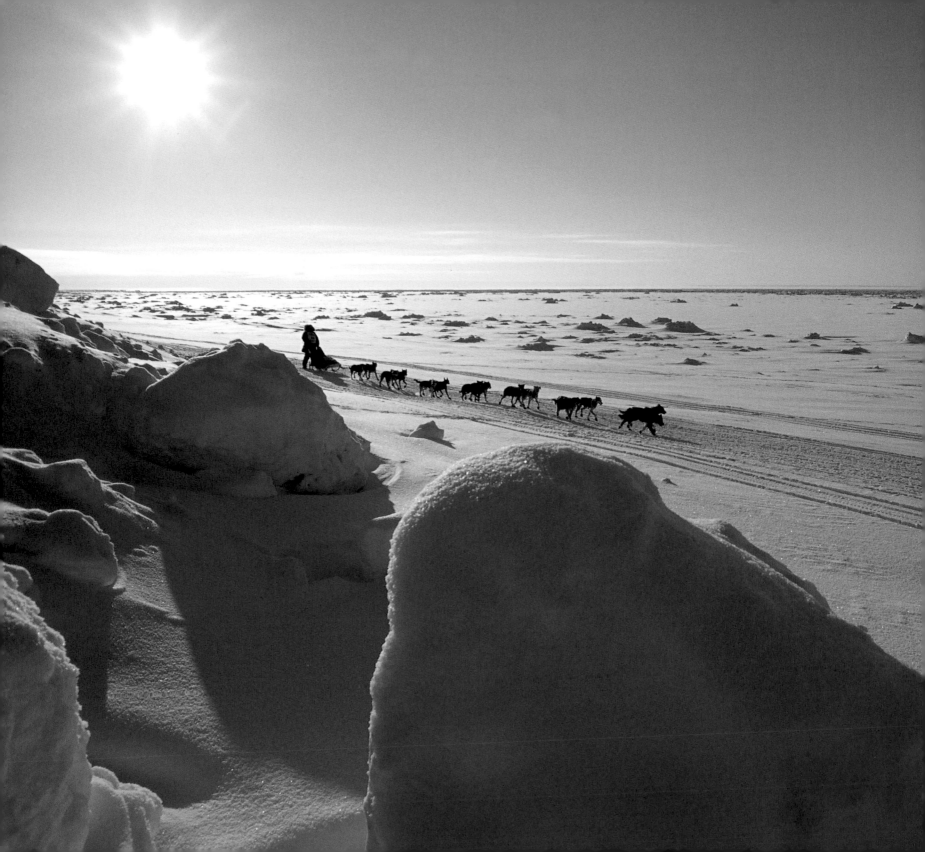

FOREWORD

LEFT *Wally Robinson on the Bering Sea within the Nome city limits.*

From the time in 1948 when my husband Joe took his first dog sled trip out the Iditarod Trail with mail carrier Lee Ellexson, he was hooked on the history and grandeur of the old route. Most of the Iditarod Trail was at that time abandoned and nearly obliterated, but we had homesteaded along its path and had been working to restore it to its former glory. Initially, what we hoped to do by starting the Iditarod race was to bring back the Alaskan Husky breed and dog mushing, a traditional transport almost forgotten because of the use of airplanes and snowmachines. Out of this inspiration grew a larger desire to publicize the Iditarod Trail so people would realize its historical value; we could then get the support needed to have the route declared a national historical trail and secure its restoration and preservation. It took lots of time and effort to get anyone even to listen to us, let alone believe in what we were trying to do.

But Joe was always a dreamer with grandiose ideas, and he was stubborn as a mule when he got on a project that he felt was right. I never knew him to give up, or to fail in anything he started. The Iditarod race of today bears testimony to that. I don't think anyone, including Joe, ever realized what a far-reaching impact the race would have on so many lives.

Our hopes and dreams have certainly come true: Dog mushing is now the Alaska state sport, the Iditarod Trail Sled Dog Race is a huge success known around the world, and we now have the Iditarod National Historical Trail from Seward to Nome. And while we did not originally intend or think of the race and trail in connection with the 1925 serum run from Nenana to Nome, the race now acts as a commemoration of that event as well.

This book will tell you about that history, the race beginnings, and the modern race of today, which while it has changed a lot from the first races, still remains much the same.

—*Vi Redington, August 2001.*

ACKNOWLEDGMENTS

I have lots of thanks to give in this new edition of Iditarod: The Great Race to Nome. *To begin, I feel lucky to again team up with photographer Jeff Schultz, whose stunning Iditarod images grace many books, magazines, and calendars. I'm grateful to Sasquatch editor Kate Rogers for her enthusiastic support, which led to this book. I thank Alice Copp Smith for her skillful editing of the manuscript, Laura Gronewold for shepherding the book to its completion, and Kate Basart and Jane Jeszeck for their work on the book's design. And I greatly appreciate all the mushers who've shared their thoughts, feelings, attitudes, and knowledge over the years, both with me and with other journalists. Many of the tales-from-the-trail included in this book originally appeared in* The Anchorage Times *or the* Anchorage Daily News, *albeit in different form.*

I am especially indebted to the now-deceased "Father and Mother" of the race, Joe Redington, Sr., and Dorothy Page, for wonderful conversations and memories. I also owe special thanks to the mushers who talked with me as I researched the Iditarod's evolution for this new edition: Terry Adkins, Jerry Austin, John Baker, Lavon Barve, Martin Buser, Ken Chase, Bill Cotter, DeeDee Jonrowe, Jeff King, Dick Mackey, Doug Swingley, and Mike Williams.

Thanks to Iditarod race coordinator Joanne Potts, for assisting me on this project and helping me corral needed information at numerous other times over the years; to Mina Jacobs and Dianne Brenner, for their gracious help in tracking down historical photos in the Anchorage Museum of History and Art's archives; and to all of those who supplied historic photos.

I'm grateful to all those who've supported my freelance writing efforts. Above all, I appreciate the love and encouragement given to me by my wife and sweetheart, Dulcy Boehle, even when writing has sometimes seemed to take over my life.

—*Bill Sherwonit*

I thank God that I have been able to make the 2001 Iditarod my 21st race. It is He that sustains me. I enjoy this race so much—it's an honor and privilege to be part of it. This book, and all my travels and photos I take along the Iditarod, could not have been done without the grace of God and a lot of help from a lot of people. Each year I shoot the race it's like a reunion of so many wonderful friends. The Iditarod is not a race, it is truly an "event" unlike any other.

First to all the dog mushers and their spouses and families—what a rare breed of people you are. Your dedication to the mushing lifestyle and your determination in the face of daily adversity is an inspiration to us all. Thank you for your help and cooperation through the years. Second I must especially thank my pilots over the years: Dr. Von Mitton, Sam Maxwell, Chris McDonnel, Danny Davidson, and all the volunteer pilots of the Iditarod Airforce. Your great flying efforts have afforded me the images in this book.

A big thanks goes to all volunteers, race fans, and ITC staff who make this race work.

While there are literally too many people to list fully, these are just a few of the great people of Iditarod who deserve special mention for getting me where I am today and making each day on the trail such a pleasure: Barry and Kirsten Stanley, Bill Devine, Bobby Nicholas, Buckey Winkley, Candi Maxwell, Carl and Kirsten Dixon, Dick and Audra Forsgren, Dick Rudy, Doug Katchatag, Jack Davis, Jack Niggemyer, Jan Newton and the entire Village of Tokotna, Jenna and Dave Squier, Jim Brown, Joanne Potts, Joe and Vi Redington, Sr., Joe and Norma Delia, Laura Kosell, Leo and Erna Rasmussen, Leroy Wands, Matilda Davidson, Maurice Ivanoff, Mike Owens, Palmer Sagoonick, Pat and Sue Hahn, Paul Claus, Stan Hooley, the Village Girls, and the Ekanwilers.

And with this being my first book with Sasquatch, it's been absolutely wonderful working with such top notch people as Kate Rogers and all the folks at Sasquatch Books,

—*Jeff Schultz*

INTRODUCTION

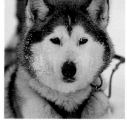

As I write this, Montanan Doug Swingley is driving his sled dog team toward victory—and his third straight championship—in the 29th running of the Iditarod Trail Sled Dog Race. It's hard to believe that 16 years have already passed since I first traveled the Iditarod Trail from start to finish, while covering "The Last Great Race" for *The Anchorage Times*.

I joined *The Times* in 1982 as a sports reporter and shortly afterward was assigned to a sports beat that proved to be a dream come true for this transplanted New Englander (by way of Arizona and California): sled dog racing. Competitive mushing offered all kinds of new and different storytelling possibilities for someone more used to reporting on basketball, football, baseball, track, and soccer. Here was a sport that symbolized the "Alaska mystique," one in which the human participants—with a few notable exceptions—proved to be refreshingly candid and down-to-earth folks for whom mushing is as much a lifestyle as a form of competition. The dogs, of course, added an entirely new element. They are such amazing athletes.

From 1982 to 1984 I reported almost exclusively on short-distance "speed" races. But in 1985, after becoming the newspaper's outdoors writer, I got assigned to the Iditarod. And what a plum assignment it was: I waited in Koyuk as Libby Riddles drove her dog team off the sea ice after they'd survived a night of horrific weather; and I later interviewed her in Nome after she'd astounded Alaska (and Iditarod fans everywhere) with her amazing victory. That year, and the next, I met many of the race's past and present celebrities, as well as its lesser lights. From the front-runners to the tail-enders, all had intriguing tales to tell. I saw the special relationship that develops between mushers and dogs and the invaluable role played by volunteers. And I experienced firsthand the bitter cold, ferocious winds, blizzards, and exhaustion that make the Iditarod such a grand adventure.

It's been nearly a decade since I last "did" the Iditarod from end to end (with pencil and paper rather than dog team), but I still follow the race closely and remain a big fan, while continuing to write stories—and the occasional book—about Alaska's very own "March Madness."

It's a pleasure to share stories of the Iditarod Trail, the race, the mushers, and the dogs; to describe historical events that helped to inspire today's highly competitive event; and to examine the many ways in which the race has changed since that first trek from Anchorage to Nome in 1973.

—*Bill Sherwonit*

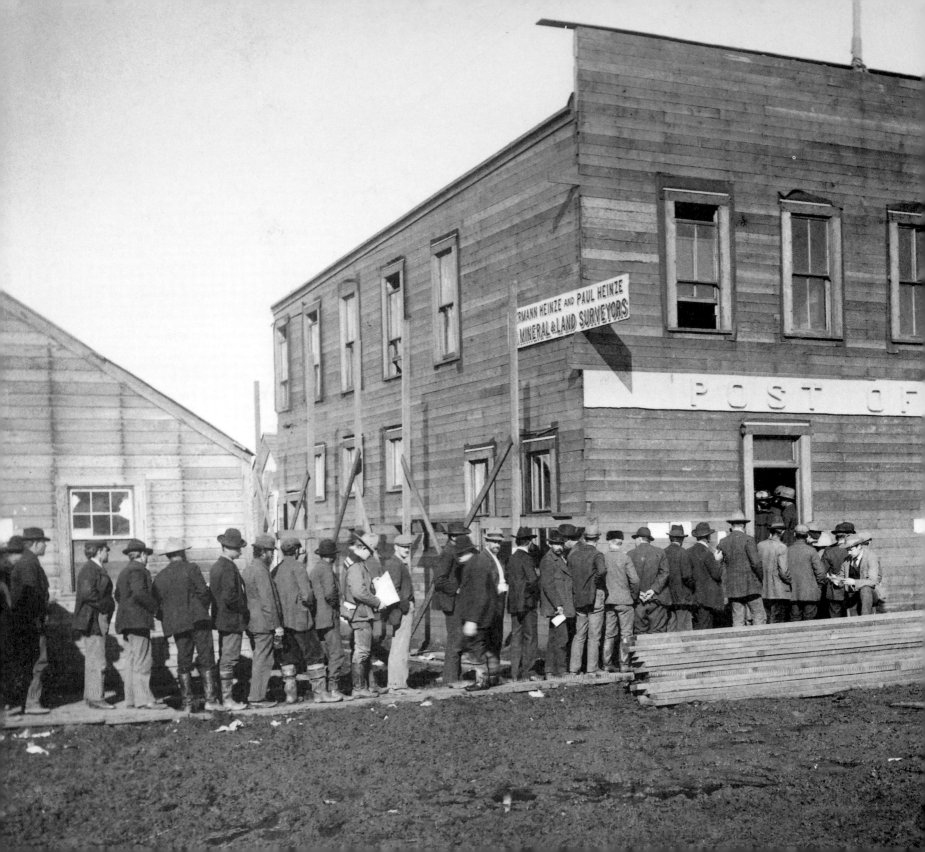

THE IDITAROD'S ROOTS AND THE TRAIL'S HEYDAY

LEFT *Residents of Nome stand in line on "mail day," during the town's gold-mining heyday.*

ABOVE *A husky sleeps in its dog box compartment.*

To uncover the deepest roots of the Last Great Race, you would have to travel back in time thousands of years and visit another continent. Though no one knows exactly when humans first used dogs to pull sleds, it appears the practice began among the indigenous peoples of northern Eurasia. Some of those earliest dog drivers would eventually cross the Bering Land Bridge into Alaska, where the oldest physical evidence of sled-dog use—sled parts and material suggesting harnesses—comes from archaeological sites in the state's Northwest region.

The dogs used by Alaska's Natives were large, powerful animals. Descended from the wolf, these early husky breeds weighed up to 80 pounds or more, with thick necks and chests and short but strong legs. One breed, perhaps developed by the Mahlemut Eskimos, gave rise to what we today call the Alaskan malamute, a large, gentle, thick-coated husky with wolflike facial features and a legendary ability to endure extreme cold.

Among the early Euro-American explorers to describe Native dog teams was Henry Bannister, who visited Alaska in the 1860s. According to Bannister's report in the 1870 edition of *The American Naturalist*, Eskimo dogs "were characterized by a bushy tail, erect ears, and intelligent expression of countenance. . . . As soon as the sled is

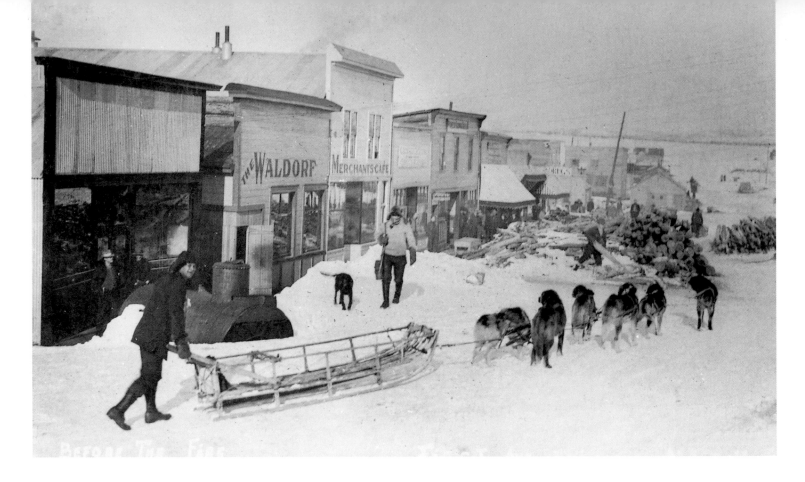

brought out . . . the dogs gather round, and, fairly dancing with excitement, raise their voices in about a dozen unmelodious strains." In that respect, at least, they show little difference from contemporary racing teams.

The Eskimo teams that Bannister encountered normally had five to seven dogs, yet they would sometimes pull loads of up to a thousand pounds. Many teams included pups, which were put into harness at an early age to learn correct pulling techniques. Like their owners, the dogs endured a hard life. In summer they were often allowed to roam free and find their own food; in winter, when their work became necessary, they would be fed nutritious meals, including seal and walrus meat.

The arrival of white Euro-Americans in Alaska greatly expanded the roles of sled dogs. From the eighteenth century to the early twentieth century, dog teams were used for transportation, exploration, trapping, hunting, hauling supplies, mining, and mail delivery. Trappers using dog-powered sleds and toboggans worked Alaska's Interior while traveling together in dog "trains" and even larger

A musher drives a team of sled dogs down Iditarod's First Avenue in 1911.

"brigades." Averaging 25 to 50 miles per day, trappers' teams would cover thousands of miles in a single winter.

Toward the end of the nineteenth century, dogs became invaluable to Alaska's gold miners. Mushers called "dog punchers" would haul food, freight, mail, and mining equipment to gold claims and then pack out gold on their return trips. As demand for gold increased, so did the price of dogs. Big, strong, durable animals could bring $1,000 or more. Sled dogs were equally important to Alaska's mail service in the early 1900s—and one of the most important routes was the Iditarod Trail.

Some segments of the course that Iditarod racers follow today were developed centuries ago by Eskimos and Athabascan Indians, long before Alaska was "discovered" by European explorers. Russian fur traders used portions of the route during the early 1800s. But without question, the Iditarod Trail's heyday was during the Territory's gold rush era, from the late 1880s through the mid-1920s.

Primarily a winter pathway (in summer the swamps, bogs, and lowland tundra it crosses are virtually impassable), the trail acted as a transportation and communication

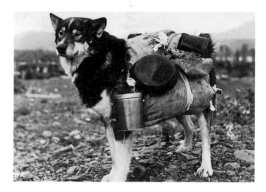

ABOVE *Malamute huskies were often used as sled dogs in winter and pack dogs in summer.*

RIGHT *A team of sled dogs hauls water through the streets of Nome.*

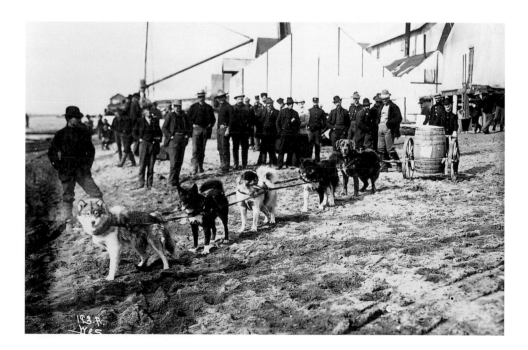

corridor that connected mining camps, trading posts, and other settlements that sprang up during the gold rush. Serving as one of Alaska's main overland routes from 1911 into the early 1920s, the Iditarod was actually a network of trails. Its main stem started at the ice-free port of Seward and ended at the gold-boom town of Nome on the Bering Sea coast. Including side branches, the entire system measured more than 2,200 miles.

The southern portion of the route was created during the late 1880s, through what was known as "Cook Inlet country." Interestingly enough, the earliest trail-blazers came seeking coal, not gold. The region's first notable gold strike was made at Resurrection Creek in 1891, and within five years more than 3,000 people had poured into the district. A second rush into the region occurred in 1898. Thousands of stampeders eventually settled in such Cook Inlet communities as Hope, Sunrise, Knik, and Susitna.

That same year, on the shores of the Bering Sea, prospectors found the gold-bearing sands of Cape Nome, thus triggering one of the biggest stampedes in U.S. history. Within two years, an estimated 30,000 fortune seekers set up camp, more than $2 million was extracted from Nome's "golden sands," and the city built a reputation as a Wild West town characterized by claim jumping, violence, and corrupt officials.

As with most stampedes, many of the gold seekers failed to strike any riches at all. By 1905, Nome's population had dropped to about 5,000, but the town remained the commercial and communications hub of Northwest Alaska. Because of its regional importance, territory officials sought to end Nome's wintertime isolation—which often stretched from October to June, when the Bering Sea was frozen and contact with the "outside" world was essentially cut off. After several attempts failed to establish a direct and economical overland route from Nome to ice-free ports in the state's Southcentral region, the U.S. Army's Alaska Road Commission ordered that a route be surveyed from Seward to Nome. Led by Walter Goodwin, a four-man team began the survey in January 1908 and in three months blazed a path hundreds of miles long.

In his survey report, Goodwin concluded that the proposed route would make sense economically only if additional gold discoveries were made along it, thus increasing the amount of traffic. In an ironic twist, just such a discovery occurred several months later. On Christmas Day 1908, prospectors W. A. Dikeman and John

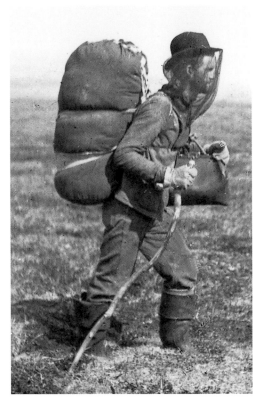

ABOVE *An Alaskan prospector with huge pack and mosquito netting—but without the benefit of a pack dog—crosses the tundra.*

RIGHT *A group of Nome residents pose on the frozen Bering Sea with sled dogs and skis, during the town's gold boom days.*

MUSHING

The English word "mush" comes from the French command *march*—literally, "March." In *Racing Alaskan Sled Dogs,* F. S. Pettyjohn traces the origins of the word: "'Mush' has been used for at least 150 years, but the phrase 'dog musher' is quite recent. Up until the first part of the twentieth century, a dog musher was known as a 'dog driver' or a 'dog puncher.' To him 'mush' meant to 'move out,' but the old sourdoughs often used it to mean travel by walking or snowshoeing. Going from village to village was referred to as 'mushing.' Travel by dog team was called 'sledding' or 'dog sledding' or, more recently, 'dog mushing.'"

Modern sled dog drivers very rarely use "mush." More common starting commands are "Hike" or simply "Let's go."

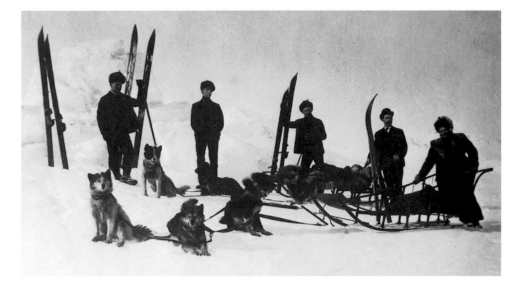

Beaton found gold on a tributary of the Haiditarod River, about 60 miles southwest of the route Goodwin had blazed—a strike that prompted Alaska's last major gold rush.

By 1912, more than 10,000 fortune hunters had been lured to the so-called Inland Empire. Most settled in either Ruby or Iditarod (derived from the Indian word haiditarod, meaning a "far distant place"), but numerous other gold-boom towns and camps were established and connected by a crude system of trails. The Iditarod strike and subsequent gold boom prompted completion of the Seward-to-Nome project. A work crew of nine men and six dog teams—again led by Goodwin—cleared, marked, and improved nearly 1,000 miles of trail during the winter of 1910–11.

Through the mid-1920s, thousands of people traveled the Iditarod's network of trails in winter. Most drove dog teams, but some rode on horse-drawn sleds. Others walked, snowshoed, or even bicycled, usually because they couldn't afford to own or rent a dog team. One such hiker, Charles Lee Cadwallader, recounted his 1917 adventures in the book *Reminiscences of the Iditarod Trail.* "The dog team was an expensive thing to possess if you did not have work for them other than pulling you over the trail," Cadwallader reported. As proof, he quoted the following prices: $200 for a "good" five-dog team; $150 for sled and harnesses; and 50 cents per dog per day to feed the team (or about $35 for a two-week journey with five dogs).

Cadwallader chose to walk from Anchorage to Iditarod in April. He explained: "At this time of year a person would not need snowshoes and would not experience any extreme cold. Ten below zero to 20 above zero would be the average temperatures to expect. The time it would take to mush in to the camp [a distance of about 400 miles] would require 12 to 20 days."

Traveling with several different companions, he walked anywhere from 14 to 62 miles per day. Though the pace was exhausting, he enjoyed the adventure: "This trail winding its way over the frozen tundra held something for the musher that outweighed his thought of being tired and every muscle being crowned with a boil. . . . This was the land of the midnight sun and it held romance. . . ."

The length of Cadwallader's daily travels, as for nearly everyone who used the trail, was determined by the distance between roadhouses. Dozens were established along the trail that connected Nome and Seward. According to the Bureau of Land Management (which in the 1980s prepared a management plan for the historic trail): "Almost as fast as the trail was surveyed, enterprising young men and women began staking out sites. . . . Those that were actually built and utilized were spaced about a day's journey apart [from 14 to 30 miles]. These inns were vital . . . for they meant a warm fire, shelter, and a hot meal after a day on the trail." All roadhouse owners were required to keep lists of their guests, to help track any who got lost.

Though prospectors, trappers, freighters, missionaries, government officials, and assorted other business people traveled the trail, mail carriers earned special acclaim for their cold-weather heroism. Until dog teams were replaced by airplanes in the 1920s and '30s, mushers who owned mail routes were "kings of the trail." Not only did U.S. laws require that mail teams be given the right-of-way, but carriers also received special treatment at roadhouses. They typically were given the best seats at the table, the first servings of food, and the best bunks for sleeping.

Mail carriers earned such pampering; their job was a difficult and hazardous one. They frequently fought blinding blizzards, frigid temperatures, and 70-mile-per-hour winds to deliver the mail on schedule.

Pete Curran, Jr., delivered mail from Solomon to Golovin on the Bering Sea from 1924 to 1938. Running a team of 21 to 23 dogs (enough to get up hills while carrying 500 to 600 pounds of mail), Curran was expected to maintain a regular weekly routine

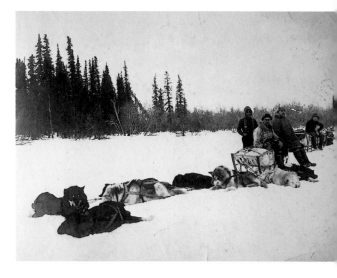

Drivers and dogs take a break from hauling cargo sleds near Ship Creek in Anchorage, in 1915.

from late November to early May: three days to Golovin, three days back to Solomon, one day of rest, then back to Golovin. The challenge came in meeting that schedule in all kinds of weather.

"You'd have to be on time regardless of the weather or trail conditions," Curran recalled. "If I lost a day, I had to make a double run the next day. So I had to go no matter what the weather. . . . Sometimes in those storms you couldn't see half of the team. You just had to trust your leader to keep going."

Billy McCarty, who carried mail along the Yukon River between Ruby and Nine-Mile Point, remembered, "There were days the poor dogs, they just hated to go. Going upriver, against a headwind, cold; oh, it really bothered them. But we had no choice. They had to go, whether it was cold, or raining, or anything. They just had to go." For their services, mail carriers were paid as much as $150 per month, "a lot of money in those days, when things were cheap," McCarty said. "Back then, it was like $100,000. Good money."

Mail carriers weren't the only mushers to build heroic reputations along the Iditarod Trail during Alaska's gold rush days. Some of the era's most famous drivers were sled dog racers. During the trail's heyday, highly publicized mushing contests were staged at several gold-boom towns, including Iditarod and Ruby. But the greatest race of that era was born in Nome: the All-Alaska Sweepstakes.

U.S. mail carrier R.H. Griffis stands with his dog team outside Nome.

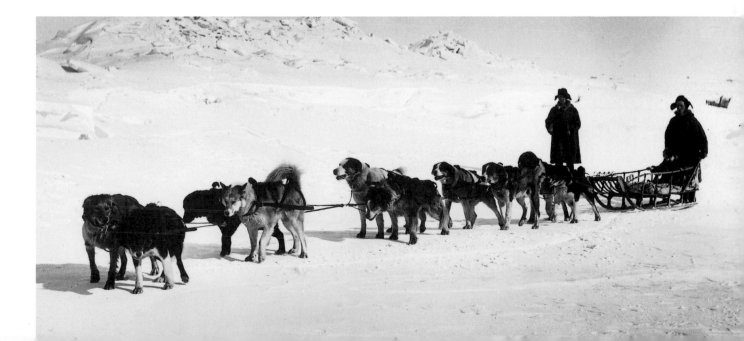

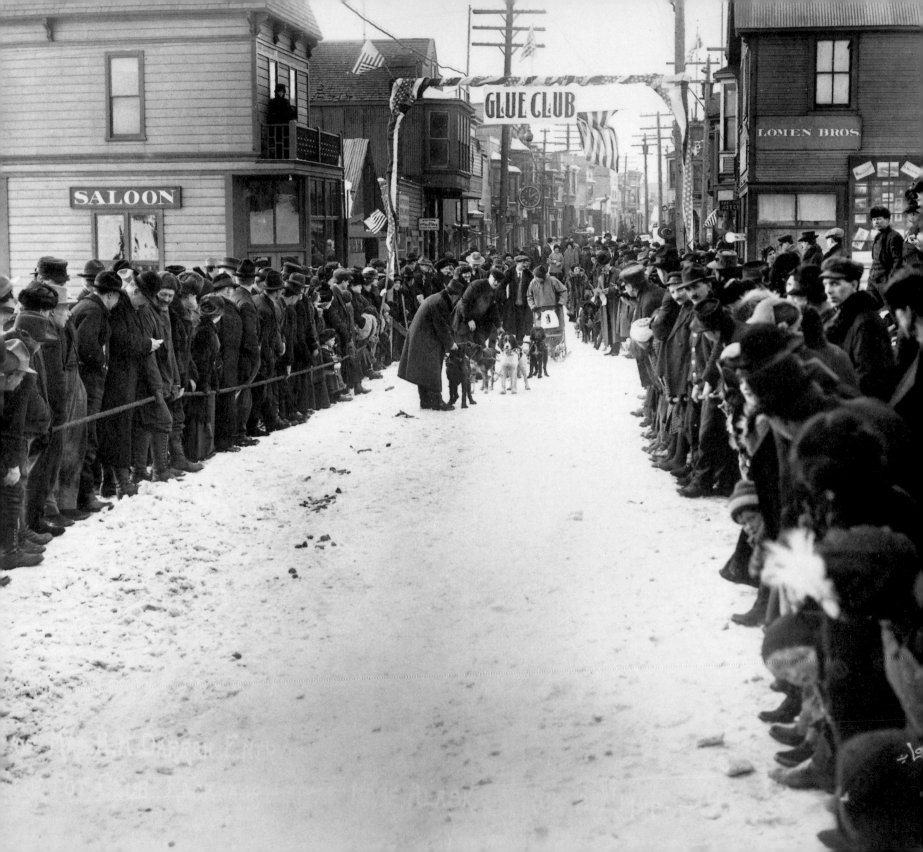

THE ALL-ALASKA SWEEPSTAKES

LEFT *Huge crowds pack Nome's Front Street as a sled dog team awaits the countdown to "Go!" during the early 1900s.*

ABOVE *A trail-weary husky.*

U ntil the early 1900s, Alaska's mushers traditionally used dogs strictly for work or transportation. Drivers had little opportunity for recreation when they harnessed up their teams. Sled dogs were occasionally raced to settle a bet or determine the fastest team in the camp, village, or neighborhood. But there was no major competition—complete with official rules, judges, trails, and purse—until 1908, when a group of Nome sled dog owners staged the first All-Alaska Sweepstakes.

It makes sense that an isolated gold-boom town literally at the end of the trail would spawn what is now recognized as Alaska's official winter sport. With mining operations shut down for the winter, Nome's residents had plenty of time for long and sometimes heated discussions about one of their favorite topics—dogs. Drivers spent hours debating the relative merits of their teams. Finally, a miner and dog driver named Scotty Allan offered a solution to the unending debates. He suggested a race.

Born in Scotland, Allan Alexander "Scotty" Allan was lured to Alaska in 1893 by gold, but he found his riches in mushing. Even before Nome's historic race, Allan was recognized as one of the best dog drivers in Alaska.

But before focusing on Scotty's achievements, we need to give credit where it's due.

Truth be known, it was Allan's six-year-old son, George, who first proposed a race to settle an argument about which family owned Nome's top dogs. George and his schoolmates organized a race for boys nine and younger. With a rather scruffy and then still unknown dog named Baldy for his leader, the younger Allan won the seven-mile, three-dog event. Nearly everyone in town attended the race, and local merchants offered prizes to the top finishers. Soon mushing replaced skating and skiing as Nome's favorite sport for both boys and girls.

With the younger set having so much fun, it was only a matter of time before adults agreed to resolve their dog debates in a similar fashion. It was Scotty Allan who said, "There be only one way to settle this thing: Do like the lads do. [Have] a race to prove it."

Following Allan's lead, a lawyer and dog lover named Albert Fink made an inspirational speech to Nome's top mushers: "As I see it, such races will become a permanent thing in Nome. We all know what an important part dogs have contributed to the development of Alaska, how dependent we are up here on them for transportation. I propose that we establish a Kennel Club, the purpose of which will be to improve the strains of Alaskan dogs, and to better their conditions. The Annual All-Alaska Sweepstakes races . . . will serve to prove which dogs are best. I predict that dog racing in Alaska will prove as popular a sport as horse racing in Kentucky."

After forming the Kennel Club, with Fink as their president, Nome's dog drivers went about the task of organizing the first All-Alaska Sweepstakes. With Allan's guidance, the club settled on a 408-mile course from Nome to Candle and back, along a trail that would cross a variety of terrain, including sea ice, mountains, rivers, tundra, and forest.

To ensure that contestants would follow a code of fair play and take proper care of their dogs, the club instituted a set of regulations that have served as the basis for modern race rules. Among the most notable:

- The cruel and inhumane treatment of dogs by any driver is strictly prohibited under penalty of losing the race and forfeiture of the team.
- Each team must take all of the dogs with which it started to Candle and return to Nome with the same dogs and none others.

The racers were obliged to return with every dog, dead or alive. Therefore, it was to

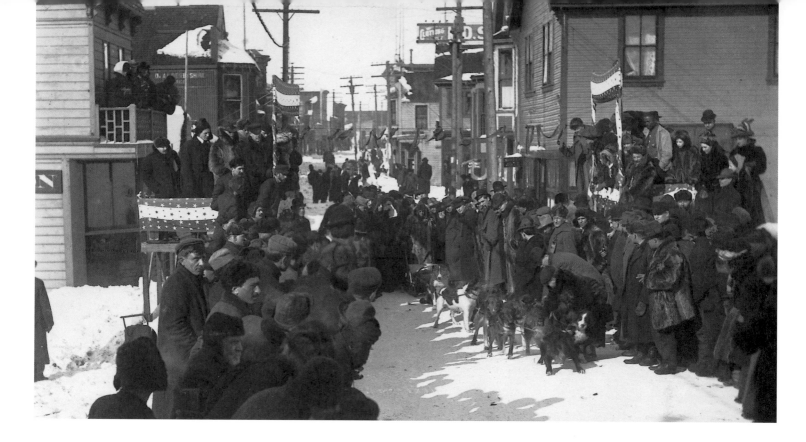

every driver's obvious advantage to treat his dogs well so that he wouldn't have to carry the extra weight of a dead or disabled dog on his sled. To prevent illegal substitutions, the Kennel Club photographed each dog and recorded its name, color, and markings.

To arouse public interest in the Sweepstakes, the club staged short races during the fall and winter of 1907–8. And Fink raised $10,000 in prize money, to be split among the top finishers. The strategy worked perfectly. By race day in April 1908, a holiday spirit enveloped the town.

A Sweepstakes queen and her court were elected, and Nome's schools and courts closed on race day. Most businesses were shut down, but one establishment that remained open—and filled to the seams—was the Board of Trade Saloon, which served as race headquarters. People went there for race updates, and also to place their bets; hundreds of thousands of dollars changed hands.

The marathon event started and finished on Nome's Front Street. Its route followed a telegraph line to Candle, and messages could therefore be relayed back to headquarters. Bulletins on the race leaders and the condition of men and dogs were periodically posted throughout Nome.

Ten teams entered the inaugural Sweepstakes. The first driver to leave the chute, Paul Kjegstad, drove his own team, although it was more common for a team owner to pick a driver. Thus John Hegness, the winning musher, drove a team owned by Albert Fink. His winning time for the 408-mile race was 119 hours and 15 minutes. Scotty Allan, driving a team owned by J. Berger, settled for second place.

Teams left the starting line at two-hour intervals, a practice that proved unfair. Because of the long wait between starts, the final team left 18 hours after the first and some mushers drove into storms that others missed entirely. So in succeeding years, the starting interval was decreased to 15, to 10, and then to 5 minutes. Finally, in 1912 and subsequent Sweepstakes races, teams left one minute apart to minimize the weather factor.

The second Sweepstakes attracted 13 mushers and was marked by several innovations. In winning the 1908 race, Hegness had run a mail-dog team, complete with freighting harness and sled. But the following year, Allan used a sleeker, lighter sled—weighing only 31 pounds, it was the forerunner of the modern racing sled. He also used simpler harnesses that allowed the dogs greater freedom of movement.

Aided by his refined gear and again driving a team owned by Berger, Allan won the 1909 race despite getting caught in a severe blizzard. It was during this storm that Baldy—whom Allan had once considered a mediocre mongrel—proved his championship mettle. Baldy somehow found his way through the whiteout and led Allan's team into the winner's circle. Within days, Scotty Allan was being heralded in headlines around the world as "King of the Arctic Trail." His scruffy leader, meanwhile, had earned the title "Baldy of Nome."

Despite Baldy's heroics, not all of Nome's attention was focused on the winning entry. The third-place team, driven by Norwegian immigrant Louis Thorstrup and owned by a Russian fur trader named William Goosak, earned considerable notoriety by using Siberian huskies. These dogs were much smaller and lighter than the big, powerful freighters used by most Sweepstakes contestants. Fox Maule Ramsay, another Nome miner and dog driver, was so impressed that he traveled to Siberia the following summer and purchased several of the small huskies. In 1910, he entered three teams of Siberians in the Sweepstakes. One of those teams was driven by John "Iron Man" Johnson, who finished the 408-mile event in 74 hours, 14 minutes, and

Famed musher Scotty Allan stands with his sled dog team in 1913; that year Allan's dogs placed third in the All-Alaska Sweepstakes.

37 seconds—a speed record that was never broken. Ramsay, driving his own set of Siberians, placed second.

The Siberian imports gained enormous popularity and became the sled dogs of choice through the remainder of the Sweepstakes series. But several mushers, Scotty Allan among them, stayed with more traditional Alaskan sled dogs, including malamutes and Native-bred huskies, setters, pointers, collies, hounds, airedales, or some combination of hounds and huskies. Allan had little reason to change dog breeds after the 1910 race. Five of his ten dogs had been injured when the team tumbled down a 200-foot cliff, yet the team still managed to finish third.

Scotty and Baldy returned to the top in both 1911 and 1912, strengthening their positions as kings of the North. Fay Delzene won the Sweepstakes title in 1913, and Iron Man Johnson earned his second victory in 1914, with Allan taking second.

The 1914 Sweepstakes marked the first appearance of Leonhard Seppala, who was destined to become an even greater mushing legend than Scotty Allan. Born and raised in Norway, Seppala had also come to Alaska in pursuit of gold. But soon after arriving in Nome he began working as a dog puncher. The sled dog racing fever that swept Nome in the early 1900s eventually infected him, and he entered his first Sweepstakes at age 37. The race was traumatic for Seppala. His team of Siberian huskies got caught in a storm and lost the trail. Then, while searching for the route along the coast, his team nearly ran off a cliff. Eventually, with several dogs suffering from cut feet and lost toenails, he dropped out.

Then came the 1915 Sweepstakes, and the start of the Seppala legend. The race favorite was, as usual, Scotty Allan. But Seppala, competing in only his second major race, outmushed the acknowledged master and placed first. Many more victories followed, in Nome and elsewhere. Seppala won the next two Sweepstakes races, before the event was discontinued in 1918. In a racing career that would span 45 years, he won dozens of titles, while traveling an estimated 250,000 miles by dog team.

And the All-Alaska Sweepstakes? The race series was never revived after World War I, but its place in history was assured. The Sweepstakes had laid the foundation for a sport that would, as Albert Fink had predicted, become a favorite throughout Alaska. Ultimately, the race would serve as an inspiration for another mushing extravaganza to Nome, the Iditarod Trail Sled Dog Race.

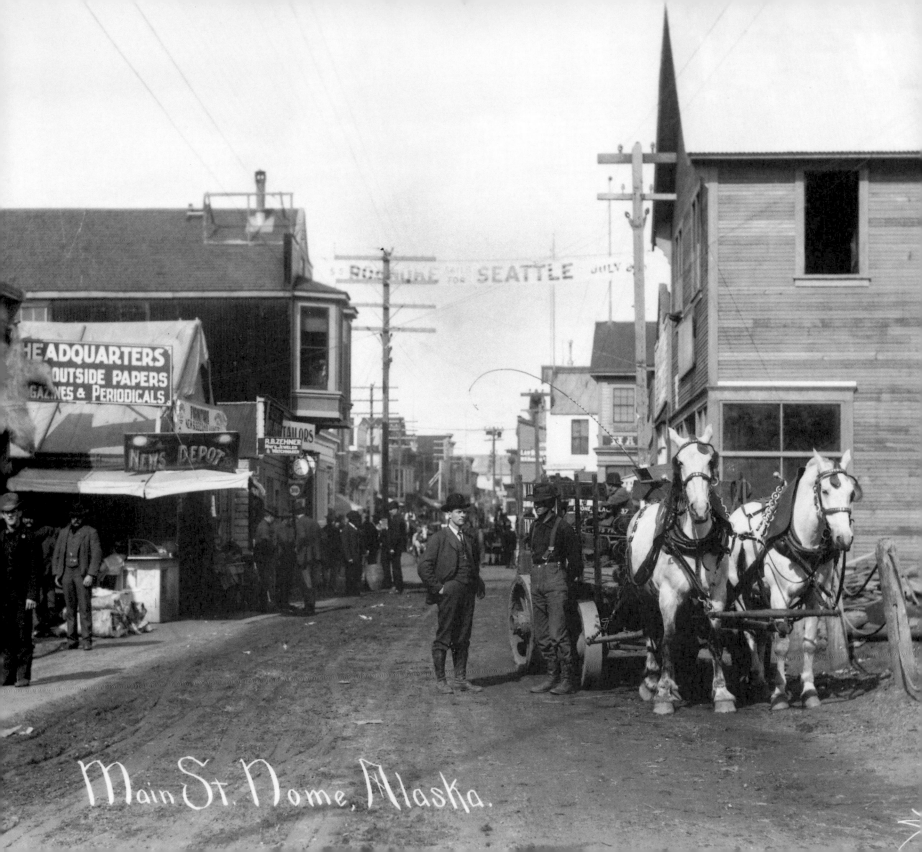

Main St. Nome, Alaska.

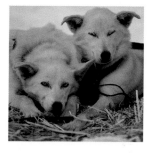

THE RACE FOR LIFE

LEFT *Main Street, Nome, Alaska.*

ABOVE *Huskies are bedded down in straw during a rest break.*

The 1920s marked the end of an epoch along the Iditarod Trail and elsewhere in Alaska's Interior. Airplanes were gradually replacing sled dog teams as the primary means of transportation, freight hauling, and mail delivery to bush communities. Yet even as their lifestyle slowly headed for extinction, a group of mushers and dogs demonstrated their value while participating in the most highly publicized and important sled dog race in Alaska's history.

No sporting event, this race was the famed diphtheria serum run of 1925, also widely known as the "Great Race of Mercy to Nome." Twenty drivers and more than a hundred dogs were recruited for this run. Their mission: to relay a 20-pound package of diphtheria antitoxin serum from Nenana to Nome, where an outbreak of the disease threatened to become a fatal epidemic that would endanger the lives of hundreds or maybe even thousands of Alaskans. In all, the teams would travel nearly 700 miles, across one of the world's roughest and most desolate landscapes, in the depths of winter. Roughly two-thirds of their route would follow the Iditarod Trail.

The highly contagious disease that prompted this unique mission of mercy struck Nome with no forewarning. The first victims were two young Eskimo children, who

died in mid-January of 1925. Dr. Curtis Welch, Nome's only physician, diagnosed the cause of their deaths as diphtheria, commonly known at that time as the "black death." Welch knew that only a miracle could save Nome—and perhaps the entire region—from decimation. His meager supply of five-year-old antitoxin would run out after a few inoculations, if it hadn't already lost its effectiveness. Then what? With no serum, the disease would likely spread like wildfire. Natives in Nome and nearby villages would be especially vulnerable, since they'd built up no immunity to this "white man's disease."

Welch set up a meeting with Mayor George Maynard and the Nome City Council to request a quarantine and figure a way to get serum as quickly as possible. Maynard suggested the medicine be flown to Nome, but others balked at such a plan. In 1925, bush flying was still in its infancy. The Territory's few planes had open cockpits and had been used only in summer. No one knew whether a plane could operate at minus 40 degrees Fahrenheit (or colder), or whether a pilot could keep from freezing in such conditions. And if a plane crashed, or was forced to land short of its destination, the serum would be lost. The mayor and the city council finally settled on a slower, but more reliable, solution: The serum would be transported via train to Nenana, where the state's rail line ended, and then to Nome by dog team.

Pleas for medical assistance were quickly sent via radiotelegraph to other Alaskan communities. The nearest antitoxin supply was in Anchorage, where Dr. J. B. Beeson had 300,000 units of the life-saving serum. If sent to Nome quickly, this amount might be able to hold back the infection until a supply of one million units arrived from Seattle.

Agreeing that dog teams, not planes, offered the best hope, Alaska Governor Scott Bone ordered a relay to be organized. Mushers would travel to designated mail-shelter cabins, and wait their turn to transport the serum.

As dog drivers quickly prepared for their roles, Dr. Beeson packaged the serum for shipment to Nenana by rail, placing it in a cylindrical container and wrapping it in insulating material. On January 26, the 20-pound bundle began its 298-mile train journey.

Back in Nome, meanwhile, Leonhard Seppala was gearing up for the most challenging race of his life. When it became apparent that dog teams would be used to transport the antitoxin, Nome's Board of Health had requested the services of Seppala and his legendary Siberian huskies.

A musher lashes up his supply sled while his dogs wait to resume their travel along the Iditarod Trail in the early 1900s.

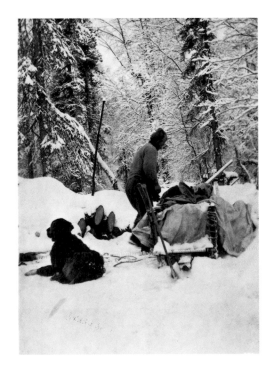

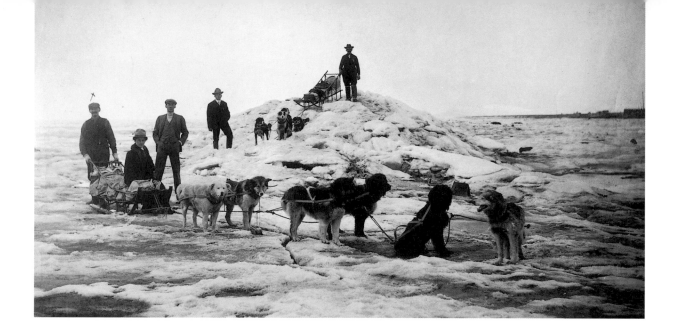

Nome residents pose with dog teams on the frozen Bering Sea in 1906.

Instructed to retrieve the serum at Nulato, about halfway between Nome and Nenana, Seppala chose 20 dogs for the 640-mile round-trip journey. He planned to drop 12 of them at stops along the way so that on the return trip he could substitute fresh dogs for tired or injured ones. Using that approach, Seppala figured he could run the team both day and night.

Leading the team would be Seppala's pride and joy, a 48-pound Siberian husky named Togo. Now 12 years old, the light-gray dog with pale blue eyes had led Seppala to victories in all of Alaska's most prestigious races, including the All-Alaska Sweepstakes. One who didn't make the team was a big, black husky named Balto. Though he'd proved to be a good enough freight dog, Balto was too slow for racing. Yet he would eventually play a major—and controversial—role in the mercy mission.

On January 28, Seppala received notice that the dog team relay had begun. Unfortunately, the message failed to explain that territorial officials had decided to speed up the serum run by using a large number of relay teams over short distances. Seppala left Nome believing he would have to travel all the way to Nulato, when in fact his journey would be much shorter.

The relay began shortly before midnight on January 27, when train conductor Frank Knight passed the serum to "Wild Bill" Shannon, a former Army blacksmith who was now a mail driver. Driving a team of nine malamutes in minus-50-degree weather, Shannon took his team to Tolovana. There he was greeted by Edgar Kalland, an Athabascan who worked as a steamboat operator in summer and a part-time mail

carrier in winter. The two men took their package into the roadhouse and warmed it by the fire, per Beeson's instructions. Then Kalland pointed his seven-dog team toward Manley Hot Springs, 31 miles away.

Fifty-five years later Kalland recalled, "It was 56 below, but I didn't notice it. We were dressed warm. We didn't have down, but I had a parky. It went below my knees, so the heat couldn't get out. You was always running or moving; your feet never got cold. . . . But then what the heck? What do you notice when you're 20 years old? You don't notice a thing. I think about it now. How did I survive?"

And so the serum was transported from one outpost to another. Mushers and dogs traveled day and night in constant subzero temperatures, through often fierce winds and occasional whiteouts. The first 15 drivers all took turns carrying the serum across the Interior and finally to the village of Unalakleet, along the Bering Sea coast. They covered 465 miles in 75 hours. But more than 200 miles still remained, and reports out of Nome indicated the diphtheria was spreading rapidly.

From Unalakleet, the trail followed the coast, where mushers were often battered by fierce winds and intense storms that produced whiteout conditions. Occasionally they would cut across the frozen sea, but at great risk. Open channels of water would appear unexpectedly, and when a strong wind blew from shore, the ice would sometimes break up and move out to sea. Rather than risk a Bering Sea shortcut, dog driver Myles Gonangnan stayed on land. As Kenneth Ungermann describes in his book *The Race to Nome,* Gonangnan's team of eight dogs was slowed while traveling through the hills between Unalakleet and Shaktoolik. The deep new snow and winds were "blowing so hard that eddies of drifting, swirling snow passing between the dogs' legs and under their bellies made them appear to be fording a fast-running river."

At Shaktoolik, Gonangnan transferred the serum to Henry Ivanoff. Less than a mile out of the Eskimo village, Ivanoff's team picked up the scent of reindeer and tried to leave the trail. Ivanoff drove his sled brake into the snow to halt the half-crazed dogs, but as the sled slowed they began to fight. While trying to restore order, he saw a team approaching from the north. It was Seppala. Still unaware of the revised relay plans, the Norwegian drove his Siberians past Ivanoff's snarled team, but fortunately heard the other musher call, "Serum—turn back!"

Though Ivanoff's team was much fresher, there was no question which musher and

THE SERUM MUSHERS, 1925

MUSHER	RELAY SEQUENCE	DISTANCE (miles)
"Wild Bill" Shannon	Nenana to Tolovana	52
Edgar Kalland	Tolovana to Manley Hot Springs	31
Dan Green	Manley Hot Springs to Fish Lake	28
Johnny Folger	Fish Lake to Tanana	26
Sam Joseph	Tanana to Kallands	34
Titus Nikolai	Kallands to Nine-Mile Cabin	24
Dave Corning	Nine-Mile Cabin to Kokrines	30
Harry Pitka	Kokrines to Ruby	30
Billy McCarty	Ruby to Whiskey Creek	28
Edgar Nollner	Whiskey Creek to Galena	24
George Nollner	Galena to Bishop Mountain	18
Charlie Evans	Bishop Mountain to Nulato	30
Tommy Patsy	Nulato to Kaltag	36
Jackscrew	Kaltag to Old Woman Shelter	40
Victor Anagick	Old Woman Shelter to Unalakleet	34
Myles Gonangnan	Unalakleet to Shaktoolik	40
Henry Ivanoff	Starts from Shaktoolik, hands to Seppala	——
Leonhard Seppala	Shaktoolik to Golovin	91
Charlie Olson	Golovin to Bluff	25
Gunnar Kaasen	Bluff to Nome	53
	TOTAL	674

dog team were more qualified to make the 91-mile trip to Golovin, the next relay point. After a brief discussion, Ivanoff handed the serum and warming instructions to Seppala, who had already driven his team 170 miles over the previous three days.

Turning his team around, Seppala was soon faced with a potentially life-threatening decision: Should he cut across Norton Bay? The inland route was much safer but would add several hours to the journey. And time was at a premium. After a few moments of indecision, Seppala chose the shortcut.

Forced to rely entirely on Togo's uncanny sense of direction, the team headed across the ice-covered bay. Large stretches had been blasted free of snow, creating glare ice on which the dogs often slipped and fell, and the sled was constantly pushed sideways by the persistent wind. Once more, Seppala's faith in Togo was justified, as the husky unerringly led the team across the sea ice despite the darkness and blinding storm.

Upon reaching Isaac's Point, Seppala fed his dogs a large ration of salmon and seal blubber and then napped for a few hours in an igloo, with the serum placed near the fire. The team resumed its journey early the next morning, though the blizzard had worsened. Gale-force winds produced wind-chill temperatures approaching minus 100 degrees. Pushing on through the storm, his dogs completed their remarkable 260-mile journey, finally collapsing in exhaustion when they reached Dexter's Roadhouse, 78 miles from Nome.

A grizzled sourdough named Charlie Olson took the serum from Seppala and, after the ritual warming, headed into the blizzard shortly after 3 p.m. on January 31. Approaching Golovin Lagoon, Olson's team was blasted by strong gusts that lifted musher, dogs, and sled and hurled them off the trail. Fortunately, all landed in a snowdrift and were unharmed. A short while later, Olson noticed his team slowing, which could only mean one thing: The dogs were beginning to freeze in the groin— an area not protected by thick fur. Olson stopped, and with aching, ungloved hands he carefully and methodically blanketed each dog in the team—a heroic effort that resulted in several frostbitten fingers. Now fighting for survival, the team struggled on to Bluff. Waiting there was Gunnar Kaasen, a Norwegian who'd driven teams for 21 years in Alaska. The longtime Nome resident had put together a 13-dog team for the relay. For a leader, he'd chosen Balto, the husky that Seppala had earlier rejected.

Initially the team made good time, but five miles from Bluff the dogs sank up to

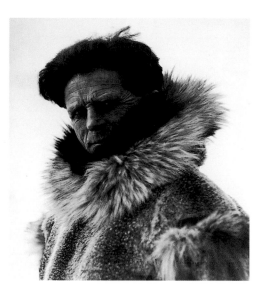

One of the serum run's heroes, famed musher Leonhard Seppala.

their bellies in drifted snow. Kaasen tried to break trail but was soon swallowed in chest-deep powder. The team had no choice but to circle around the drift. Slowly, led by Balto, it probed through the darkness and eventually regained the trail. Shortly after, while crossing the frozen Topkok River, Balto suddenly stopped and refused to move despite Kaasen's impatient shouts. The driver walked forward and was shocked to see Balto standing in shallow overflow (a place where water is forced to the surface of the ice and flows across it). Fortunately, the dog had stopped in time to keep his teammates from entering the icy water.

After drying Balto's feet, the musher circled around the overflow and again pushed ahead. At one point the blowing snow became so dense that Kaasen couldn't see even those dogs closest to the sled. He had no choice but to trust Balto's instincts. The poor visibility caused Kaasen to miss the small settlement of Solomon. Instead he drove on to Bonanza Flats, where a sudden gust flipped the sled and knocked over several dogs. After righting the sled and untangling the team, Kaasen checked to see that the serum was still securely tied down. But the package was gone.

It was too dark to see. Falling to his knees, he pulled off his mittens and groped frantically through the snow with bare hands. Panicked thoughts ran through his mind. Could he have lost the serum farther back on the trail? After the serum had traveled so far, would he be the one to fail? Despair gave way to relief, however, when his right hand touched the familiar package. After joyfully lifting it from the snow, he carefully retied it to the sled.

Kaasen's team reached Point Safety sometime after 2 a.m. on February 2. Inside the cabin slept Ed Rohn, who wasn't expecting Kaasen until morning. Rohn had been asked to make the final sprint to Nome, but Kaasen decided not to wake his replacement. After all, the worst was over and only 25 miles remained. And though his dogs had suffered, they were still running well. So Kaasen continued on to Nome, finally reaching the town's deserted Front Street at 5:30 a.m. The 20 teams that participated in the "Great Race of Mercy" had traveled 674 miles through often stormy weather in less than five and a half days, a remarkable accomplishment.

Kaasen quickly ran to Welch's home and presented his package to the doctor. Using the antitoxin judiciously, Welch was able to cure those who were ill and prevent the infection from spreading. No further deaths from diphtheria were reported. The

Bluff City, 53 miles outside Nome, is where Gunnar Kaasen began the final leg of the serum run in 1925.

epidemic was halted, and in less than three weeks the quarantine was lifted. Five days after Kaasen made his special delivery, the second batch of serum arrived in Seward. This supply was also sent by train to Nenana and then carried across the state by dog teams, including many that had joined in the first relay.

After the serum run, all recognized participants were given a "donation" from a public fund, as well as per diem paid by the Territory. Most earned $30 to $40. Governor Bone also presented the drivers with a citation praising their heroism. And the H. K. Mulford Company, which produced the serum, sent inscribed medals to members of the first relay and also awarded Kaasen $1,000 for his part in the race.

Though the medical emergency ended within a few weeks, some secondary effects of the mercy mission reverberated for years afterward. On the positive side, Nome's diphtheria outbreak and the heroic serum run helped focus attention on the disease. Until 1925, diphtheria annually caused 20,000 deaths within the United States. But publicity given to the Nome epidemic helped bring about widespread inoculations and greatly reduced the disease's deadly impact.

On the down side, the serum run created considerable controversy and jealousy. In particular, Gunnar Kaasen's decision to bypass Ed Rohn started a feud that lasted several decades. Many Nome residents—Rohn and Seppala among them—claimed that Kaasen had purposely bypassed Rohn to reap the publicity and other rewards. Kaasen's supporters, meanwhile, accepted his explanation of the final night's events. Some even argued that it would have been a mistake to give the serum to Rohn, who had no experience traveling in stormy weather. The $1,000 reward given to Kaasen added to the controversy, as did an acting offer made to him by a motion picture company.

Seppala was further disgruntled when the media chose Balto as the serum run's canine hero and became outraged when Togo's race record was incorrectly attributed to the big freighting dog. But the final, crushing blow came when Balto, instead of Togo, was immortalized in a cast-bronze statue that was placed in New York City's Central Park.

Perhaps, as Seppala insisted, greater credit should have been given to Togo. But the statue of Balto seems a fitting tribute to an ordinary husky who came through against heavy odds and represented all the canine participants in the great serum race—truly man's best friends in the winter of 1925.

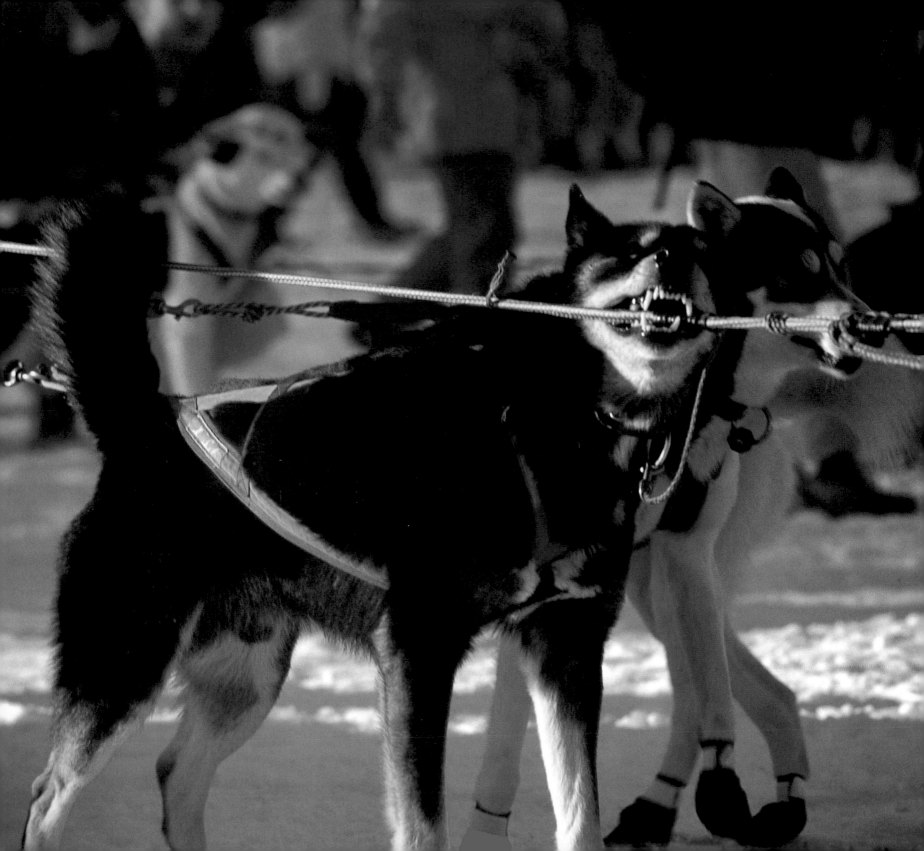

ORIGINS OF THE IDITAROD RACE

LEFT *While waiting in the staging area of the 2000 race, an eager sled dog bites and tugs on the gang line in an effort to get the snow hook free so he can run.*

ABOVE *A discarded sled belonging to Doug Swingley waits at the Tokotna checkpoint to be mailed back to Anchorage. Because of rough trail conditions, mushers often send replacement sleds to one or two strategic checkpoints along the trail in case the sled they are riding becomes damaged.*

The year was 1966. Four decades had passed since airplanes had begun to edge out sled dog teams as the mail carrier of choice. Now even more drastic changes were occurring. Sled dog racing had continued to survive—and even thrive—in some population centers, most notably Fairbanks and Anchorage. But throughout much of Alaska, mushing was on the downslide; the sled dog subculture seemed headed for extinction. The decline was most evident in small rural communities, where sled dogs were rapidly being replaced by snowmobiles (also known as snowmachines in Alaska).

"Dog teams were disappearing fast in the mid-1960s," Joe Redington, Sr., recalled years later. "Snowmachines were taking over in the villages. When I visited Interior villages in the fifties, every household had five or six dogs. They were the only transportation. But by the late sixties, village dogs were almost gone."

Redington, a longtime Alaskan and devoted musher, didn't like that disappearing act. But neither did he have a solution—at least not until he met Dorothy Page at the 1966 Willow Winter Carnival. Then and there, the future "Father and Mother of the Iditarod" had a conversation that helped revive and reenergize the sport of mushing in Alaska.

Page, a self-described history buff, had seen her first sled dog race in 1960, shortly after moving to Alaska from California. In 1966, she'd been named president of the Wasilla-Knik Centennial Committee; her primary task was to organize an event to celebrate the 100th anniversary of America's purchase of Alaska from Russia. She decided to stage "a spectacular dog race to wake Alaskans up to what mushers and their dogs had done for Alaska. We wanted to pay them a tribute."

The Iditarod Trail seemed ideal for such an event. It was, after all, a famous route

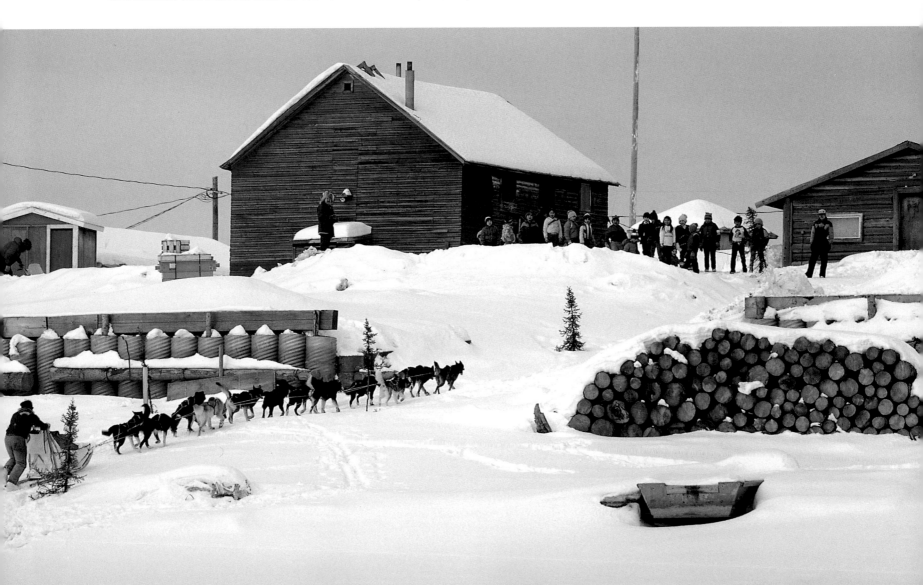

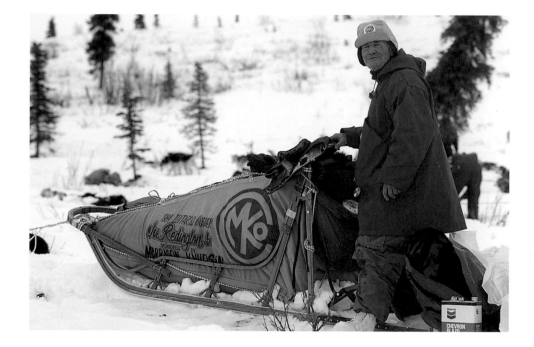

LEFT *In 1984 on one of his very first races, Vern Halter, an attorney turned dog musher, runs behind his sled up the bank of the Yukon River to a warm welcome from children at the village of Nulato.*

RIGHT *The father of the Iditarod, Joe Redington, Sr., pauses by his sled at the Rainy Pass checkpoint during the 1984 Iditarod. Redington was always known to travel with the heaviest sled on the trail; you can see it bulging here. The can of white gas ("blazo") shown here clearly dates this photo as mushers no longer use gas stoves, but instead light straight alcohol in a pot for instant hot heat.*

PAGE 26 *In her rookie year of 1984, Francine Bennis's team crosses over an ice bridge as it snakes its way around open water on Dalzell Creek. The Dalzell Gorge is one of the most difficult and scariest sections of the trail, especially for rookie mushers. Every year the creek freezes differently and a musher never knows what's around the next bend.*

used by mushers during the gold rush era. And it passed through both Knik and Wasilla, which would bring the race close to home. There was only one problem, but it was a big one: No dog driver would back the idea. Then Page crossed paths with Redington at the Willow carnival. Little did she know it, but Joe Sr. was the perfect man for the job.

Born February 1, 1917, "in a tent on the Chisholm Trail in Oklahoma," Redington was fathered by a drifting laborer who variously worked as a farmer, rancher, and oil-field worker. His mother was an "Oklahoma outlaw who took off for the hills" shortly after Joe's birth. Following his mother's departure, Joe shared a nomadic life with his father, James, and brother, Ray. In 1948, the family's travels brought them to Alaska. Shortly after crossing the border, the Redingtons stopped for fuel. The owners of the service station presented them with a gift: a puppy. It was, in retrospect, an omen of things to come.

The Redingtons weren't rich, but Joe used what money he had to buy land in Knik. By chance, that property was adjacent to the Iditarod Trail, which after a quarter-century

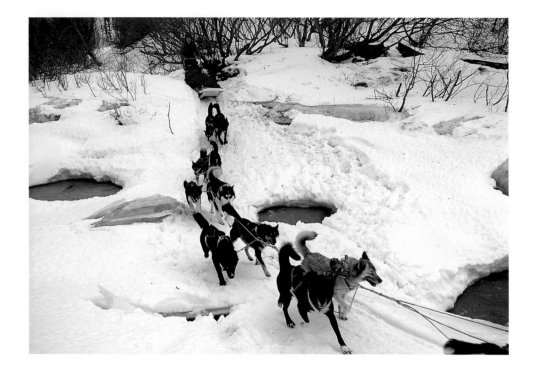

of disuse had become overgrown. In the fall of 1948, Redington met Lee Ellexson, an Alaskan sourdough who'd driven mail-carrying dog teams along the Iditarod Trail in the early 1900s. "Lee sold me some sled dogs," Joe says. "He'd tell me stories of the old days and took me out on the trail. He sold me on mushing."

By the end of his first winter in Alaska, Redington owned 40 dogs and had started up his Knik Kennels. At first he used the dogs for work rather than recreation. They hauled equipment and the logs Redington used to build his cabins. They also helped in rescue and recovery missions. Redington contracted with the U.S. Air Force to recover the wreckage of aircraft that had crashed and to rescue, or recover the remains of, military personnel. From 1949 to 1957, using teams of 20 to 30 dogs, he hauled millions of dollars' worth of parts and hundreds of servicemen from remote areas. From 1954 to 1968, he also used dog teams in his work as a hunting guide. But always he kept a special interest in the Iditarod Trail.

In the early 1950s, Joe and his wife, Vi, began to clear portions of the trail and

THE MUSHERS

Who are these men and women competing in the race to Nome?

The large majority of the Iditarod's 60 to 70 entrants reside in Alaska's South-central, Interior, and Northwest regions and represent a broad spectrum of the state's population. Some live in the state's rural areas, commonly known as "the bush," where they lead subsistence lives—hunting, fishing, trapping, and gardening. But most live along the road system, within a few hours' drive of Anchorage or Fairbanks, where they can find supplies, veterinary care, and sponsors. A few are urban dwellers, living in or near the Anchorage metropolis. About 10 percent are typically Outsiders—the Alaskan term for anyone from the Lower 48, Canada, or overseas.

Race rules require mushers to be at least 18 years old. And all rookie entrants must complete approved mid- to long-distance qualifying races.

Only a handful of entrants could be classed as professional mushers, earning a living as sled dog racers—Susan Butcher (before her retirement), Rick Swenson, Martin Buser, Jeff King, and Doug Swingley are prime examples. These are the large-kennel owners, with 70 to 100 dogs or more, devoting themselves to the sport year-round.

For most Iditarod mushers, sled dog racing is either a part-time business or a hobby, albeit an expensive one. Race related costs range from $10,000 to more

than $25,000, including the $1,750 entry fee (all mushers who finish may get up to $1,049 of that back) plus dog food, equipment, kennel maintenance, dog-care expenses, transportation, and training. And financial rewards are lean for all but the highest finishers. The 2001 Iditarod had a purse of $550,000, with a winner's share of $62,857. But only the top 19 places paid more than $10,000.

Iditarod mushers represent a wide array of professions and ages. Many work seasonal jobs to support their "habit." The race lineup has included carpenters, commercial fishermen, hunting guides, lawyers, surgeons, veterinarians, airline pilots, reindeer herders, gold miners, plumbers, personnel managers, small-business owners, writers, biologists, ivory carvers, corporate presidents, members of the military, and retirees.

Whatever the size of their kennels or the nature of their goals, Iditarod racers typically begin training by late summer or early fall. Four-wheelers, motorized carts, or trucks are used to run the dogs when there's no snow, and heavy-duty preparation begins once the ground is covered in white. From November through March, everything takes a back seat to mushing concerns, as dog owners prepare their teams for the grueling trek to Nome with ever-longer training runs. By race day, most will have traveled 2,000 miles or more with their teams.

lobbied to have it added to the National Historic Trail System. (Congress finally designated the Iditarod a national historic trail in 1978.) Then, in 1966, Dorothy Page proposed her centennial race.

Joe Sr. excitedly responded, "That would be great." But he agreed to support Page's idea only if the event offered $25,000 in total prize money, an extraordinary amount for that time. (The prize money, or "purse," is divided among a race's top finishers; depending on the event, anywhere from 10 to 30 racers may split the purse.) By contrast, Anchorage's long-established and widely acclaimed Fur Rendezvous World Championship, begun in 1946, offered only $7,500 in 1967. "I wanted the biggest dog race in Alaska," Redington explained. "And the best way to do that was to offer the biggest purse."

The proposed event, scheduled for mid-February 1967, initially met with considerable opposition. Some of Alaska's most notable mushers predicted it would fail

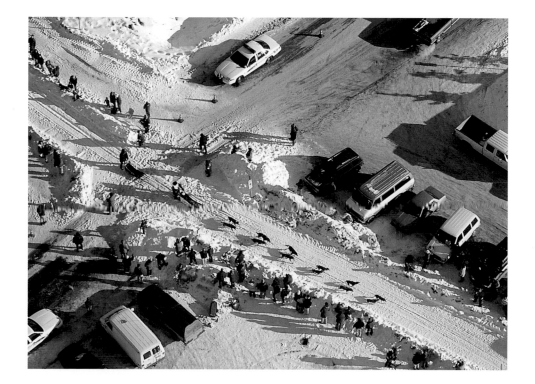

miserably. Instead, it was a smashing success that attracted an all-star field of 58 racers. Run in two heats over a 25-mile course, the race was officially named the Iditarod Trail Seppala Memorial Race, in honor of mushing legend Leonhard Seppala.

Over the years, the Iditarod race's origins have been closely linked with the "Great Race of Mercy" to Nome. Most people believe the Iditarod was established to honor the drivers and dogs who carried the diphtheria serum, a notion the media have perpetuated. In reality, "Seppala was picked to represent all mushers," Page stressed. "He died in 1967 and we thought it was appropriate to name the race in his honor. But it could just as easily have been named after Scotty Allan. The race was patterned after the Sweepstakes races, not the serum run."

The centennial race was won by Isaac Okleasik, a resident of Teller on the Seward Peninsula. His portion of the $25,000 purse was $7,000, by far the biggest mushing payday of that era. But the Iditarod soon appeared to be a one-time big deal. The race was canceled in 1968 for lack of snow and interest. It was reinstated in 1969, but only $1,000 in prize money could be raised. Not surprisingly, the field also shrank, from 58 mushers to 12.

Enthusiasm for an Iditarod Trail race all but died that year. Only one person kept the dream alive: Joe Sr. Rather than see it fade away, he wanted to expand the event, make it longer, better, more lucrative. Initially, Redington planned a race from Knik to the gold-boom ghost town of Iditarod. "Everybody asked, 'Where the hell is Iditarod?' Nobody knew anything about Iditarod then," Joe said. "So I changed it to Nome. Everybody knew where Nome is. That was our first smart move."

It may have been smart, but it wasn't well received. Skeptics labeled the proposed thousand-mile sled dog race an "impossible dream." And some folks began calling Redington "the Don Quixote of Alaska." Paying no attention to the cynics, Redington promised in 1969 that there would be a long-distance race to Nome by 1973, with an outrageous purse of $50,000. Despite some major obstacles, trail-clearing and fund-raising among them, Redington pulled off his impossible dream. Thirty-four drivers signed up for the first-ever Iditarod Trail Sled Dog Race, and $51,000 was raised.

Joe Sr. billed the Iditarod as a 1,049-mile race (which is still the official distance). There was no question that the course was at least 1,000 miles long; and the "49" was intended to symbolize Alaska, the forty-ninth state. In reality, the distance

PAGE 27 Downtown Anchorage streets are turned into dog trails as seen here in this aerial view during the 1999 race. The team is running on Cordova Street that just the night before had snow dumped onto it and spread around with a grader.

BELOW Swedish rookie musher Morten Fonseca gives a high five to spectators who are lining the race course in midtown Anchorage during the 2001 race. The ITC requires a musher to have a dog handler ride with him for the Anchorage start. Morten Fonseca has decided to have his handler on a second sled.

RIGHT Veteran musher Ramy Brooks's team of 16 dogs charges down the chute at the restart in Willow during the 2001 Iditarod. While not the "official restart" home, the area of Willow has been used a number of times when poor snow conditions in Wasilla have prohibited a safe restart there.

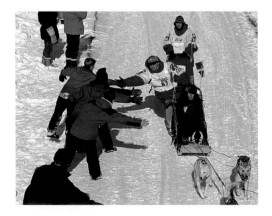

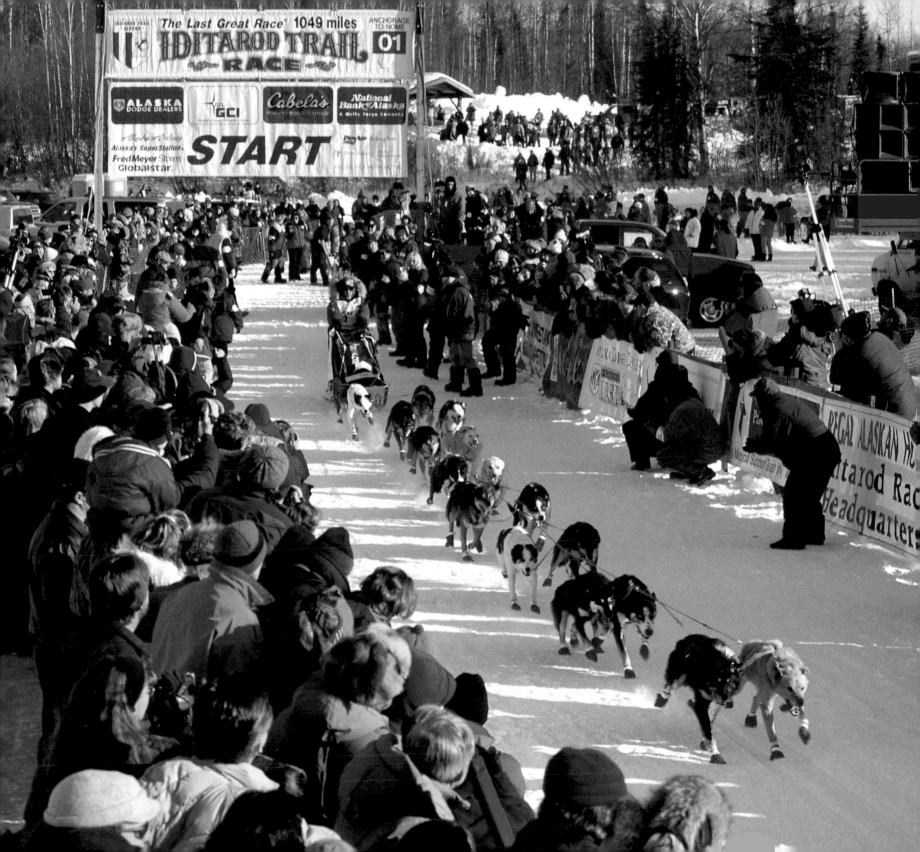

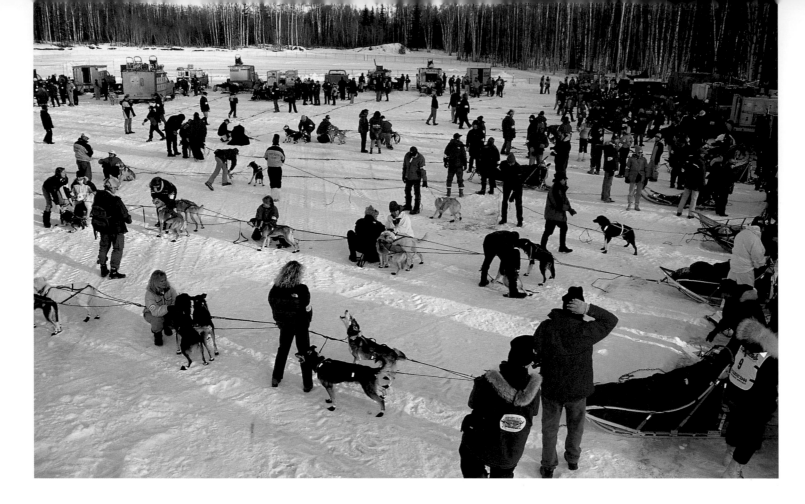

traveled by Iditarod teams is over 1,100 miles.

Twenty-two of the 34 teams reached Nome in March 1973. The winner was Dick Wilmarth, a little-known entrant from the tiny community of Red Devil, who finished in 20 days. A mysterious footnote to the race involves Wilmarth's lead dog, Hot Foot, who somehow got loose at the end of the trail in Nome and was not seen again until two weeks later, after finding his way back home to Red Devil, more than 500 miles away. His return was especially amazing because there are two major rivers, the Yukon and the Kuskokwim, between Nome and Red Devil.

The race had exceeded everyone's expectations, even Redington's. But another serious and unforeseen problem had arisen: A large number of dogs had died along the trail (depending on which published account you read, the toll was anywhere from 16 to 30), causing an uproar and protests, especially among animal rights groups.

"We got lots of letters and telegrams telling us to stop this cruel race," Redington

Mushers hook up their dogs in a staging area at Wasilla in 2000 and await their appointed time to leave. Teams leave the restart line every two minutes and make up this time differential during their mandatory 24-hour layover.

said. "Even Governor Bill Egan wrote to us. There was a lot of pressure to stop. The SPCA took out half-page ads. It's true a lot of dogs died, mostly from pneumonia and dehydration. It wasn't good. But we were trying to take good care of the dogs. The first two years were tough on the dogs, but gradually we learned how to properly care for them."

The next year, the Iditarod continued to have financial problems, and the purse dropped to $34,000. Yet 44 mushers signed up. Carl Huntington, an Athabascan racer from the Interior village of Galena, took first place in 20 days, 15 hours. Afterward, Redington took a poll of the mushers. "I asked them, 'Do you want to see another race?' They all said yes. I think it was established after 1974. The mushers said they'd go even if the purse wasn't big."

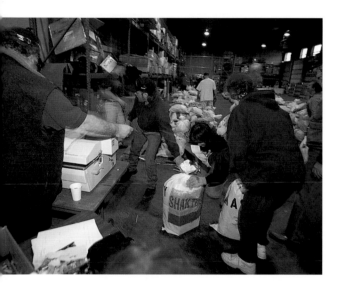

Volunteers add metered postage to mushers' food and supply drops. This mail then goes out to the checkpoints along the trail that have post offices. Other checkpoints without post offices, such as Rainy Pass, Finger Lake, Yentna Station, Rohn, and Ophir, get their supplies flown in by the volunteer Iditarod "Airforce."

The 1975 Iditarod was a landmark race for two reasons: A major corporate sponsor pledged $50,000, and several rules were added to ensure proper care and health of the dogs. The dog death rate dropped dramatically that year, with only two reported losses. But in 1976, the race's sponsor withdrew its financial backing in response to continued negative publicity about dog care. The Iditarod Trail Committee's Board of Directors wanted to postpone the event two years while building its finances, but Redington refused, believing that such a postponement "would have killed the race."

With help from Dorothy Page and her husband, Von, Joe Sr. again kept the show going. The race has grown steadily—with a few rough episodes along the way—ever since. For well over a decade now, the Iditarod has earned national and international credibility and fame as "The Last Great Race."

The race purse has increased to $550,000, with more than $60,000—an amount greater than the entire purse in 1973—awarded to the champion, as the Iditarod has evolved into Alaska's sporting version of "March Madness." Dozens of journalists from throughout the United States and overseas have reported from the trail. Television networks have covered the race and produced post-race specials. And entrants have represented 16 foreign countries: Argentina, Australia, Austria, Canada, Czechoslovakia, Denmark, France, Germany, Great Britain, Italy, Japan, New Zealand, Norway, Russia, Sweden, and Switzerland.

By almost any measure, the Iditarod is a success. The dream is real, thanks to the spirit, foresight, and determination of an adventurer named Joe Redington, Sr.

Wayne

THE IDITAROD'S UNSUNG HEROES: THE DOGS

LEFT *A sled dog wrapped in a blanket is alert as it basks in the sunshine at the Tokotna checkpoint during the 2001 race.*

ABOVE *Paul Gebhart's dog "Wayne" waits inside his box on Paul's dog truck at the restart of the 1998 Iditarod.*

The mushers are the glamour figures in this sled dog race across Alaska. They drive the teams and determine the race strategy; they get the attention and the praise. The top contenders and a few back-of-the-packers are household names in Alaska and, increasingly, throughout much of the Lower 48. Like quarterbacks in football, the mushers probably receive too much credit for successes and too much blame for losses. And with few exceptions, the dogs labor in obscurity and anonymity.

Dogs are often called the true heroes of this event. But they are also the unsung heroes. Only rarely does the name of a sled dog get mentioned by the media. Even more rarely does one become famous. Anyone who follows the race closely knows that Rick Swenson has won five Iditarod championships, Susan Butcher and "Outsider" Doug Swingley of Montana four, Jeff King and Martin Buser three each. But how many people recall that Swenson's main leader in each of his first four wins was a dog named Andy? And who remembers that Granite was a key player in three of Butcher's victories? Or that a dog named Nugget led championship teams to Nome two straight years, under two different mushers? And how many Iditarod fans know that Axle and Dugan were the pair that led Libby Riddles to her unexpected win in 1985?

Though individual dogs receive little glory or recognition, they are the athletic stars of this mushing marathon—they're specially bred, raised, trained, and conditioned to run long distances in often harsh conditions. "There's a common misconception that these dogs are pushed too hard. That's just not true. They want to go. All you have to do is go to the starting line to see that," veterinarian Del Carter explained before a race in the late 1980s. "These dogs live to run. They enjoy running the way a golden retriever loves to retrieve.

"What we're dealing with here are highly trained athletes. There's a lot of difference between evaluating the condition of sled dogs and the average household pet. The dogs may come into a checkpoint very tired. They may have an elevated temperature. But that's no different than a marathoner."

The dogs who run this race are the descendants of breeds used during the gold rush era to pull freighting sleds filled with gold, mining equipment, food, mail, or other supplies. To haul their heavy loads, mushers naturally preferred large, strong dogs such as the Alaskan malamute, a northern purebred probably developed from wolves by the Mahlamut Eskimos.

Because these animals were in limited supply, dogs of all breeds and sizes got harnessed to sleds. As the demand increased, so did the price. A big, powerful dog could sell for $1,000 or more at the end of the nineteenth century. Eventually a canine black market developed in the Lower 48. Dogs were bought or stolen, then sent to Alaska and sold to miners and freighters for inflated prices. According to some reports, "no dog larger than a spaniel was safe on the streets of Seattle, San Francisco, or Los Angeles." After delivery, the dogs brought north from the Lower 48 were often interbred with northern species to produce Alaskan huskies of every description.

Malamutes and various types of large mixed-breed huskies were ideal as working animals, but they didn't have the stamina or long-distance speed valued by sled dog racers. During the All-Alaska Sweepstakes series from 1908 to 1918, many competitive mushers switched to Siberians, a smaller, faster, and more durable husky species first imported to Nome from Russia in 1908.

For many years, Siberians were the race dog of choice. But in their constant search for the winning edge, many mushers began to crossbreed the dogs. Siberians and other Alaskan huskies were bred with hounds, setters, spaniels, German shepherds,

VOLUNTEERS

Mushers and dogs are the focus of attention when the Iditarod is run each March. But the race from Anchorage to Nome wouldn't be possible without the behind-the-scenes work of Iditarod volunteers. Literally thousands of Alaskans, and many men and women from outside the state as well, help to organize this mushing extravaganza.

- Snowmachine crews break trail for the racers and mark the route, often while enduring extreme cold, fierce winds, or blizzards.
- Airplane pilots, known collectively as the "Iditarod Airforce," fly dog food and other

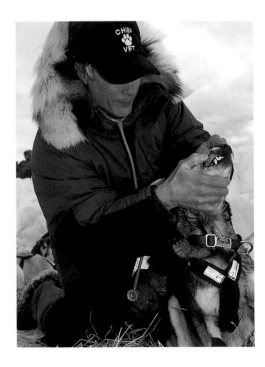

supplies into checkpoints along the route, provide transportation for veterinarians and race officials, transport dropped dogs, and make themselves available for any necessary search-and-rescue operations.

- Veterinarians conduct pre-race examinations on the dogs, check their well-being at checkpoints along the trail, report dog-care rule infractions, and carry out any required emergency medical procedures.

- Ham radio operators stationed at checkpoints provide race updates, relay messages, and coordinate search-and-rescue operations.

- Residents of some checkpoint communities prepare meals, drinks, and desserts for the mushers (served at a central location).

- Designated "checkers" sign mushers in at checkpoints, make certain that mushers are carrying their mandatory gear, and provide information to racers, officials, and the media.

- Computer operators make updated race information available to the media and the public.

- Other volunteers serve as dog handlers at the Iditarod start, answer phones at race headquarters, make dog booties, look after dogs that have been dropped from the race, or simply act as all-around errand runners.

Though most volunteers keep a low profile, their contributions are not overlooked. As one race official explained, "There wouldn't be an Iditarod without the volunteers."

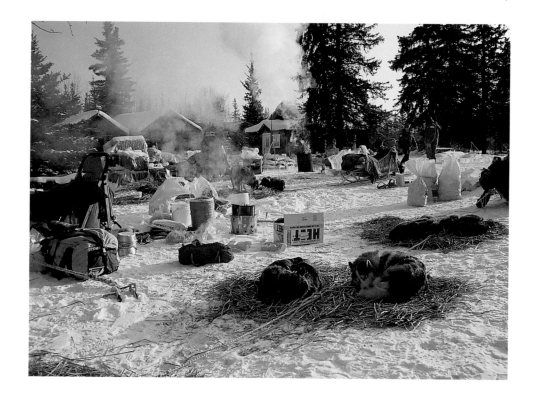

and even wolves, with a constant goal: to produce fast dogs with tough feet, good conformation, proper size, great endurance, a willingness to please, and a strong desire to run. Only rarely do dogs combine all these elements.

Today all the top racing teams feature mixed breeds, which can be grouped into two general classes: the sprinters—those that compete in short races where speed is a premium—and the marathoners—the long-distance dogs that are tested in endurance events such as the Iditarod. Yet the distinction between sprinters and marathoners has become blurred as top Iditarod racers seek ever faster teams. In fact, many of today's most successful Iditarod racers have incorporated sled dog lines developed by famed speed mushers like Gareth Wright and George Attla. "The foundations for our teams were laid way back in the '30, '40s, and '50s by village racers," says three-time champion Martin Buser. "We simply continue to experiment with the breeds that have proven successful, always seeking that extra edge."

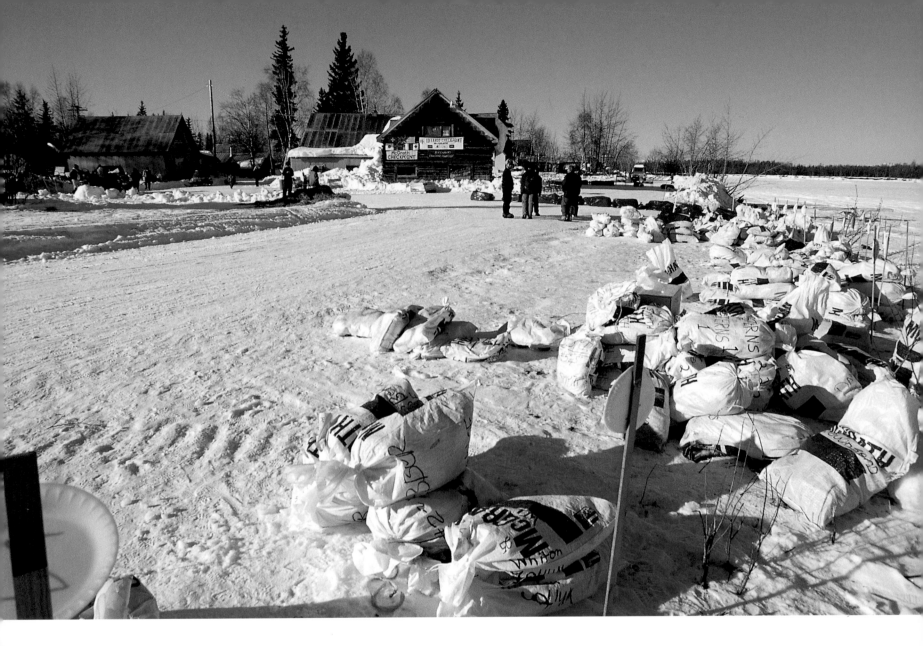

Long-distance dogs tend to be slightly larger than their speed-racing counterparts, generally weighing in at 45 to 55 pounds (sprinters average 5 to 10 pounds less). But mushers generally agree that very little separates the top athletes in either category. "The best dogs are interchangeable," says Swenson. "There are dogs that could make the transition, though it's unlikely they could be successful at both types of racing the same year because the training is so different."

No matter how selectively bred, highly trained, well fed, and well conditioned, a team won't perform to its potential unless all its members remain healthy. The people most intimately associated with the Iditarod—drivers, race organizers, veterinarians—agree that care of the dogs is the top priority.

Iditarod officials require that all dogs be examined by veterinarians during a pre-race checkup, a tradition that started in 1974. All dogs must have current vaccinations for distemper, rabies, and other canine diseases, and they are carefully scrutinized for any signs of illness or weakness. Teeth, eyes, tonsils, heart, lungs, joints, and feet all get inspected. Chief concerns are infections and foot injuries that may not have completely healed, and physical conditions that have somehow escaped previous scrutiny. In addition, female dogs are examined for signs of pregnancy. A dog can be removed from the race if veterinarians find evidence of abnormalities or conditions that would predispose the animal to injury or death, including epilepsy, syncope (fainting), or pregnancy. Typically, only a small percentage of the dogs fail to pass the

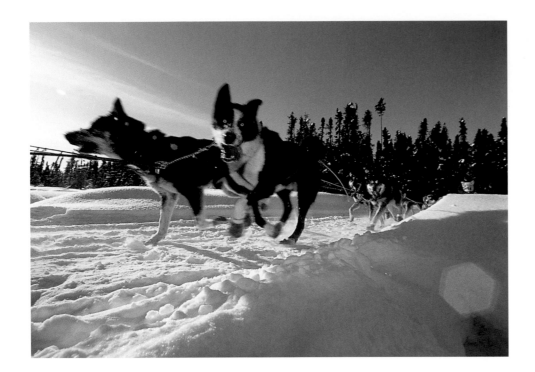

exams, evidence that mushers have taken great care in preparing their teams for the race. During the examination, veterinarians also implant microchips, to verify each dog's identification during and after the race.

The emphasis on dog care continues out on the trail. At each stop, the dogs are tended to first. The driver becomes fire-builder, cook, and physician for his or her dog team. Before worrying about their own needs, mushers make certain that the dogs are fed and bedded down, feet are checked, and sick or injured dogs are treated. As added insurance, veterinarians are stationed at all of the race's checkpoints. In recent years, about three dozen volunteer "dog doctors" have worked the trail under the direction of the head veterinarian.

Del Carter, who served as an Iditarod veterinarian for several years, once explained, "The things we look for during the race are problems with feet and shoulders, respiratory problems, dehydration, diarrhea. And we make it a practice to look at the teams both when they're coming into a checkpoint and after they're rested. A lot of times,

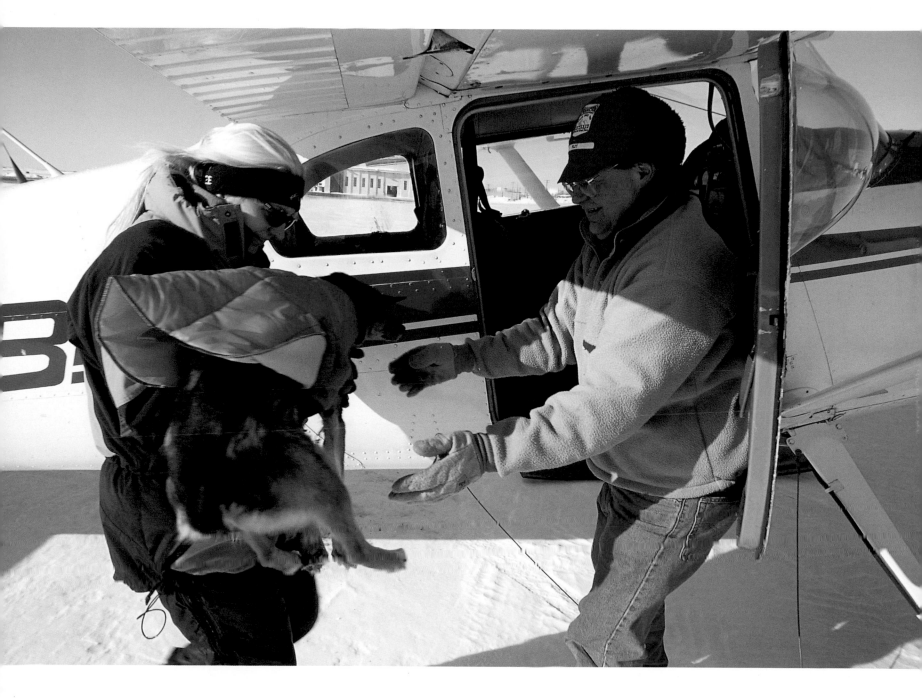

there's a big difference in the way they look after they've rested awhile."

In addition to general health checks, the vets also test for drugs. Iditarod mushers are prohibited from using any drugs that suppress signs of illness or injury, or that would cause the dogs to perform beyond their natural abilities. Race rules list 12 general types of drugs that drivers may not give their dogs, including stimulants, muscle relaxants, tranquilizers, anti-inflammatory drugs, and anabolic steroids. Race veterinarians will, if necessary, use drugs to treat an injured or sick dog, but that dog is then automatically withdrawn from the race.

Juan Alcina's dogs rest at the Tokotna checkpoint during the 2001 race. Iditarod dogs typically get 12 hours of rest during a 24-hour period.

Rick Mackey's dogs—Cindy, Betty, Sky, and Commander—sleep on a bed of straw at the Nikolai checkpoint during Iditarod 2001. During the early races, dogs would simply lie on the snow or mushers would cut spruce boughs for them to sleep on. Now straw is provided by the ITC at each checkpoint to ensure a good bed and rest for the dogs.

No musher has ever been disqualified for dog drug abuse. But a problem over the years has been physical abuse of dogs. To ensure the well-being of dogs competing in the Iditarod, race officials have established a comprehensive set of rules and policies governing "dog procedures." Among other things, these address

- Dog numbers. Mushers must begin with at least 12 and no more than 16 dogs, and have at least 5 dogs in harness at all times. No dogs may be added to teams after the race has started.
- Shipping dropped dogs. Mushers may leave exhausted or injured dogs at designated dog-drop sites (dogs may be dropped at all but two of the Iditarod's checkpoints).
- Dog care. A musher will be penalized if proper care is not maintained. Dogs must be kept in good condition, and all water and food must be ingested voluntarily.
- Hauling dogs. Mushers may not allow any dogs to be hauled by another team. If dogs must be carried in the sled (because of injury, illness, or exhaustion, for example), they must be hauled in a humane fashion and covered if conditions require.
- Cruel or inhumane treatment of dogs. Mushers aren't allowed to commit "any action or inaction which causes preventable pain or suffering to a dog" (Rule 16).

Mushers found guilty of cruel or inhumane treatment may be disqualified from the race. From 1973 through 2000, three mushers were kicked out of Iditarod races because they broke the rule on inhumane treatment. Past champion Jerry Riley of Nenana was barred "for life" in 1990 because race officials felt he showed a pattern of dog abuse over several years. Riley was reinstated in 2000 after he clearly demonstrated a changed attitude and acceptable behavior with his dogs.

Iditarod officials readily admit that race disqualifications—and in the extreme, lifetime banishment—are intended to send a message, both to mushers and to the public. As race marshal Donna Gentry explained after the expulsion of racer Wes McIntyre in 1985 for cruelty to his dogs, "This problem does not reflect the race as a whole. Mushers as a group take care of their dogs at the sacrifice of themselves. There is a special bond that develops between a musher and his dogs. They become part of the family."

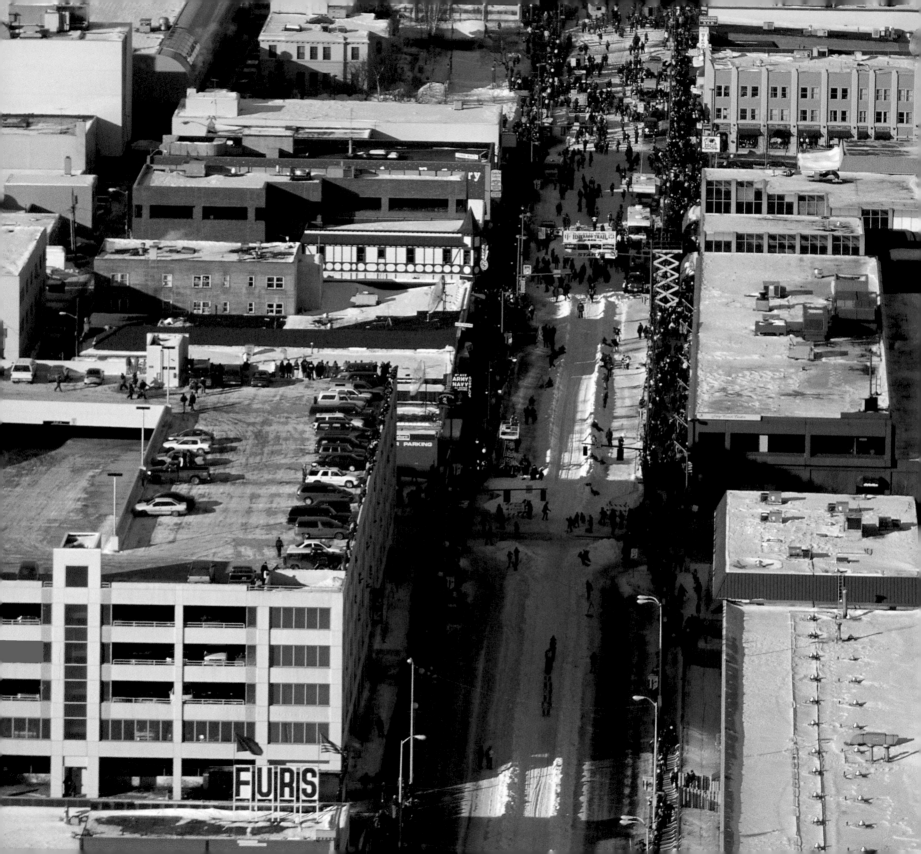

THE RACE ROUTE TO NOME

LEFT *Fourth Avenue in downtown Anchorage becomes the main stage on the first Saturday in March as over 1,000 sled dogs take to the streets.*

ABOVE *An unidentified spectator watches teams.*

The Iditarod traditionally begins on the first Saturday in March, in downtown Anchorage, Alaska's largest city. For years Anchorage was the race's official starting point, but since 1995 its role has been strictly ceremonial. Some might wonder about its inclusion in the Last Great Race in any manner, since the city wasn't even on the original Iditarod trail. But logistically and financially, it makes good sense. With a population of about 260,000, Anchorage is the state's population, communications, and business center. And it is, after all, only 20 miles off the Iditarod Trail's historic Seward-to-Nome route.

As dawn breaks over the Chugach Mountains, a crowd of mushers, dog handlers, veterinarians, race organizers, media representatives, and bleary-eyed spectators gathers along Fourth Avenue. Dogs are unloaded from the trucks that brought them to the staging area (they travel in compartmented camperlike shells called "dog boxes"), and the canine heroes of this sporting drama serenade the city with a symphony of barks, yips, yaps, and howls.

Most mushers have been awake for hours. Some haven't slept all night. Veterans as well as rookies can be affected by pre-race butterflies. "There's always some jitters, no

matter how many times you go through this," admits Joe Garnie, who's competed in 15 Iditarods and finished as high as second. "Once the word is 'Go!' and you're heading down the trail, you can relax. But not before."

From the Fourth Avenue starting line, mushers must drive their teams along several miles of streets and city trails before reaching the comparative safety of the foothills east of Anchorage. (Snow that's been stockpiled throughout the winter is trucked downtown and spread on roads the night before the start.) Thousands of yelling, applauding, whistling spectators line Anchorage's streets for what is essentially a demonstration ride. The combination of huge crowds, loud noises, exploding camera-flash units, and pets running loose is enough to distract even the most disciplined teams and test the dog-handling skills of the most experienced racers. There are also street intersections to negotiate (traffic is stopped whenever dog teams approach), tunnels to pass through, bridges to cross, sharp corners to turn.

Since 1995, Iditarod entrants have been joined in their tour of Anchorage by "Iditariders," who sit on the mushers' sleds. To earn a ride, Iditarod fans must bid, auction-style, on mushers and pay anywhere from $500 to $7,500. Winning bidders are whisked 11 miles through Anchorage, pulled by a hard-charging team of 12 Iditarod dogs (mushers are allowed to use up to 16 when the racing begins).

From Anchorage, the route roughly parallels the Glenn Highway to Checkpoint No. 2, Eagle River, a town of about 30,000 people. Their 20-mile ceremonial run ended, the dogs are reloaded into trucks and returned to holding areas for the night. The following morning, teams converge on the town of Wasilla, home of the Iditarod headquarters and the Susitna Valley's population center. Here, the race to Nome begins for real.

The restart, in many ways, is an instant replay of what transpired in Anchorage. Again dogs grow frenzied as they're unloaded from trucks, placed in harness, and forced to wait their turn at the starting line. Again, the teams leave one at a time, two minutes apart, in a sequence determined by drawing (the number one spot is traditionally reserved for an honorary musher). Again, thousands of spectators line the starting chute.

Once the teams are out of Wasilla, the urban hoopla is left behind. Ahead of the mushers lie more than 1,000 miles of backcountry trail, where dogs and the majority

ABOVE *On the start day of Iditarod 2000 in Anchorage, Rich Bosela keeps his sled upright on a 90-degree turn at Fourth Avenue and Cordova as his "Iditarider" feels the thrill and power of 16 huskies pulling.*

RIGHT *Spectators, jammed along the Wasilla restart in 2000, take pictures, wave, and yell to Jeff King as he whisks past them headed toward the next checkpoint at Knik.*

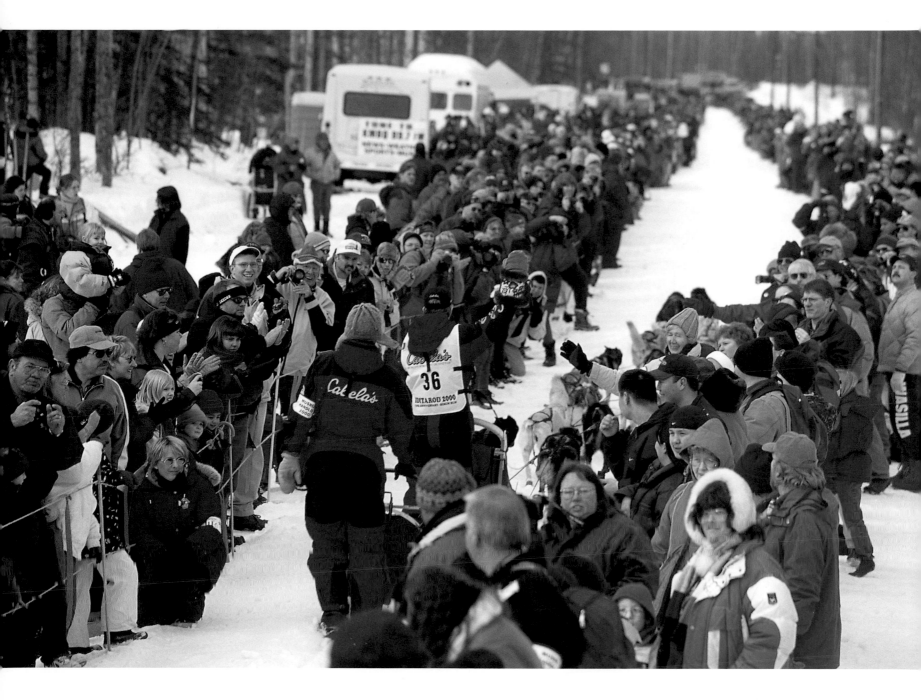

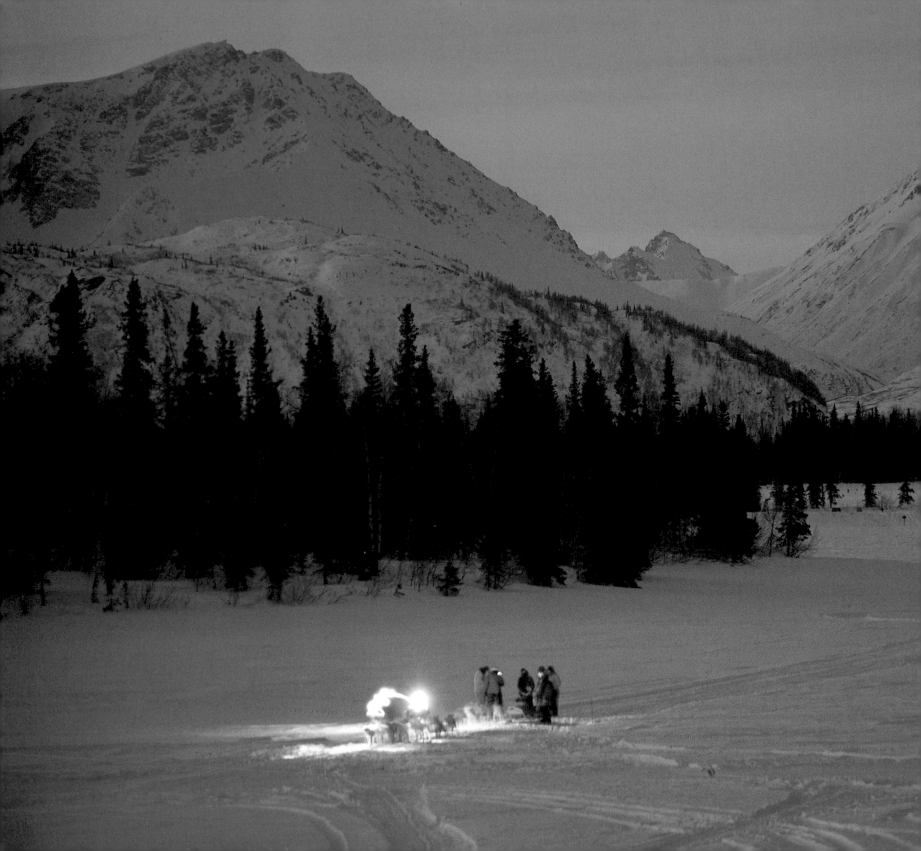

of mushers feel most at home. Here they will test themselves against the weather, the wilderness, and each other, while traveling a route that offers every imaginable winter challenge. In any given year, Iditarod mushers and their teams may have to endure extreme cold, waist-deep snow, hurricane-force winds, whiteouts, river overflow, moose attacks, and dogfights. Racers contending for the championship will also face exhaustion and hallucinations brought on by sleep deprivation.

Connecting Wasilla with checkpoints at Knik, Yentna Station, and Skwentna, the first 100-mile section of trail is often called "Moose Alley." Though moose congregate in this area each winter, in most years they don't present serious problems for teams. But in winters of heavy snow they can be extremely dangerous. The snow buries much of their food supply and makes movement difficult. Rather than struggle through deep and sometimes crusted snow, moose do the logical thing: Where possible, they use roads, railroad beds, snowmobile tracks, and sled dog trails for easier walking. Once a moose has chosen such a route, it's often unwilling to leave, and mushers must detour around it. Sometimes moose do more than block the trail, however. They've attacked Iditarod teams on several occasions because they're stressed, weakened by starvation, or feel threatened by the dogs (which resemble wolves, their natural enemies). The most highly publicized attack occurred in 1985, when a cow moose stomped Susan Butcher's team and shattered her championship dreams. Before being shot by another musher, the moose killed two dogs and seriously injured a half-dozen more.

Except for moose, there are few extraordinary challenges along the 100-mile section of trail from Wasilla to Skwentna (population 90). The terrain is generally flat, and the route—marked with painted stakes, tripods, reflectors, or flags—is easy to follow. Even here, however, mushers have sometimes taken a wrong turn, particularly in the earlier races, when the trail wasn't as well marked.

Beyond Skwentna, the route slowly begins to rise as it approaches the Alaska Range. Once past the Finger Lake homestead and checkpoint at Mile 194, teams face one of the trail's most nerve-wracking sections. Especially scary is the up-and-down ride through Happy River Gorge, where mushers follow a roller coaster–like trail that rises and falls for several miles along steep and heavily forested hillsides. Improved trail-making in the late 1990s has eased this passage, but every year some mushers still have horror stories to tell of their harrowing ride.

LEFT *As dawn begins to break over the Alaska Range, a team is met in the middle of Finger Lake by volunteer checkers with headlamps on. Along with logging the musher's time and number of dogs, the checkers must verify the musher has his mandatory gear: dog food, dog booties, axe, sleeping bag, snowshoes, cookstove, vet book, and promotional gear. They then direct the musher to the water hole and a parking spot or, if the musher desires, he or she can go through the checkpoint, stopping only long enough for a vet to check the dogs.*

BELOW *Ed Iten gets water from a hole chopped in Puntilla Lake at Rainy Pass during the 2001 race. Hot water is the first priority when a musher arrives at a checkpoint.*

After surviving Happy River, teams come to Puntilla Lake and the Rainy Pass Lodge checkpoint, a welcome sight to those who've endured the trail's early rigors. Here they can rest dogs, calm frazzled nerves, and make repairs to themselves or their gear.

Above Puntilla Lake, mushers pass beyond the tree line into alpine tundra. In winter, this is a vast, desolate world of white. Surrounded by rugged peaks rising above 5,000 feet, the teams climb a valley that offers little or no protection from wind-driven blizzards roaring through the Alaska Range. Teams have occasionally lost the trail in a blinding whiteout, and some mushers have suffered frostbite from the cold.

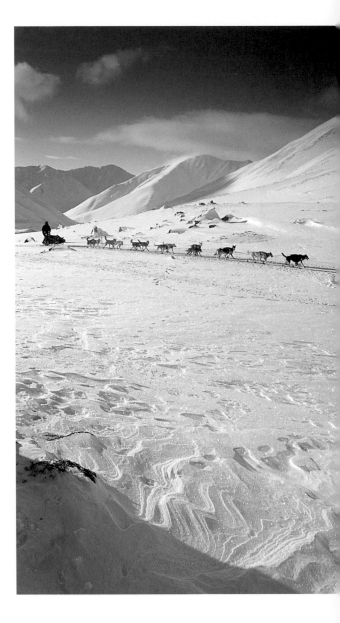

Extreme cold and alpine storms are not the only hazards that mushers and dogs face. Even in ideal weather, mushers can encounter problems while descending through the Dalzell Gorge, which more than one Iditarod musher has described as "a living nightmare." From Puntilla Lake to 3,200-foot Rainy Pass, teams gain more than 1,000 feet in elevation in 20 miles. Once over the divide, mushers follow a steep, winding trail that plunges about 1,000 feet in 5 miles through a narrow, boulder-filled canyon and crosses ice bridges spanning a partly frozen creek. The passage through Dalzell Gorge is at times a controlled fall because dogs have difficulty getting traction on the slippery, twisting path.

"I was scared to death," defending champion Jerry Riley admitted in 1977 after surviving a wild ride through the gorge. "It was four hours of riding my brake, trying to slow my team down—four hours of terror." Riley at least made it through the canyon with sled and team intact—and dry. Many others have not been so lucky. In 1988, for example, rookie driver Peryll Kyzer broke through an ice bridge and fell into the creek. After getting herself, sled, and dogs back on dry ground, she was forced to spend the night in a wet sleeping bag.

After crossing the Alaska Range, teams come to Rohn, the first checkpoint in Alaska's Interior region. A roadhouse was built here in the early 1900s to serve dog team drivers who hauled mail and supplies along the Iditarod Trail. The original Rohn Roadhouse is no longer standing, but in its place is a 1930s log cabin, now managed by the federal government as a public shelter cabin. From time to time, it's also been used by trappers. And for several days in early March, the cabin is transformed into the "Rohn Resort." Like the original roadhouse, the resort caters to mushers and dogs, while serving as Iditarod Checkpoint No. 9, 272 miles from Anchorage. For many

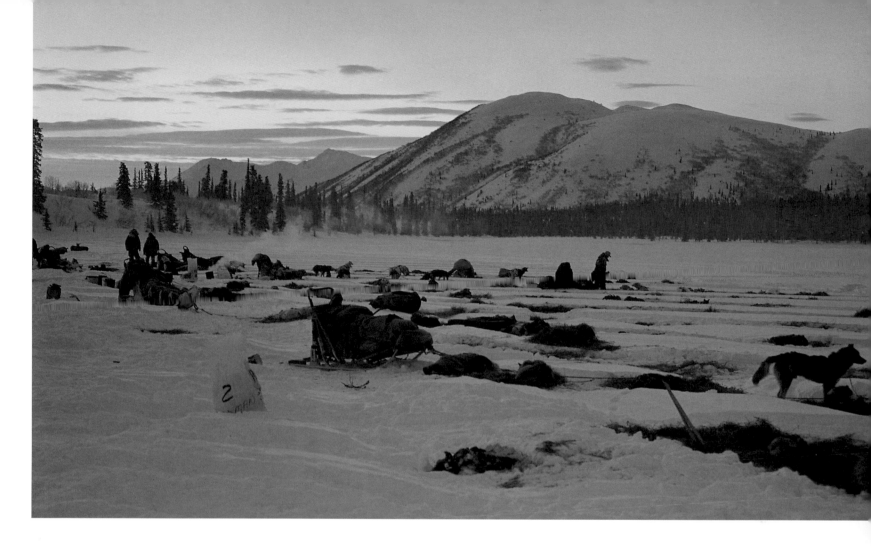

LEFT *Rookie John Bramante crosses the*
summit of Rainy Pass in the Alaska Range
on a sunny morning during the 2000 race.
The Rainy Pass summit, 20 miles beyond the
checkpoint, is the highest spot on the trail at
3,160 feet

ABOVE *Teams rest in the early morning*
hours before sunrise at the Rainy Pass
checkpoint on Puntilla Lake during the
2000 Iditarod.

years, Rohn was the place for mushers to take their mandatory 24-hour layovers. But since the late 1990s, many mushers have moved farther up the trail for their "24."

From Rohn, it's 80 miles to the next checkpoint, Nikolai. Here teams pass through the notorious Farewell Burn. In 1976, a fire swept across some 36,000 acres of tundra and spruce forest, producing a scarred landscape and a maze of burned timber. Federal crews cleared a trail through the Burn in the mid-1980s, but travel here can still be slow and difficult because the area typically receives little snow cover and mushers must occasionally deal with stumps or deadfall. There are also long stretches of sedge-tussock tundra, which can force teams to travel at a snail's pace in years of little snow. (Tussocks are clumps of grass that mushroom out as they grow to heights of 2 feet or more; when frozen and not covered by snow, they form a natural obstacle

course.) Colonel Norman Vaughan once had to be airlifted out of the Burn when he cracked two ribs during a collision with a frozen tussock. Another victim was Lolly Medley, who wrecked her sled and tore ligaments in her knee when she crashed into a stump during the 1984 race.

The mushers' arrival at Nikolai marks their entrance into a new cultural region. The first nine checkpoints—from the Anchorage-area metropolis to the semi-wilderness cabins, homesteads, and lodges at places like Skwentna, Finger Lake, and Rohn—are reflections of the white, Western European culture. But from Nikolai to Kaltag, teams will travel through a region that is inhabited primarily by its original people, the Athabascan Indians.

Nikolai is the first of the small Athabascan villages through which the race passes. More than 350 miles from Anchorage, this tiny settlement (population about 125) along the banks of the Kuskokwim River treats the Iditarod as a major winter social event, on a par with Christmas. Some years the village school has been closed for a

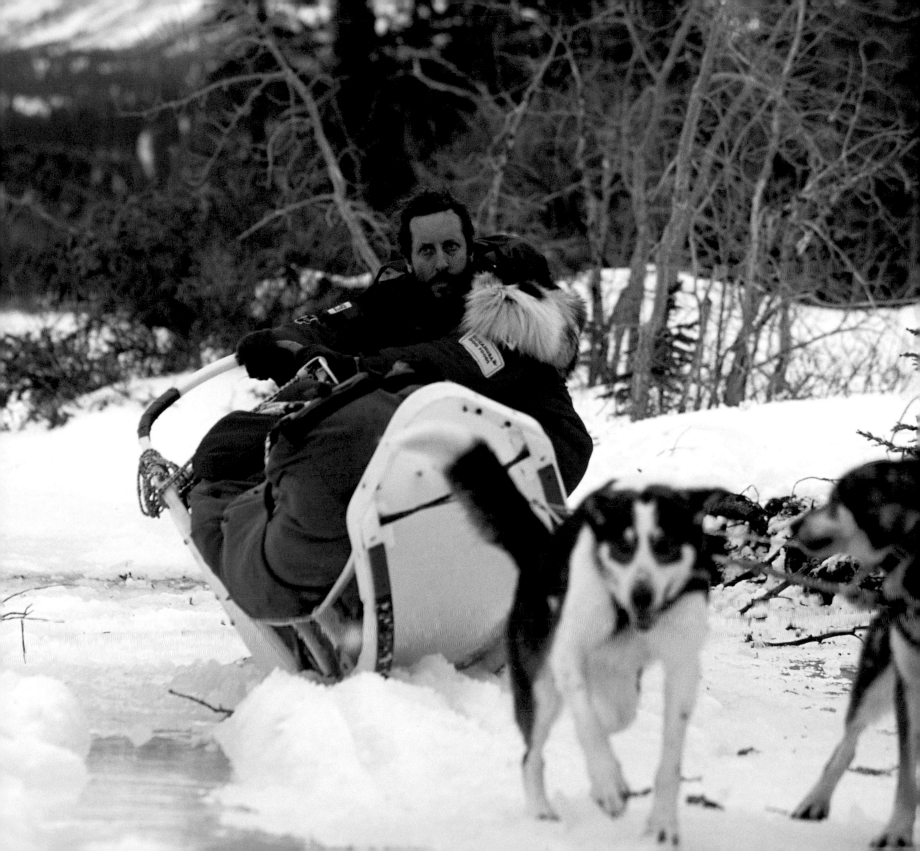

few days when the front-runners arrived, and students have been given Iditarod-related assignments.

From Nikolai, the race course swings west, roughly paralleling the Kuskokwim River to McGrath as it crosses swamps and spruce forest and in places runs along the river itself. Originally settled by Athabascans, McGrath attracted miners during the gold rush days of the early 1900s. A trading post was opened in 1904, and within three years a town had been established, named after Peter McGrath, a U.S. marshal

Dave Sawatzky passes abandoned gold mining buildings at Ophir in this aerial view in 1997.

stationed in the area. While it has a population of only 500, McGrath is the largest settlement in this part of the state, complete with two stores, restaurant, bar, and roadhouses. McGrath's large airfield and its abundance of facilities make it a popular Iditarod gathering place. The first team to reach this checkpoint is sure to draw a huge crowd at any time of day or night.

Leaving the crowds behind at McGrath, mushers drive another 23 miles to Takotna. Now home to only 50 or so year-round residents, Takotna served as a riverboat landing and regional supply center during the gold rush. Among the smallest communities along the race route, Takotna has become known for giving mushers one of the biggest and warmest welcomes, complete with a huge spread of homemade foods. This welcoming spirit and the checkpoint's location have made it a favorite resting place of mushers as they've pushed farther up the trail before taking their mandatory 24-hour layovers.

Over the next 100 to 150 miles, teams pass through a time warp, as they travel through a region that earlier in the century hosted one of Alaska's largest gold rushes but now holds little more than ghost towns and memories among its valleys and hills. The first ghostly remnant is Ophir, named in 1908 after a nearby placer-mining creek. The creek, in turn, had been given its name by Bible-reading prospectors; it refers to the "lost city of Ophir," the source of King Solomon's gold. In its glory days, Ophir's population peaked at 2,000. Now it has no year-round residents.

Beyond Ophir, the Iditarod assumes a split personality of sorts. Since the late 1970s, the central portion of the race has taken two different paths, to give more Interior villages a chance to serve as checkpoints. In even-numbered years the teams follow the northern route, from Ophir to Cripple, then on to Ruby, Galena, Nulato, and Kaltag. In odd-numbered years they travel along the southern route, from Ophir to Iditarod and then on to Shageluk, Anvik, Grayling, Eagle Island, and finally to Kaltag. The two routes differ by only 10 miles. (See the table on page 57.)

Whether the teams head north or south, they reach the trail's official midpoint at a gold-boom ghost town located more than 500 miles from Anchorage. Some years it's Cripple, other years Iditarod. Only a few weather-beaten, abandoned buildings in Iditarod now mark the site that gave the trail its name. Scattered among the

ruins are store receipts, rusted machinery, glass jars, and an ancient bank vault. Although the golden glow has vanished from these former boom towns, a trophy full of gold nuggets is given to the first musher arriving at the midway checkpoint.

From the Iditarod's halfway point, teams head to the Yukon River, which the race trail follows for about 150 miles. By tradition, the first racer to reach the Yukon is treated to an elegant seven-course meal, courtesy of an Anchorage hotel, plus a cash prize of $3,500.

Depending on the year, either Anvik or Ruby serves as "gateway" to the Yukon. Anvik is a small Athabascan village of about 80 people who are heavily dependent on subsistence activities like hunting, fishing, trapping, and gardening. Ruby, established during the gold rush, developed into a booming river port that served the mining camps. By World War II, Ruby was on its way to becoming a ghost town like so many other gold rush–era settlements. However, a group of Natives from another village moved into the site, and today Ruby's population is about 190 people, mostly Athabascans. Ruby has produced a handful of Iditarod racers, including one of the best known and most respected: Emmitt Peters, winner of the 1975 Iditarod and widely known as "the Yukon Fox."

The Yukon passage offers a variety of obstacles, ranging from bitter cold to boredom. Temperatures may drop to minus 50 degrees and below. In high winds, which mushers are almost sure to encounter somewhere along Alaska's largest river, wind-chill temperatures may fall well below minus 100 degrees. Long stretches of the Yukon can also become monotonous. To ease the routine, many mushers carry cassette players and/or radios. "It used to be you'd stop and have a coffee break," Rick Swenson said in the late 1980s. "Now you stop and put in a tape. It's important in minimizing mood swings and keeping you awake."

The Yukon run ends at Kaltag, an Athabascan village of about 240 people. Here the race's northern and southern branches are joined and the trail again follows a single path. Located more than 760 trail miles from Anchorage and about 350 miles from Nome, Kaltag has been described as a border town—a gateway between two cultures. From there, the race trail follows a route that's been used for hundreds of years, connecting the Interior's Athabascans with the coastal Eskimos. Teams follow the centuries-old "Kaltag Portage" for 90 miles, as it rises to a thousand-foot pass,

BELOW Bill Cotter changes sled runners in Kaltag during the 1999 race. A musher typically changes runners 12-15 times during a race to ensure the fastest glide.

RIGHT Zack Steer is shown here shortly after leaving Tokotna on a sunny day during the 2000 race. The road, maintained only in the summer, is used to connect the village of Tokotna with the mining area of Ophir.

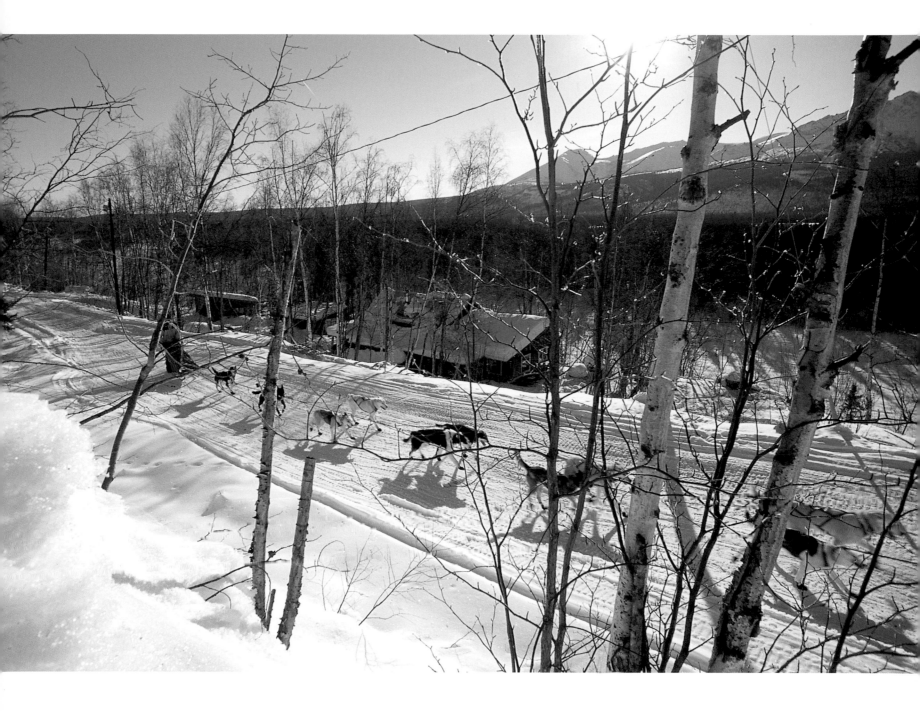

then gradually descends toward the village of Unalakleet. When that stretch is completed, only 261 more miles remain. And the final sprint begins.

During the Iditarod race's early years, even the most competitive mushers treated the first 800 to 900 miles as an extended camping trip. Happy to share each other's company, they traveled together, broke trail together, sat around campfires together. Until they reached the coast.

Peryll Kyzer hangs her gloves to dry in the only building still standing at the ghost town of Iditarod in 2001. At remote checkpoints like Iditarod, heated structures come at a premium. Usually the Iditarod committee sends out two or more weather proof tents.

Unalakleet marked the point where camaraderie gave way to competition. As an Associated Press story reported from Unalakleet on March 20, 1977: "Now, the amiable camping trip that began March 5 in Anchorage has ended and the race is on. Leaders have dropped all but the most essential gear, and rest stops from here to the finish will be brief. Machiavellian tactics, secrets, and games are beginning, as the trail moves into its final phase."

As the race has evolved and the purse increased to more than $500,000, the two-part drama has gradually been replaced by a much longer single-act play, at least for those who seek to win. Yet even in this more competitive era, the intensity picks up

IDITAROD RACE ROUTES

NORTHERN ROUTE (EVEN-NUMBERED YEARS)		SOUTHERN ROUTE (ODD-NUMBERED YEARS)	
Checkpoint	*Distance (miles)*	*Checkpoint*	*Distance (miles)*
ANCHORAGE TO EAGLE RIVER	20	ANCHORAGE TO EAGLE RIVER	20
EAGLE RIVER TO WASILLA	29	EAGLE RIVER TO WASILLA	29
WASILLA TO KNIK	14	WASILLA TO KNIK	14
KNIK TO YENTNA	52	KNIK TO YENTNA	52
YENTNA TO SKWENTNA	34	YENTNA TO SKWENTNA	34
SKWENTNA TO FINGER LAKE	45	SKWENTNA TO FINGER LAKE	45
FINGER LAKE TO RAINY PASS	30	FINGER LAKE TO RAINY PASS	30
RAINY PASS TO ROHN	48	RAINY PASS TO ROHN	48
ROHN TO NIKOLAI	80	ROHN TO NIKOLAI	80
NIKOLAI TO MCGRATH	48	NIKOLAI TO MCGRATH	48
MCGRATH TO TAKOTNA	18	MCGRATH TO TAKOTNA	18
TAKOTNA TO OPHIR	25	TAKOTNA TO OPHIR	25
OPHIR TO CRIPPLE	60	OPHIR TO IDITAROD	90
CRIPPLE TO RUBY	112	IDITAROD TO SHAGELUK	65
RUBY TO GALENA	52	SHAGELUK TO ANVIK	25
GALENA TO NULATO	52	ANVIK TO GRAYLING	18
NULATO TO KALTAG	42	GRAYLING TO EAGLE ISLAND	60
		EAGLE ISLAND TO KALTAG	70
KALTAG TO UNALAKLEET	90	KALTAG TO UNALAKLEET	90
UNALAKLEET TO SHAKTOOLIK	42	UNALAKLEET TO SHAKTOOLIK	42
SHAKTOOLIK TO KOYUK	48	SHAKTOOLIK TO KOYUK	48
KOYUK TO ELIM	48	KOYUK TO ELIM	48
ELIM TO GOLOVIN	28	ELIM TO GOLOVIN	28
GOLOVIN TO WHITE MOUNTAIN	18	GOLOVIN TO WHITE MOUNTAIN	18
WHITE MOUNTAIN TO SAFETY	55	WHITE MOUNTAIN TO SAFETY	55
SAFETY TO NOME	22	SAFETY TO NOME	22
TOTAL	1,112	TOTAL	1,122

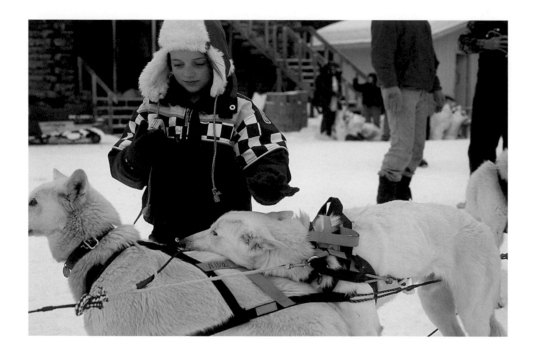

once the race leaders reach Unalakleet. The Bering Sea coast is the final proving ground, separating the elite from the also-rans. This is the point where mushers will take all but the highest caliber dogs off their teams.

In contrast to the mushers' growing intensity is the gaiety and spirit of celebration in Unalakleet. As in many communities along the race route, the Iditarod produces a holiday mood in this Inupiat Eskimo village. Located on the shore of Norton Sound, Unalakleet is the biggest Native settlement on the Iditarod Trail. Its nearly 900 residents support themselves largely through commercial fishing and subsistence hunting and fishing. But winter is a difficult time in this windy place (*Unalakleet* means "place where the east wind blows"), and the Iditarod helps to brighten a somber season.

Past Unalakleet, the trail rises into coastal hills, then descends back toward the shoreline and the next checkpoint, Shaktoolik. In making this 40-mile run, teams are often blasted by ferocious northeast winds that whip up loose snow and create blinding ground blizzards. Inhabited by about 200 Eskimos, Shaktoolik, like most of its neighbors, is characterized by a subsistence lifestyle. In March the village is also

characterized by huge, hardened snowdrifts, some of them dozens of feet long and higher than your head, built up during the long winter.

Two of the Iditarod's most memorable and inspirational episodes began in Shaktoolik. In 1982, a noted Inupiat musher and ivory carver from Shishmaref, Herbie Nayokpuk, drove his team into a fierce storm, hoping to break away from the other front-runners. But conditions became so extreme that Nayokpuk and his dogs were forced to retreat, costing him any chance of winning the race. Three years later, another musher took a chance similar to Nayokpuk's. But this time the gamble worked. And it led to the "Legend of Libby." A resident of Teller, 70 miles north of Nome, Libby Riddles drove her dog team into a severe storm when no other mushers dared to. She and her dogs survived a harrowing night on the sea ice of Norton Bay and went on to win the 1985 race, creating an instant legend.

Charlie Boulding rounds a turn as he leaves the Nulato checkpoint during the 2000 Iditarod. Nulato, an Athabascan Indian village of 200 people, is traveled through on the northern route in even-numbered years.

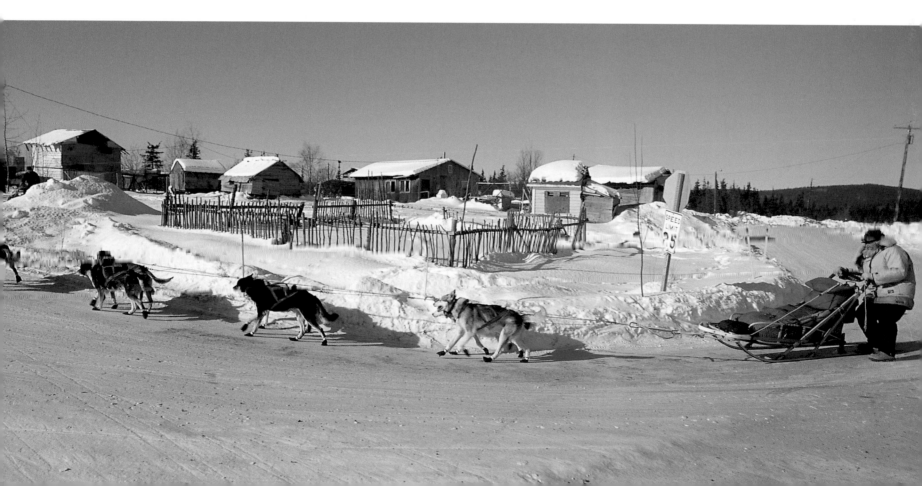

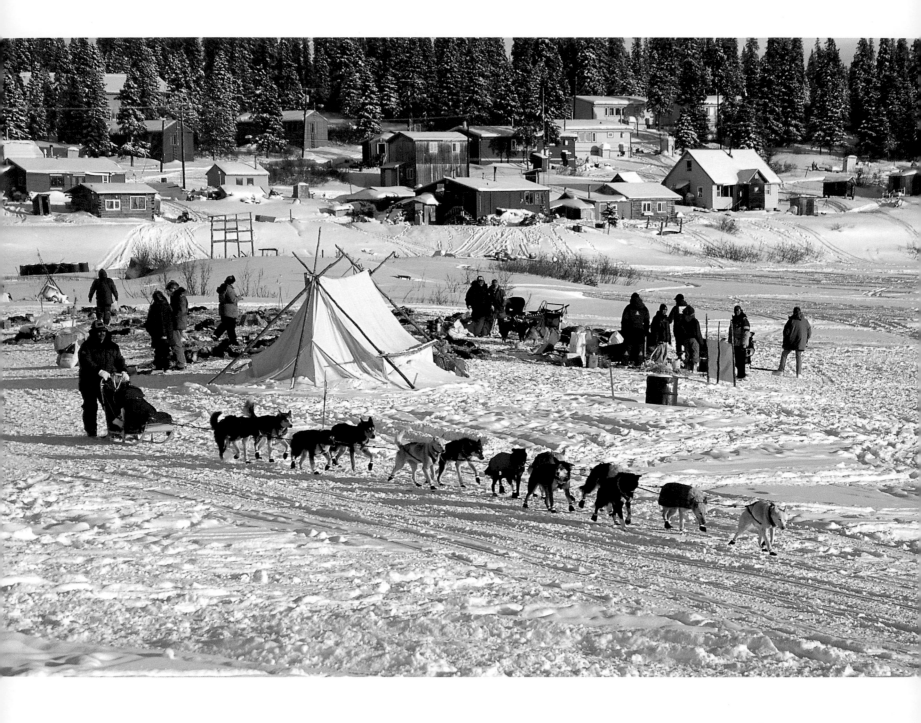

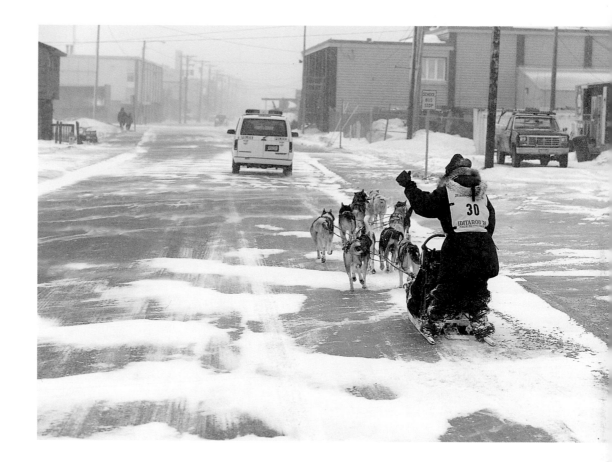

LEFT *After taking his 8-hour mandatory layover, Mike Williams leaves White Mountain, the last village checkpoint before reaching Nome 77 miles away. The wall tent in the background serves as the main check-in point where teams may rest, while mushers can get out of the cold in a public building several hundred yards away.*

RIGHT *Cindy Gullea waves to the crowd as she mushes down Nome's Front Street during a windstorm in 1998 on her 14th and final day on the trail. Cindy arrived in 48th place. The arrival of each musher is signaled 2 miles out from the finish line by the Nome fire siren going off, then as each musher gets on to Nome's Front Street, they are escorted by a police vehicle with its light flashing, as seen here in front of Cindy.*

After taking their teams north across the frozen Norton Bay, mushers arrive in the Inupiat village of Koyuk (population 260), only 171 miles from Nome. From Koyuk the race route bends west and follows the Seward Peninsula's southern coastline, connecting three more tiny Eskimo villages: Elim, Golovin, and White Mountain. At White Mountain, mushers are required to take an eight-hour layover. This mandatory stop (gradually expanded over the years from four to six to the current eight hours) ensures that dog teams will get at least one extended rest over the final miles. The extended stay also guarantees that a crowd of people will gather here despite the Inupiat village's small size (200 residents): race officials and volunteers, media, locals who come from surrounding villages on snowmachines, and race fans flown in by plane.

From White Mountain, only one checkpoint—Safety, 22 miles from race's end— and 77 miles separate Iditarod teams from Nome. This stretch may be the stormiest of all, frequently hammered by fierce coastal winds and, not uncommonly, by ground blizzards that produce blinding whiteouts and near-zero visibility. A particularly bad area has earned the name "Solomon Blow Hole" because its winds are so predictably fierce. Every year, it seems, some teams get blasted by its gales. Over the years, numerous mushers have lost the trail, or been forced to stop their teams and camp out, while battered by the Arctic storms that sweep across this harsh coastal landscape. More than a few racers have come close to losing their lives.

Several heart-pounding sprints to the finish have been staged over this final stretch of trail. On eight occasions between 1973 and 2000, Iditarod champions and runners-up were separated by less than an hour. Three times—in 1977, 1978, and 1982—the winning edge was less than five minutes. And in one remarkable race, a single tick of the clock separated first place from second. Dick Mackey was the winner of that 1978 race, barely getting the front of his dog team across the finish line before Rick Swenson's after more than 1,100 miles of racing. (Swenson, it should be noted, outlasted Jerry Riley and then Susan Butcher in the other two races that came down to the wire.)

Though the winners draw the biggest crowds and earn the most attention, all mushers and dogs who reach Nome are treated as champions. With their arrival on Front Street signaled by the town's siren, even the back-of-the-packers receive an official welcome as they pass beneath Nome's famed burled arch, and they're greeted by a faithful band of friends and fans who offer applause and congratulations. All finishers are honored at post-race banquets and awarded brass belt buckles and special patches that reflect their personal victories after a journey that even in this fast-paced era may last up to two weeks or more.

LEFT *Crowds gather in Nome at all times of day and night and in all weather conditions to see the mushers come in. Here a 1999 crowd gathers in the wee hours of the morning during a windy snowstorm.*

ABOVE *Called the "widow's lamp," this lantern is lit at the finish line in Nome on the starting day of the race and is not taken down or blown out until the last musher reaches the city. The last musher to cross the finish line also receives the "red lantern" award.*

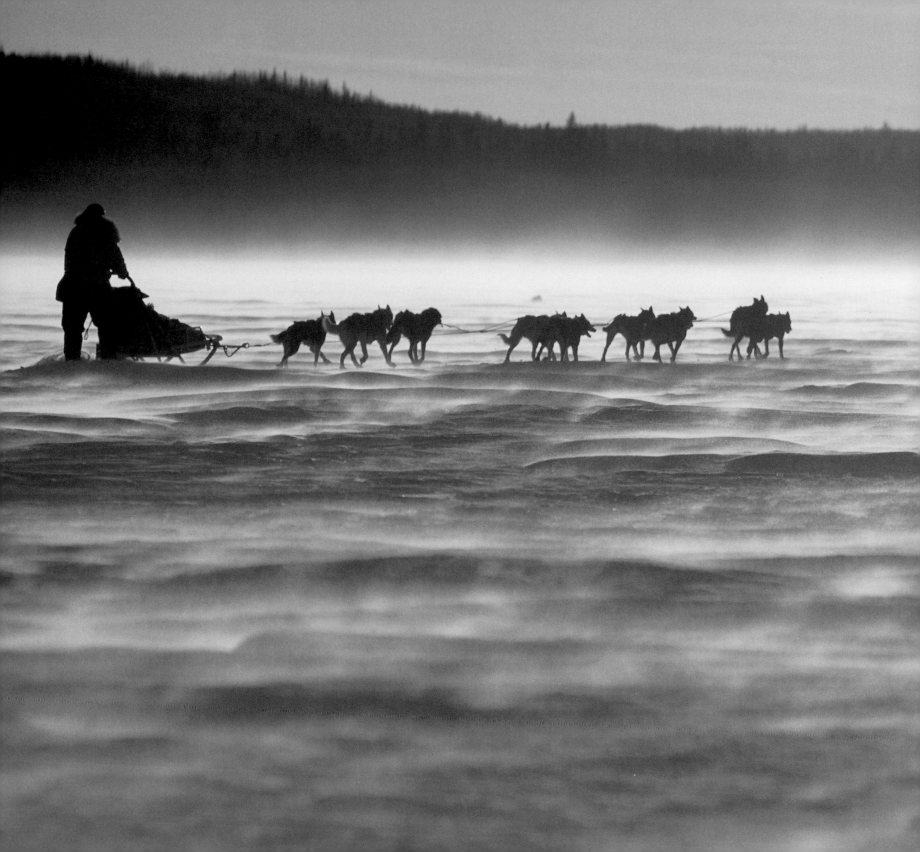

INTO THE UNKNOWN

The earliest Iditarod races were not so much competitive events as grueling wilderness treks. The first one, especially, was a venture into the unknown. Recalling that first race to Nome in 1973, musher after musher agrees that no one—racers or officials—knew what to expect. Many people, including some participants, openly wondered how many drivers and dogs would become casualties of the world's first long-distance race since Nome's 408-mile All-Alaska Sweepstakes ended in 1917. Others questioned whether the racers would even find their way to Nome. Several weeks before the race, a group of soldiers on Army maneuvers were sent on snowmobiles to open a route across Alaska. But only one of six machines made it the entire distance. Then storms followed the snowmobilers, burying most of the crude path they'd made. So Iditarod teams essentially had to do their own trailbreaking across long stretches of unmarked wilderness.

"You have to remember that sections of the Iditarod Trail hadn't been used for decades, so they were grown over or had simply disappeared. There were lots of places where we didn't have any trail to follow that first year. We had to figure it out as we went. That meant lots of trial and error," says Ken Chase, an Athabascan Indian musher

from Anvik and one of the 37 men who set out from Anchorage on March 3, 1973.

Dick Mackey, another of the originals, remembers lots of suspense—and anxiety—at the starting line, particularly among members of the racers' families: "Mothers and daughters and so forth were all crying. It was tough on them because we were headed off into the middle of nowhere. We were explorers, and they feared they might never see us again. And I suspect that many of us too wondered if we'd make it."

Because of the uncertainties and potential hazards, organizers allowed "double teams" of mushers to compete in '73. Three such teams entered: Robert and Owen Ivan; Ford Reeves and Mike Schreiber; and John Schultz and Casey Celusnik. As it turned out, the double teams weren't nearly as fast, or as durable, as the single-driver entries. The Ivan brothers placed 16th, while the Reeves-Schreiber pairing and half of the Schultz-Celusnik team scratched; John Schultz stayed on the trail after his partner dropped out, finishing 22nd and last.

Trailblazers of a sort, the first Iditarod racers wisely carried a surplus of survival gear, which they packed into large, heavy, wooden freighting sleds like those that trappers might use. Up to 13 feet long and weighing 80 to 90 pounds, these were sleds built for hauling and transport, not racing. Equipment and food were stuffed into heavy, bulky tarps. Fully loaded, a sled might weigh 400 to 500 pounds (contrast that with today's Iditarod loads, which average 150 pounds). With such weight and little likelihood of a set trail, never mind a race course, most mushers naturally chose working dogs for their teams.

"You needed dogs that would slog through two or three feet of fresh snow, while pulling these huge sleds," recalls Montanan Terry Adkins, a veteran musher who competed in 20 Iditarods between 1974 and 1994. "A lot were trapline dogs, not racers." Big and powerful, dogs were chosen for strength, stamina, and tough feet, not speed.

However tough they might be, the feet of work dogs were not necessarily prepared for 1,100 miles of sometimes brutal conditions. Mushers therefore made primitive booties to shield paws from injuries. Materials ranged from cloth to moosehide and sealskin. Mackey even tried children's socks. To keep booties on the dogs' feet, racers commonly used adhesive tape or black electrician's tape. When booties wore out or were no longer needed, mushers sometimes would have to rip the tape off with their teeth.

Dog care, too, was in many ways primitive by today's high-tech standards. In a way,

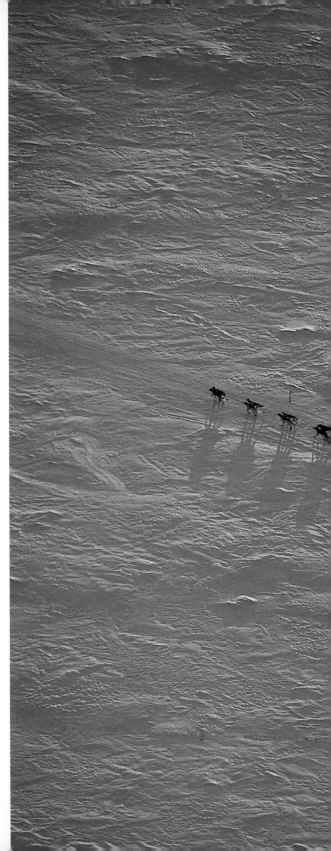

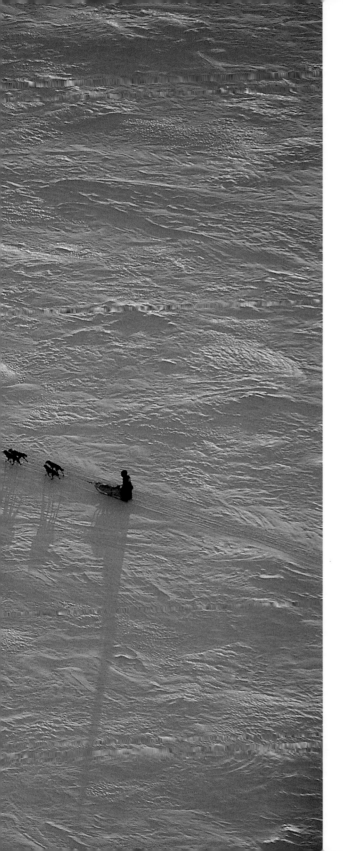

the race was an unprecedented experiment in long-distance racing diets, nutrition, foot care, pacing of the dogs, rest patterns, and medical treatments.

Adkins, then an Air Force officer based in Anchorage, served as the Iditarod's only veterinarian in 1973. "I was the only one they could sucker into doing it," he chuckles. "They had me leapfrogging up and down the trail, looking at hundreds of dogs. There was so much that we didn't know then, that we couldn't have known." Lots of dogs got sick or hurt, and as many as 30 died. Even the most experienced mushers were unprepared for the long-distance stresses dogs would face.

"I lost a dog to pneumonia," says Chase, a trapper and racer who'd run dogs nearly all his 32 years, coming into the '73 race. "It caught me completely off guard, because I'd never had that problem before. Believe me, it was hard for us all, dealing with those deaths."

Chase was part of a large Native Alaskan contingent entered in the first Iditarod. From rural villages off the road system, their numbers included some of sled dog racing's most respected names of that era: George Attla, the famed "Huslia Hustler," who'd made his reputation in Anchorage's Fur Rendezvous World Championship race; Herbie Nayokpuk, later to be nicknamed "the Shishmaref Cannonball"; Bobby Vent; Victor Kotongan; and Isaac Okleasik, winner of the 1967 Iditarod Trail Seppala Memorial Race.

By the early 1970s, a few of the Native racers—the prime example being Attla—had begun breeding programs that emphasized traits critical to racing success. But most villagers still used their dogs for both work and racing.

Given the abundance of racing talent, the winner of that first race to Nome shocked Alaska's mushing community. Dick Wilmarth, a little-known miner from Red Devil, finished more than 13 hours ahead of runner-up Bobby Vent. His elapsed time was 20 days, 49 minutes, and 41 seconds. By comparison, the last-place finisher in 2000 reached Nome in a little over 15 days. Wilmarth's only Iditarod appearance earned him $12,000 and a lasting place in Iditarod lore.

Though a non-Native musher won the inaugural Iditarod, Athabascan and Eskimo racers took four of the top six spots. And they would dominate the event for the next three years. Athabascans from Interior Alaska would win the 1974, '75, and '76 races: Carl Huntington, Emmitt Peters, and Jerry Riley, respectively. Even more impressive is

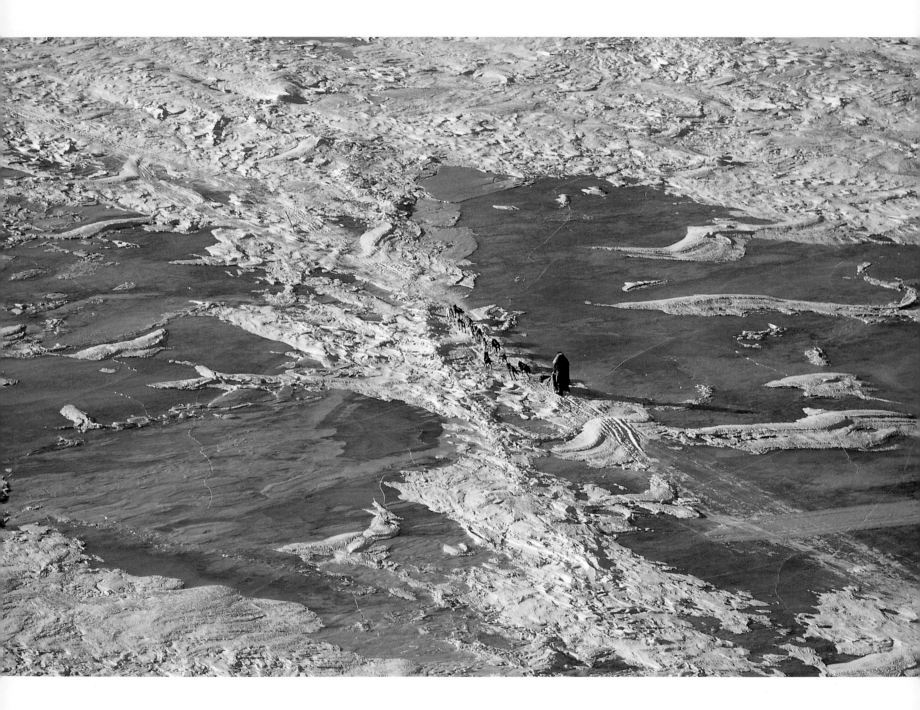

LEFT *John Barron makes his way down the Yukon River toward Galena in the 1998 Iditarod. Wind blown snow is packed like concrete, making it hard to set any kind of trail by the trail breakers who go ahead of the teams and mark a route.*

ABOVE *Charlie Boulding grabs a bite to eat indoors at the McGrath checkpoint in 2000 as another musher just arrives.*

BELOW *Mike Williams rings out his wool boots at a shelter cabin shortly after being up to his knees in overflow on the Old Woman River.*

the fact that Native village mushers took the top four places in 1974, three out of the top four in 1975, and three out of the top five in 1976.

Huntington's win was memorable for a few reasons. Besides becoming the first Alaskan Native to win the Iditarod, to this day he remains the only racer, Native or not, to win both the Iditarod and the "Fur Rondy" (as locals affectionately dub the Fur Rendezvous World Championship), Alaska's premier "sprint" sled dog race, in which teams run three heats of 25 miles each. A piece of Iditarod trivia: Huntington's victory is notable for being the slowest championship run ever, taking more than 20 days, 15 hours.

Huntington, like Wilmarth, would become a one-time Iditarod wonder. After scratching in 1975, he would never again enter the race. More impressive, in the long run, is the record of Emmitt Peters.

Born in 1940, Peters is a lifelong resident of Ruby, a tiny Athabascan village on the Yukon River whose roots can be traced to the gold rush era. Gold strikes in 1907 and 1911 sparked a stampede into the area and the birth of the town. Eventually it would become a booming river port that served the region's mining camps. Ruby's population peaked at 2,000 residents, and the town became known as a cultural melting pot, inhabited by immigrants from several European countries. In addition to miners and entrepreneurs, Ruby for nearly two decades was home to mushers who carried mail for the Northern Commercial Company. By World War II, though, Ruby was on its way to becoming a ghost town. It was saved from extinction only when a group of Natives from another village moved into the site.

Nowadays Ruby's 190 or so residents still depend on sled dog teams despite the increased use of snowmachines and four-wheelers. The community serves as an Iditarod checkpoint in even numbered years, when the race follows its northern route along the Yukon River. Over the years, a handful of village mushers have competed in the Iditarod, but the most famous, by far, is Emmitt Peters, "the Yukon Fox."

Peters entered his first Iditarod in 1975 with a team of trapline dogs. Although technically a rookie, the 34-year-old driver of a "blue-collar" team was considered among the top contenders for one simple reason: a dog named Nugget. In 1974 Peters had loaned Nugget to Carl Huntington, and the Alaskan husky had responded by leading her teammates to an Iditarod title. Under her owner's command, she gave an

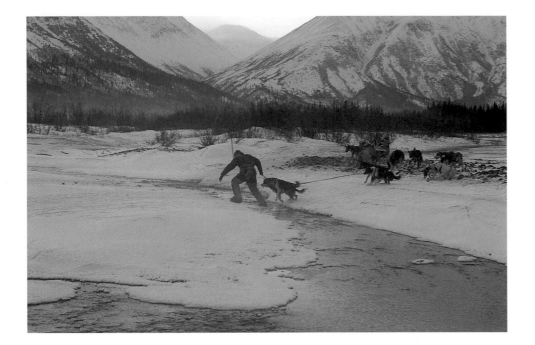

LEFT *Ed Iten brings his dogs across a short section of open water during the 1999 Iditarod. Steam comes off the river as the temperature is 35 degrees below zero. Though mushers are not sure why, Huskies typically won't willingly go across open water because they don't seem to like to get their feet wet.*

RIGHT *Alaskan Native musher Mike Williams uprights his sled after his dogs traveled over a mile without him, shortly after leaving the Rohn checkpoint in 1999. Just earlier the team came upon a short stretch of open water and as Mike jumped across the water to avoid getting his feet wet, his weight on the handlebar broke it and he fell down, leaving the dogs to run free down the trail. Fortunately for Mike, the sled tipped over and got stuck on a stump in the river bed. He used a piece of driftwood and lots of duct tape to repair the sled and continue through the Farewell Burn to the village of Nikolai. All this at 35 degrees below zero!*

PAGE 72 *Paul Gebhart seems like a mere speck on the back side of the mountain known by locals as "Little McKinley," between Elim and Golovin on the next to last day of his 2000 race.*

even more impressive performance. Led by Nugget, Peters's team shaved more than six days off Huntington's winning time, and nearly five and a half days from Wilmarth's record, with the then-unimaginable time of 14 days, 14 hours, and 43 minutes. Besides setting a race record that would last five years, Peters would be the last rookie to win the Iditarod, as the event became ever more competitive.

Those closest to the Iditarod still marvel at Peters's performance. Five-time champion Rick Swenson says, "What Emmitt did is still probably the greatest Iditarod achievement ever."

Peters, in turn, gives much of the credit to Nugget, the first lead dog to earn back-to-back Iditarod championships. Sadly, tragedy followed triumph. The winter after her victory, Nugget got away from Peters during a training run near Anchorage. Two days later she was found dead beside a city street, apparently hit by a passing motorist.

The Yukon Fox didn't miss a race for the next ten years. And he finished "in the money"—among the top 20—every time. One year he finished second, another year he took third, and twice he placed fourth.

Few people now recall that only a debatable interpretation of the race rules in 1978 likely kept Peters from a second championship. Author Tim Jones reported the circumstances in his 1982 book *The Last Great Race:* "Because of the generosity shown in the villages [during the Iditarod's early years], the rules were changed to allow mushers to accept help at checkpoints, taking away the fear of being disqualified for accepting help from a friendly villager. . . . However, there were still interpretations. Such an interpretation in the [1978] race may have cost Emmitt Peters the victory. Peters supposedly accepted warm water and, after it was reported, race officials held him up at Solomon, just thirty-two miles from Nome. They held Peters for an hour even though nothing in the rules called for such an action. Peters followed [winner

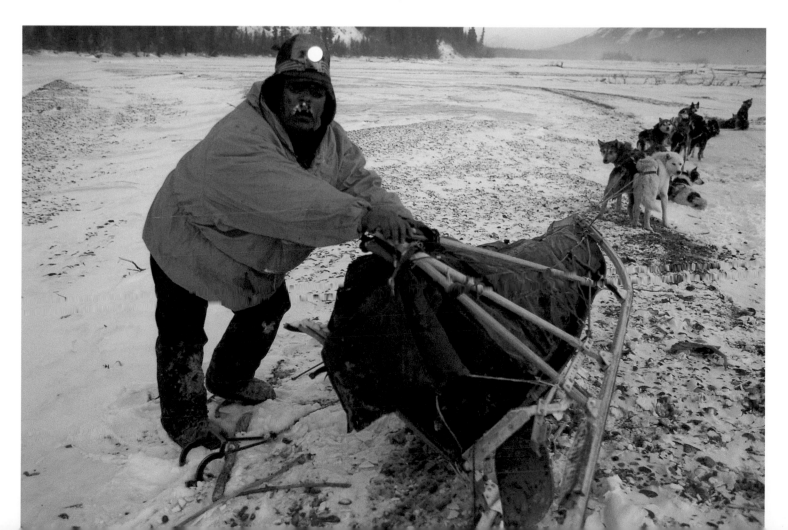

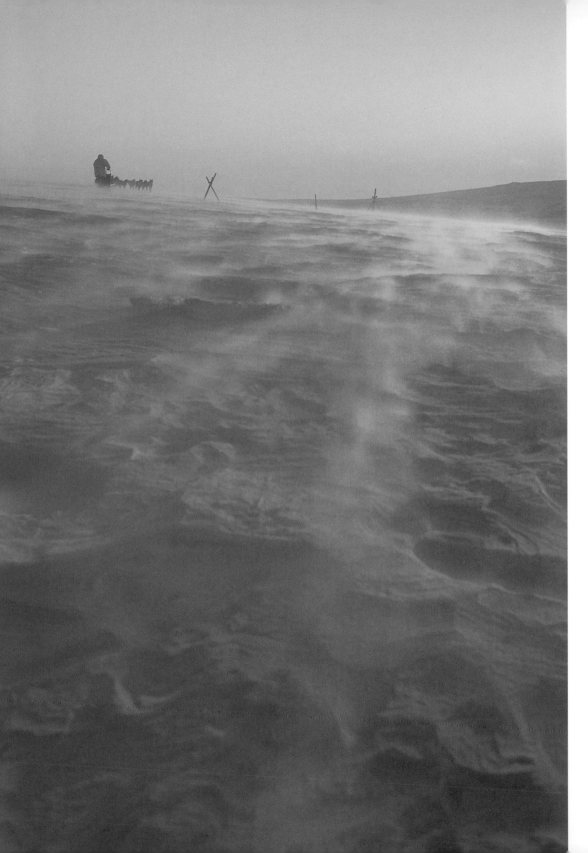

CHECKPOINTS

In driving their teams to Nome, mushers keep to a well-planned schedule. Most run their dogs six hours and then rest the team. Over the long haul, teams average one hour of rest for every hour of travel.

Carefully figured into the mushers' travel schedules are stops at each of the Iditarod's official checkpoints (26 in even-numbered years, 27 in odd-numbered years), where they are required to sign in and may have their mandatory gear inspected.

After mushers have signed in at a checkpoint, they can park their team in a designated holding area, called a corral. Once settled in a spot, they prepare the team's meal, feed the dogs, check their feet, look for any signs of injuries or illness, and bed them down. (Before a team leaves the checkpoint, a veterinarian too will check the dogs' health.) Then, if necessary, they'll make equipment repairs. Only when such chores are completed will most of the men and women in this race take care of their own needs.

As a rule, mushers are free to leave checkpoints whenever they choose. (Some prefer to make their stays as short as possible, believing that their dogs rest easier out on the trail, away from commotion at checkpoints.) But there are a few notable exceptions to that rule. Since 1975, teams have been required to take a 24-hour layover at one of the race's designated checkpoints. Race regulations state that this

mandatory stop be taken "at a time most beneficial to the dogs," but when is ultimately left to the mushers. It's during the 24-hour layover that time differentials from Anchorage's staggered starts are adjusted. To make sure mushers comply with the layover rule, they're required to sign both in and out when they take their "24."

Nowadays, mushers must also take two 8-hour layovers. One of those must be at a checkpoint along the Yukon River; the other is at White Mountain, 77 miles from Nome. The intent of these mandatory stops is to ensure that the dogs get sufficient rest—further evidence that the dogs' well-being is the Iditarod's No. 1 priority.

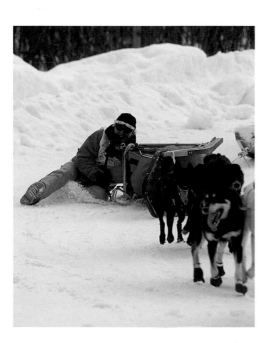

Dick] Mackey and [runner-up Rick] Swenson across the finish line only thirty-six minutes behind them, almost half an hour less than the hour he'd been held up. The whole race might have turned out differently."

For all their success, Peters and other Native mushers weren't totally focused on winning or competitive edges. "Native village mushers were really the ones who taught the urban guys how to get from Anchorage to Nome in those early years," says Jerry Austin, himself a longtime non-Native resident of St. Michael, a tiny community on the Bering Sea coast. Hardly cutthroat in their approach to the race, most Native mushers were fun to travel with, says Austin, with lots of stories to tell. They were also hard-working trailbreakers when necessary.

During the 1976 race, a group of mushers were pinned down by stormy weather at a mining ghost town named Poorman, south of the Yukon River. Low on food, without a trail or snowmachines to break trail, teams were at a standstill until Native mushers Billy Demoski of Galena and Warner Vent of Huslia put on their snowshoes and began stamping out a path. "These were real snowshoes," says Austin, "not the little things you see today, about as tall as the men were. Billy and Warner snowshoed miles and miles that day, no one complaining, and their dogs just followed, along with the rest of us."

Stamping out trails and getting lost were a big part of the game in those early years. Traveling in pairs or small groups, racers were frequently forced to stop their teams and search out a route. At least one musher would watch the dogs, while others walked around, seeking some evidence of a trail. Such stops made it nearly impossible to plan a checkpoint-to-checkpoint race strategy. On the other hand, it helped to foster camaraderie and, sometimes, lifelong friendships among the racers.

Because they often had to find their way through poorly marked or even untrailed wilderness, and because headlamps, like booties and sleds, were primitive by today's standards, mushers rarely traveled at night. Instead, they'd set up camp, build fires, share stories.

"Rick [Swenson] and I used to joke that we could stop anybody with a good, big campfire," Austin says. "People wouldn't want to go on, not knowing where the trail might go. We'd have a bow saw along to cut wood—you'd never see anyone doing that today—and we'd sit around the fire for hours."

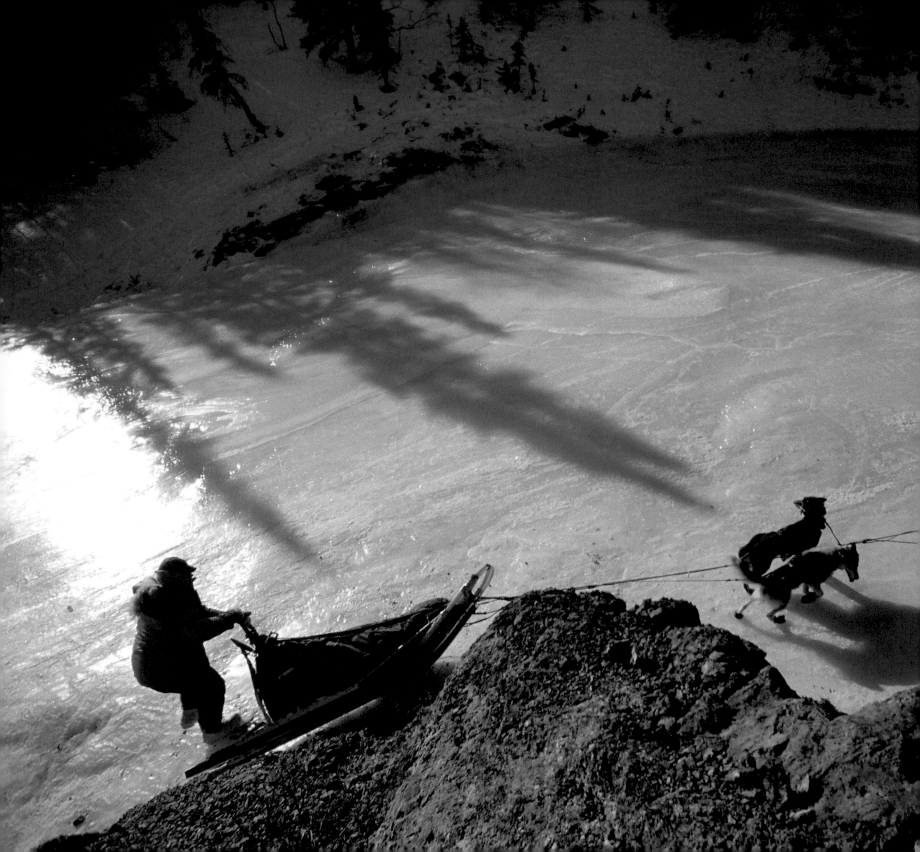

As many as two dozen mushers might eventually park their teams and gather round the fire, "telling stories, sharing lies, playing cards, having a good ol' time," laughs Terry Adkins. "You just don't see that anymore, at least among the serious racers."

Many of the campfire tales featured the dangers of the trail. Reports of the early Iditarod races are filled with harrowing survival stories, and several drivers had close brushes with death. One of the most terrifying incidents occurred in the very first race, 1973, along the South Fork of the Kuskokwim River, north of the Alaska Range. Traveling along the frozen river, musher Tom Mercer's team came upon a huge hole in the ice. Mercer, from Talkeetna, compared the noisy rush of water to the sound of Niagara Falls. "I couldn't believe I was hearing it," he reported. "It was roaring up ahead, louder and louder. The ice was slick, with overflow on it, and a hole in the ice nearly 100 feet in diameter was sucking the overflow water down into the main river channel with great force."

A large, powerful man, Mercer swung his team out of the overflow current and around the gaping hole without much difficulty. But after traveling awhile, he began to worry about his friend, Terry Miller of Palmer, who was behind him. Returning upriver, Mercer found Miller spread-eagled in the overflow, a short distance above the roaring hole, one of his hands gripping the sled and the other clutching an ax that he'd stuck into the ice. If Miller let go of the sled, his team would almost certainly be sucked into the hole and drown. If he relaxed his grip on the ax, he too would be pulled into the river.

Racing to his friend's aid, Mercer helped maneuver Miller's team away from the death trap and onto safe ground. The threat had ended, but the nightmare memory didn't fade so easily. Two years later Mercer admitted, "These really dangerous places on the trail are things most mushers don't talk about. There is nothing funny about them. They scare you when they happen, and they scare you to death every time you think about them after that."

Only a year after Miller's ordeal, a group of racers got caught by a severe mountain storm while trying to find their way through the Alaska Range. Above tree line, in a valley that affords little or no protection from wind-driven blizzards, the teams faced temperatures to 50 degrees below zero, with 50-mph winds that dropped the wind

chill to minus 130 degrees. The mushers got lucky; all survived, and only a few were frostbitten. But given this and other incidents in 1973 and '74, many Iditarod veterans felt it was only a matter of time before someone died. Alaskan trapper and 1980 champion Joe May once flatly predicted, "Somebody's going to buy it in this race. . . I'm surprised it hasn't happened already. You talk to any musher, and every one of them has a story to tell. Some of them have come awfully close. Awfully close."

May himself nearly bought it during the 1979 Iditarod, while driving his dog team along an exceptionally windblown section of the Bering Sea coastline locally called the Topkok Funnel. May was fighting his way through whiteout blizzard conditions when his dogs stopped and simply refused to go any farther. After trying in vain to get them moving again, the tiring musher had little choice but to dig in himself. Minus his heavy overmittens—he'd loaned them to Don Honea, an Athabascan musher from Ruby, who had earlier gotten into his own life-threatening jam—and using a snow-shoe as a shovel, May dug a snow cave while battered by wind-driven snow pushed by gales of 50 to 80 mph. Chilled, dehydrated, and exhausted, he grabbed his sleeping bag and crawled into the makeshift shelter.

How much time May spent inside the cave is unclear—he and others later guessed

PAGE 73 *Bill Bass slides around a turn during the Anchorage ceremonial start day on Fort Richardson.*

PAGE 74/75 *Lavon Barve pushes his sled around a rock face as he climbs up what is called "the glacier," 13 trail miles after leaving the Rohn checkpoint in 1996. The glacier is a section of trail near the Post River that travels uphill and typically consists of glare ice as water runs downhill after seeping from a spring.*

LEFT *One of Rick Swenson's dogs sleeps peacefully on a bed of straw after a snowfall the previous night at Unalakleet during the 2001 race.*

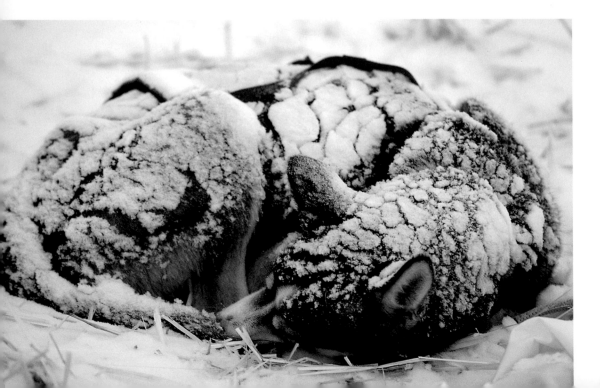

four to eight hours—but it was long enough for him to begin sinking toward hypothermia-induced unconsciousness and, possibly, death. What saved him, in all likelihood, was the arrival of Honea, the racer May had earlier helped out of trouble. With winds dropping, snow easing, and visibility much improved, Honea happened to stumble upon May's sled and dog team. When no one responded to his calls, Honea began to search the area, poking into snowdrifts and shouting loudly. Finally, he managed to rouse May, still groggy from his ordeal. Assisted by Honea, May added some layers of clothing (including the returned mittens) and "stomped around" to rewarm himself in the now-calm air. Then, with his dogs ready to resume their race after several hours of what for them had been restful sleep, he climbed back onto his sled. Accompanied by Honea, he drove on to the next checkpoint, Safety, and then to a fifth-place finish in Nome.

Another racer who came close—on more than one occasion—was Norman Vaughan of Anchorage. A retired Air Force colonel, Vaughan had plenty of mushing and cold-weather experience. In 1928, he had driven a dog team in Admiral Richard Byrd's successful expedition to the South Pole. Four years later he had competed in the first (and last) Winter Olympics sled dog race, at Lake Placid, New York. And during World War II he had been commander of the military's first dog team search-and-rescue unit.

Vaughan entered his first Iditarod in 1975 at age 69. He was doing fine until he reached the South Fork of the Kuskokwim River, north of the Alaska Range, where his team ran into deep overflow. "In places it was 10 inches deep and the dogs just weren't able to sustain their pace," he explained afterward. "I ended up leading the dogs myself and of course my feet got quite wet. The problem was, when I got past the overflow, my boots were frozen solid." Vaughan tried to cut the boots from his feet with an axe, but failed. So he drove his team 26 miles to Farewell (then an Iditarod checkpoint) and caught a plane to Anchorage, where his numb, blistered feet were treated for frostbite.

Not about to be discouraged, Vaughan reentered the Iditarod the following year. By the time the race had entered the Alaska Range, he was in last place, traveling alone. About 7 miles beyond Rainy Pass Lodge, a strong wind began to howl. Soon his team was stuck in a thick ground blizzard that obliterated the trail. Wading through deep

ABOVE *David Sawatzky is frosted up after a cold run from McGrath to Tokotna in the 2000 race.*

snow, unable to get his bearings, Vaughan crisscrossed the valley, vainly seeking the race route. Eventually he drove his team far off the race trail. After three days of futile searching, both musher and dogs had run out of food.

"On the fourth day, the dogs had eaten the [leather] harnesses," he later reported. "I don't mean chewed them off, I mean eaten them completely. I only had five harnesses left from the fourteen I started with. I was pulling the sled in snowshoes, pulling those dogs. Still the sled wouldn't move." When he failed to arrive in Rohn, race officials launched a massive search effort using both aircraft and snowmachines, but the searchers failed to find him for several days.

On his fifth day in the mountains, Vaughan became hypothermic. "I was thinking poorly and slowly, so I knew I'd better get in the sleeping bag because I had no other way to get warm. I had long since discarded my stove because I ran out of fuel. . . . It was then that I made the decision to kill a dog. I was going to drink the blood and feed the meat to the other dogs. I thought it would be easier to do than take raw meat and swallow it."

Fortunately, no such sacrifice had to be made. Snowmachiners Gene Leonard and Frank Harvey spotted Vaughan's tracks and found him late on the fifth day. They fed Vaughan's dogs and gave him some hot coffee. Then they towed musher, dogs, and sled back to the checkpoint at Rainy Pass Lodge. Despite his ordeal, Vaughan vowed he'd be back some day to finish the race. Sure enough, he entered and completed the 1978 Iditarod, placing 33rd out of 34 finishers.

The same year that Vaughan nearly had to sacrifice a dog to save his own life, Jerry Riley became the third straight Athabascan villager to win the Iditarod. Always known as a fierce competitor and hard-driving musher, Riley would become a controversial figure because of his reputation for being hard on dogs. Eventually banished from the Iditarod in 1990 because of dog deaths in his teams, he would be allowed to return in 2000. During his heyday in the 1970s, Riley placed at or near the top four times, including his one victory and two runner-up finishes.

No one could have guessed it at the time, but Riley's 1976 win would be the last Iditarod victory for a Native musher, at least through the 2001 race. Unbeknownst to anyone, the Iditarod was entering a new era, one to be dominated by professional

ABOVE *Lavon Barve shown here in the 1997 Iditarod.*

RIGHT *A rough trail between Finger Lake and Rainy Pass took its toll on rookie John Bramante's sled stanchions. Three whittled spruce branches, four hose-clamps, a few yards of twine, Velcro, and electrical tape, coupled with persistence and ingenuity, make the sled runnable to a checkpoint up the trail where John has a replacement sled waiting.*

BELOW *Rick Mackey won the race in 1983. He and his father, Dick, who won the race by only one second in 1978, are the only father-son team to win the Iditarod.*

PAGE 80/81 *Mark Freshwaters runs through the heart of the Dalzell Gorge in 1984.*

mushers who own large kennels, live along the road system, and have corporate sponsorship backing.

The epitome of that professionalism has been Rick Swenson. Now widely known as the winningest competitor in Iditarod history, the five-time champion grew up in Minnesota and began mushing recreationally while living in that state's Boundary Waters Canoe Area. At 22, Swenson read about Alaska's thousand-mile sled dog race across Alaska. His imagination fueled by Iditarod stories, he moved north in 1973.

Once in Alaska, Swenson built a home in the tiny bush community of Eureka, about a three-hour drive by gravel road northwest of Fairbanks, and settled into a sourdough's lifestyle. He dabbled in fur trapping and gold mining. And he became obsessed with sled dog racing.

Swenson entered his first race to Nome in 1976. That rookie year, he says now, was simply an adventure. He had no illusions about winning; simply finishing seemed an enormous challenge. Finish he did—impressively, in tenth place. Inspired by his rookie showing, Swenson sets his sights higher. And higher again. Ultimately he built a dynasty that has been matched by only two other mushers, Susan Butcher and Doug Swingley.

Swenson's first win wasn't long in coming. In 1977 he edged defending champion Jerry Riley by 4 minutes, 52 seconds to win the race. That victory marked both the end of Native Alaskan supremacy and the start of a six-year run in which Swenson's teams captured four championships (in '77, '79, '81, and '82) and never finished lower

than fourth. His 1981 winning time of 12 days, 8 hours, 45 minutes was also a new speed record, breaking the old Iditarod mark by nearly two days.

As his victory total mounted, Swenson became something of a mythic figure in Alaskan mushing circles, projecting an aura of invincibility. It seemed as if the Iditarod were his to lose, rather than anyone else's to win. He became an accomplished strategist, excelling at the psychology of dog racing. At times he appeared to toy with his rivals, letting others have the lead early in the race, only to take it from them when it counted most—at the finish. Never did Swenson "run away" from the pack. In all his victories, he won head-to-head battles with other mushers in sprints down the Bering Sea coast—thanks largely to the leadership abilities of one of the Iditarod's first canine stars, Andy.

A mixed-breed husky born on the Fourth of July in 1975, Andy was an "exceptional nuisance" as a puppy largely because of his enormous energy. But put into harness, he became a once-in-a-lifetime leader. "Probably the biggest thing about Andy was his incredible eagerness to work," Swenson noted. "Not only did he want to be my leader, he refused to let any team be in front of him. At times he'd drag the whole team, without any encouragement from me. That kind of drive, so strong and determined, is what's so hard to find." In both 1979 and 1982, says Swenson, Andy almost singlehandedly pulled him to victory over the final miles. In seven years of Iditarod racing, the dog led his teammates to four victories plus second-, fourth-, and fifth-place finishes.

With Andy in the lead, winning the close ones became Swenson's trademark. Four of his five victories (the fifth didn't come until 1991) have been by less than an hour. Twice he won by less than five minutes: in 1977, when he beat Jerry Riley, and in 1982, when he edged Susan Butcher by 3:43.

As his legend grew, Swenson's mystique would shape the strategies of other mushers even in years when his own team wasn't capable of winning, affecting, for instance, where and when his competitors would rest their dogs. In 1983, for example, when he finished fifth, he never really challenged for the lead; yet, as one observer noted, "Because he is Rick Swenson, everyone assumes there is a master plan, a carefully guarded secret to winning the Iditarod." Winner Rick Mackey (son of 1978 champion Dick Mackey) would later admit he feared a late rush by Swenson

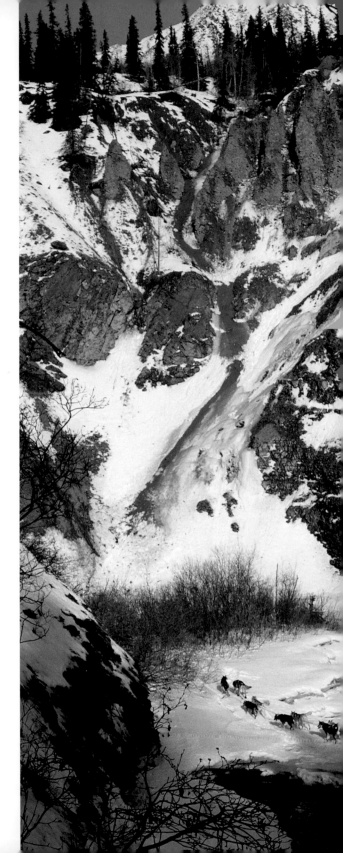

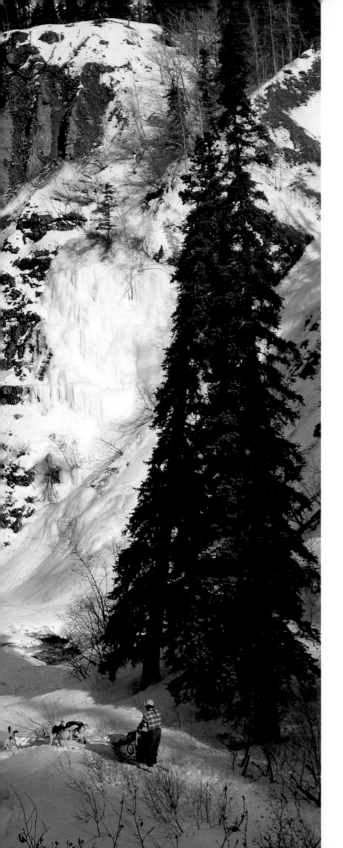

even after building an advantage of several hours: "You keep wondering when he's going to come smoking past you."

Only once has Swenson lost a close decision, in what proved to be the most dramatic and controversial finish in Iditarod history. After more than 14 days of howling winds, ground blizzards, numbing cold, and sleep deprivation, Wasilla musher Dick Mackey beat Swenson by a single second.

Mackey entered the 1978 Iditarod with impressive credentials. One of only two men (Ken Chase of Anvik was the other) to finish each of the first five races to Nome, he'd been a perennial top-ten finisher but never number one. Swenson, meanwhile, had run only two previous Iditarods but already wore the title of champion.

Mackey figured that Swenson was again the musher to beat, so his strategy was simple: Stay close to Rick. Throughout the Interior and along the Bering Sea coast, he did just that. Pushing hard, Mackey slept little, maybe ten hours over the final week of racing. But his strategy worked. At Safety, 22 miles from Nome, Mackey shared the lead with Swenson. It was, as he'd hoped, a two-team race.

In Nome, people began talking of a dead heat, a photo finish, as updates periodically filtered in. With nine miles to go, Mackey held a two-mile lead. It seemed he was pulling away. But with four miles remaining, Swenson regained the lead—though only by the length of his team. As the town's siren blared, signaling the teams' arrival, spectators crowded the fences that line Nome's 50-yard-long finishing chute. Through the dawn light, Swenson and Mackey pushed their dogs up Front Street. According to a newspaper account:

> All eyes stared down the street, as the distant figures focused.
> "They're dead even," someone shouted as the mushers stormed the chute.
> Mackey's whip cracked. Swenson bore down.
> Roars went up and people screamed the teams to the line. It was over. But few knew who had won.
> Swenson's sled was over the line, resting a few feet in front of Mackey's, with six dogs in harness. But Mackey's team of eight was stretched further forward. Mackey fell from his sled, collapsing on the ground. His wife flew to his side.
> The mushers disappeared under the deluge of press, race officials, and family.

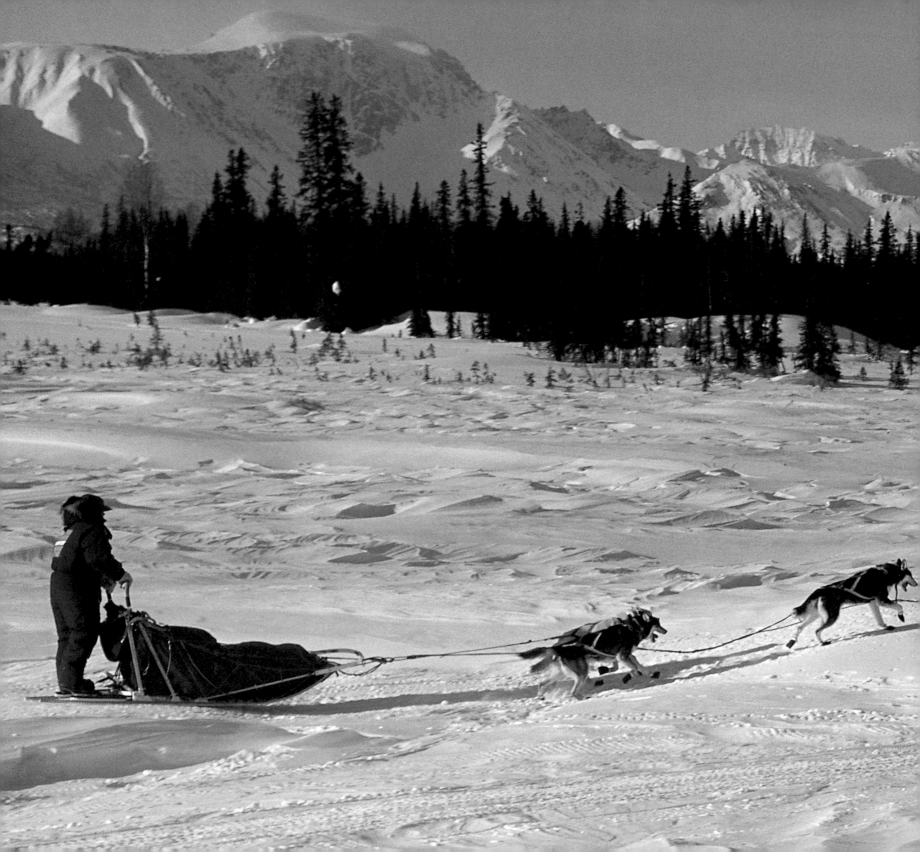

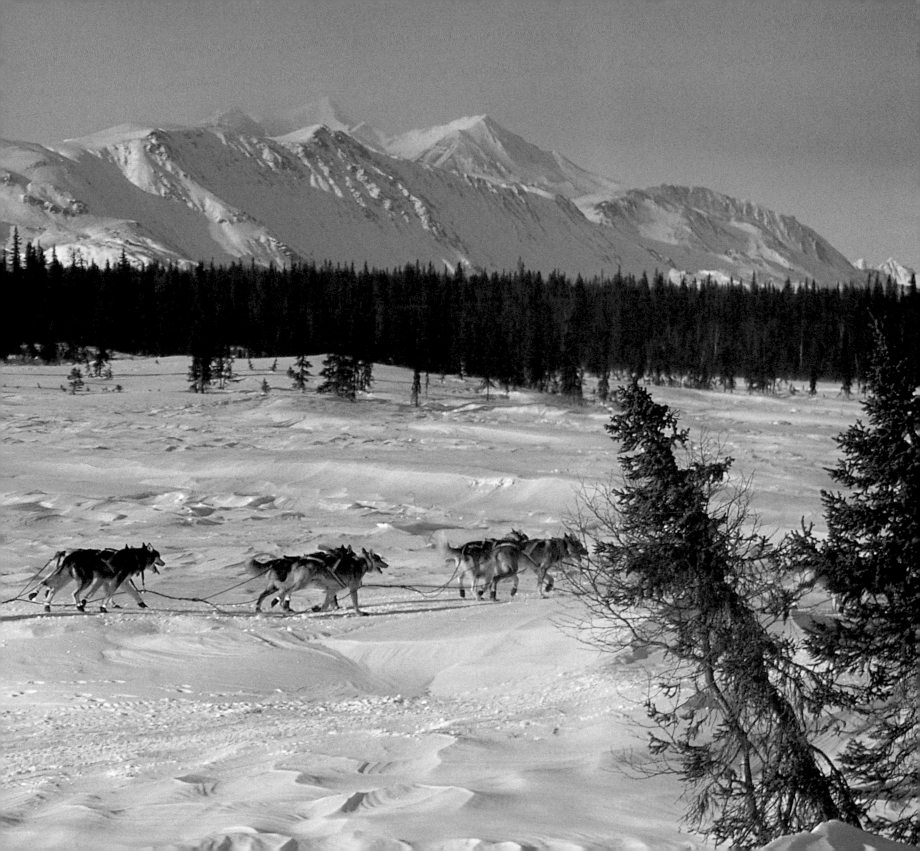

Voices croaked. Confusion reigned.

"It's the first dog across the line that determines the winner," race marshal Myron Gavin said. "The winner is Dick Mackey."

The crowd's roar hit a crescendo. Icicles frozen into his mustache, his eyes glazed and glassy, his mind rummy from no sleep, Mackey understood. He had won the 1978 Iditarod Trail Sled Dog Race, riding in at 6:52 a.m. on a sparkling, crystal-blue morning. . . .

"It's about time," the 45-year-old musher said. "It's been a dream of mine for six years now."

Thinking that he had earned the victory, Swenson waved to the crowd after crossing the finish line. When notified of the race marshal's decision, he handled what had become an upsetting loss in style. According to a second newspaper report, "Swenson didn't rant and rave. He didn't complain. 'If you made a decision, stick by it,' he told the race marshal. Swenson kept a smile on his sunburned face and his thoughts to himself." Swenson's gracious demeanor at that moment stands in striking contrast with the public persona he carried for many years, that of a gruff, sometimes mean-spirited competitor.

Despite Swenson's undisputed status as "king of the Iditarod," a challenger to his throne began to emerge as the first decade of Iditarod racing was coming to an end. Susan Butcher, like Swenson, had come to Alaska to race sled dogs. And like Swenson after his rookie year, she brought an incredible determination not only to win, but to be the best.

Raised in Massachusetts by parents who encouraged independence and self-expression, Butcher left home at the age of 17 and headed west to Colorado. Always a lover of animals, she got hired as a veterinary assistant and discovered the joys of mushing. She also read a magazine account of the first Iditarod. Right then and there, Butcher knew exactly what she wanted: to live in Alaska, and to run the Iditarod.

The notion of a woman running the Iditarod was still a novelty when Butcher came north in 1975. No women entered the 1973 race, but two pioneering females signed up the following year: Mary Shields of Fairbanks and Lolly Medley of College (a Fairbanks suburb). Some men—including a few mushers—scoffed at the notion that

PAGE 82/83 *Vern Halter drives his dogs along a section of trail near Finger Lake, with the Alaska Range in the background.*

ABOVE *The weariness shows in the face of three-time champion Martin Buser as he takes a break at the Cripple checkpoint in 1996.*

ABOVE *The thermometer at McGrath reads 28 below zero during the 1999 race, when mushers experienced 4 days where the temperatures were typically 25-35 degrees below zero.*

BELOW *A sign placed in the Dalzell Gorge says it all.*

PAGE 86/87 *Johnny Baker runs in late afternoon light on the Yukon River shortly after his mandatory 8-hour layover in the village of Ruby in the 1998 race. As the first musher to reach the Yukon, Johnny received a special 7-course gourmet meal prepared for him on a camp stove by an Anchorage chef and $3,500 in prize money from the Regal Hotel in Anchorage.*

women might be tough and talented enough to do the Iditarod. In her memoir *Sled Dog Trails,* Shields recalls one male spectator in Anchorage shouting, "You better turn back now, while you're still close to civilization. You'll never make it to Nome!" The words hurt, Shields admitted. But they also made her more determined to succeed. Led by a dog named Cabbage, Shields finished 23rd out of 26 mushers, one spot ahead of Medley.

As Shields drove her team up Front Street in Nome, she received an unprecedented welcome: "About thirty women, bundled in their parkas and kuspuks, stretched across the finish line holding a banner over their heads 'You've Come a Long Way, Baby.' . . .

The roar from the crowd thundered to the stars. All of Nome was there to celebrate, especially Nome's women."

For the record, 18 men scratched that year, including the likes of George Attla, Jerry Riley, and Isaac Okleasik, champions all.

Still, women racers were something of a curiosity when Butcher entered her first race to Nome in 1978 at the age of 23. No woman had ever finished "in the money," let alone challenging for the title. Helped along by Joe Redington, Sr., who provided guidance and a couple of dogs from his kennel, Butcher would change all that. Yet she always considered herself a musher, plain and simple, not some "female musher."

Never lacking in confidence or ability, Butcher as a rookie predicted a top-20 finish, then placed 19th. The next year, she declared that she would make the top ten and finished ninth. In 1980, she announced a new goal—the top five—and then proceeded to take fifth.

Following a second fifth-place finish in 1981, Butcher seemed ready for a serious run at Swenson, and she left no doubts about her intentions to dethrone the defending champ. Equally determined was Inupiat Eskimo Herbie Nayokpuk.

A revered musher from the village of Shishmaref, Nayokpuk had been a perennial Iditarod contender since the early 1970s. Known as "the Shishmaref Cannonball" for his shot-out-of-a-cannon racing style, he had finished second in 1980, third in 1974, and fourth in 1975. Yet victory kept eluding the Cannonball.

Deep into the 1982 race, a raging blizzard forced a temporary halt to the race, as the teams made their way along the Bering Sea coast. More than a dozen mushers—Swenson, Butcher, and Nayokpuk among them—took shelter in the village of

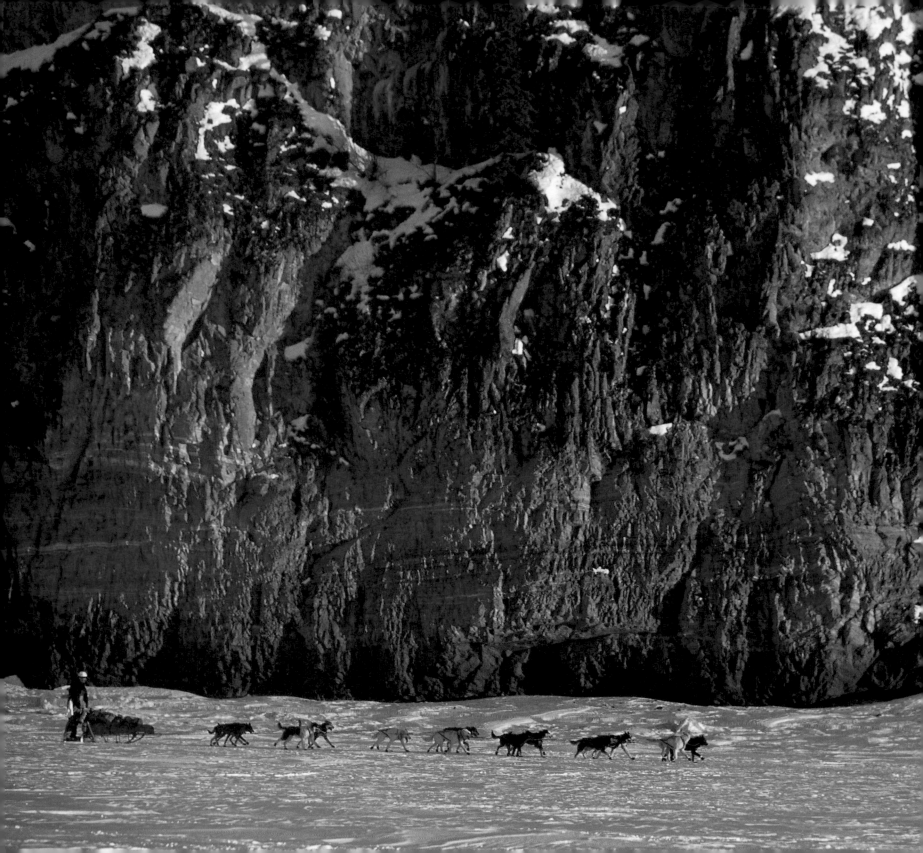

Shaktoolik rather than travel through the storm to Koyuk, 58 trail miles north. To reach the next checkpoint, teams would have to cross ice-covered Norton Bay, which offers no protection from the wind. The bay is also a notoriously difficult place on which to follow the trail; markings are often moved by shifting ice, or knocked down by gale-force blasts and buried by snow.

Sensing his chance for victory, Nayokpuk left the warmth and safety of Shaktoolik and drove his team into the teeth of the storm. "It was good weather for me," he later explained. "I've gone out in worse weather than that. I would have made it easy if I'd just gone out two hours earlier."

Nayokpuk departed at noon and made good progress for five hours. But after he'd traveled 22 miles, the winds increased to 60 miles per hour and the visibility became so poor that neither he nor the dogs could follow the trail. Deciding it would be foolish to continue, he stopped the team, put his sleeping bag inside the sled bag, and climbed in. Sleep, however, was impossible: "The sled was real small and I had to kind of sit. I was real wet. I was just shivering in there."

Three snowmobilers from Koyuk went looking for Nayokpuk and found him at 1 a.m. They waited for daybreak to move. But in the morning the storm was so fierce that the group chose to retreat to Shaktoolik rather than face into the gale. Even traveling with the wind, they had great difficulty following the trail. At one point the men searched more than an hour for markers. After finally reaching the checkpoint, Nayokpuk all but conceded defeat. "I really ruined my dogs when I couldn't find the trail," he lamented. "I think they're bummed out." As Nayokpuk feared, the unsuccessful run took a heavy toll. When the storm finally let up, his team no longer had the stamina or enthusiasm to keep out with the leaders. The Cannonball finished seventh, while Swenson won his record fourth championship. Butcher placed second, only 3 minutes and 43 seconds behind.

The end of a decade once dominated by Native mushers ended with Swenson in his accustomed spot. But a new rival was clearly nipping at his heels.

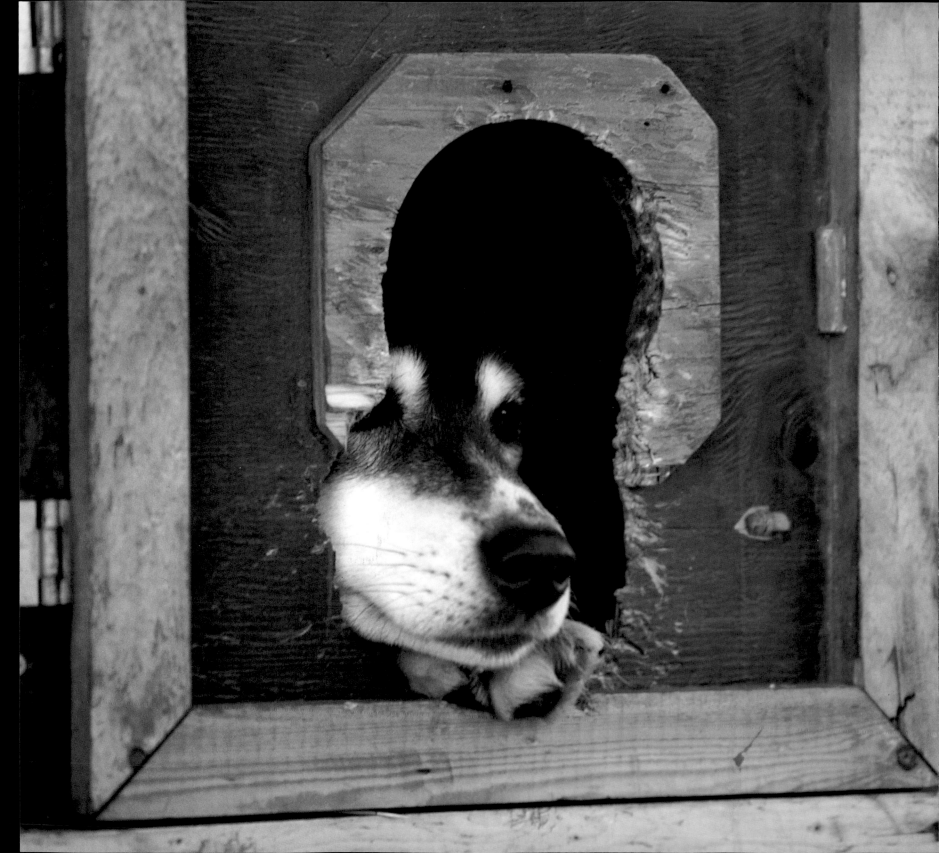

THE LEGEND OF LIBBY AND SUSAN

LEFT *Raymie Smyth's dog "Quick" waits patiently in his dog box at the ceremonial start of the 1998 race.*

ABOVE *Susan Butcher's beaver mitts, with "gee" for right and "haw" for left.*

Susan Butcher's steady and sometimes spectacular rise in the Iditarod standings during the late '70s and early '80s had caught the attention of competitors, fans, and media alike. Even without an Iditarod victory, she had become one of Alaska's best-known mushing celebrities. Yet as years passed and expectations mounted, the Iditarod crown continued to elude her grasp.

Butcher's narrow loss to Swenson in 1982 was followed by a disappointing—at least to Susan and her backers—ninth-place showing in 1983. Rick Mackey followed his father's 1978 victory with a win of his own, to overshadow the growing Butcher-Swenson rivalry. For the first and so far the only time, two members of a family had claimed Iditarod championships.

Butcher rebounded to second in 1984, but the big story that year was Dean Osmar, a little-heralded entrant from the Kenai Peninsula community of Clam Gulch. A commercial fisherman, Osmar had competed in only one previous Iditarod, placing 13th as a rookie, and he entered the 1984 race as one of many long shots. Lots of people were surprised when Osmar took the lead at Ophir, 476 miles into the race. Even more surprising, he then began to build a big lead. Still, no one took him seriously.

Other contenders knew Osmar's dogs weren't particularly fast. Sooner or later, they'd reel him in.

Osmar's strategy—set a fast early pace, build a big lead, then hold on—had been tried before but invariably was foiled by blizzards, poor trail conditions, or dog burn-out. Larry "Cowboy" Smith, a former rodeo performer from Dawson City in Canada's Yukon Territory, was perhaps the Iditarod's best known early pacesetter, or "rabbit." Fast starts and down-the-stretch fades became his trademarks during the early 1980s. Twice he came tantalizingly close to being number one, with a personal-best third-place showing in 1983. But Cowboy was never able to keep his dogs running fast enough for long enough to finish on top.

Everyone figured Osmar would have a similar fadeout. But he and his dogs fooled them all. Maintaining a steady if unspectacular pace through the Interior and then along the Bering Sea coast, he withstood a late challenge from Butcher to win by 1 hour and 34 minutes. Since his unexpected win, early front-runners have never again been taken as lightly, nor allowed to build big leads.

As for Butcher, doubts continued to grow about her ability to move into the winners' ranks. Some competitors even hinted that Butcher didn't have "the right stuff" to be a champion, that she sabotaged her own dreams of victory. She seemed incapable of escaping the shadow thrown by her Eureka neighbor and rival, Rick Swenson—always destined to be an Iditarod bridesmaid but never the bride.

Others may have doubted, but Butcher never lost faith. She entered the 1985 race with great expectations, boldly touting her team as "my best group of dogs ever." But her championship dreams were again crushed, this time while she was mushing through an area nicknamed "Moose Alley." Just beyond Wasilla, this 100-mile stretch often attracts large numbers of moose in winter. Most years they don't present serious problems for Iditarod racers, but in winters of heavy snow they can be undernourished, stressed, and extremely dangerous.

Running along a twisting, turning section of trail, Butcher's team suddenly came face-to-face with a pregnant cow. "I didn't see the moose until it was in the team," Butcher would tearfully tell reporters later. "I don't think the dogs even saw it. It came stomping through until it was about halfway into the team. It killed one dog pretty quickly, plus it got the dogs all tangled and twisted, so I couldn't get the team past it."

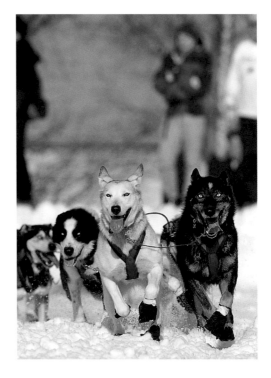

Veternarian Sonny King's dogs round the hairpin turn at Cordova Street and Fourth Avenue in downtown Anchorage at the start of the 2000 race. The dogs are wearing booties which protect their pads from rocks and other sharp material on the trail.

Eyes wild with panic, the moose reared up and came crashing down on two of the dogs. For 20 nightmarish minutes she stayed among the dogs, lashing out with deadly hooves that tore flesh, ruptured organs, and cracked bones. The yelps of Butcher's frightened, injured dogs mixed with the moose's snorts and grunts. Butcher had no gun. She tried waving her parka and shouting, but that only seemed to rile the frenzied animal more.

Finally another racer, Duane "Dewey" Halverson, arrived on the scene. Seeing the moose among Butcher's dogs, Halverson remembered an incident five years earlier, when a moose had charged three Iditarod teams and chased mushers Dick Mackey, Warner Vent, and Jerry Austin into the surrounding forest. Austin and Mackey had both shot the moose several times before it finally collapsed. Several dogs were injured, but none died.

Halverson, who routinely carried a gun when mushing, fired four shots into the cow before she went down. "I was praying on that last one," he said. "I only had one bullet left."

The toll on Butcher's team was heavy. Two dogs died and six others were seriously hurt, suffering either leg damage or internal injuries. With only eight of her sixteen dogs left and several of those in questionable condition, Butcher had to drop out of the race. More agonizing than her withdrawal, however, was the loss of the dogs, whom Butcher considered part of her extended family. Some might criticize her race strategy or personality, but no one would ever challenge her love for, and commitment to, her dogs.

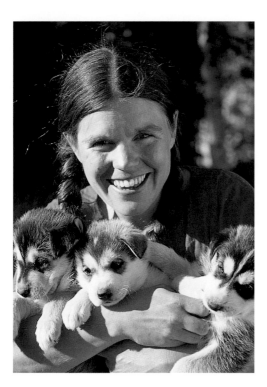

Susan Butcher, shown here with a new litter of puppies, has won the race four times. Even though she has not run the race since 1994, she is certainly the most well-known musher, remembered as "that woman who wins all the sled dog races in Alaska."

With Butcher so quickly out of the running, attention turned to the other usual suspects. Swenson seemed due for another run at the title, after "off years" in '83 and '84, when he had finished fifth and sixth. Rick Mackey, Herbie Nayokpuk, Jerry Austin, Sonny Lindner, Emmitt Peters—any of them might win. Hardly anyone mentioned Libby Riddles, even though her dog team had finished third the year before while driven by her partner, Inupiat Eskimo Joe Garnie of Teller.

Riddles had placed 18th and 20th in her two previous Iditarod appearances ('80 and '81). Good performances, but not ones that would attract much attention to this 28-year-old resident of Teller, a small coastal town north of Nome. Outside racing

circle's, Riddles was a virtual unknown. Even within the mushing community, she was overshadowed by Susan Butcher, the most prominent female in Iditarod history.

Riddles's team didn't look like championship material in the early going. The racer suffered more than her share of problems: first the brake on her sled busted, then her team got away. Fortunately, neither incident proved disastrous. A replacement brake was quickly found, and Riddles caught her runaway dogs before any were injured, thanks to the assistance of two competitors, Chuck Schaeffer and Terry Adkins.

Then, just when things were starting to look up, several dogs became infected with viral diarrhea. "It's disgusting when they get sick," she later commented. "They're not eating and not able to work. You have to give them long periods of rest." Luckily for Riddles, the team got lengthy, unplanned rest breaks when race officials ordered the race stopped at both Rainy Pass and McGrath because storms had delayed food deliveries farther up the trail. "That really worked out well for me," she readily admitted. "The dogs recovered nicely."

Despite her early woes, Riddles gradually worked her way to the front of the pack. She reached the Bering Sea village of Unalakleet in second place, two hours behind Lavon Barve of Wasilla, and was the first musher to leave.

Riddles drove into Shaktoolik at 2:17 in the afternoon, in the middle of a severe ground blizzard. Despite winds that gusted to more than 40 miles per hour and near whiteout conditions, Riddles at least had the option of heading across Norton Bay in daylight. Her rivals wouldn't arrive until evening. And none would choose to challenge the storm in darkness.

Even with daylight to help her find the trail, Riddles had second thoughts. She called up Garnie and asked for advice. He urged her, "Go!" So did two other people whose opinions she respected. So Riddles headed into the storm. Gusting winds, now blowing up to 60 miles per hour, created a ground blizzard as she left Shaktoolik. But conditions soon got even worse. Whiteout made it nearly impossible to follow the trail, and wind-chill temperatures dropped to minus 50 degrees and below.

"As soon as we left town, it went from being a race to a survival test," Riddles said. "But I'd already made up my mind that if I couldn't get across, I'd camp. There's nothing more depressing than backtracking. You lose all those miles you've gained. And the next time you leave a checkpoint, the dogs are real reluctant to go. They

ABOVE *In 1985, Libby Riddles was the first woman to win the Iditarod. She brought world fame to the race by not only winning, but by taking a gamble with a daring run through a blizzard.*

RIGHT *Two lead dogs, born to run, head down the trail at the Anchorage start line.*

PAGE 94/95 *DeeDee Jonrowe and team run up a steep section of trail shortly after leaving the Rainy Pass checkpoint during the 2001 race. The Rainy Pass area is undeniably the most scenic portion of the race.*

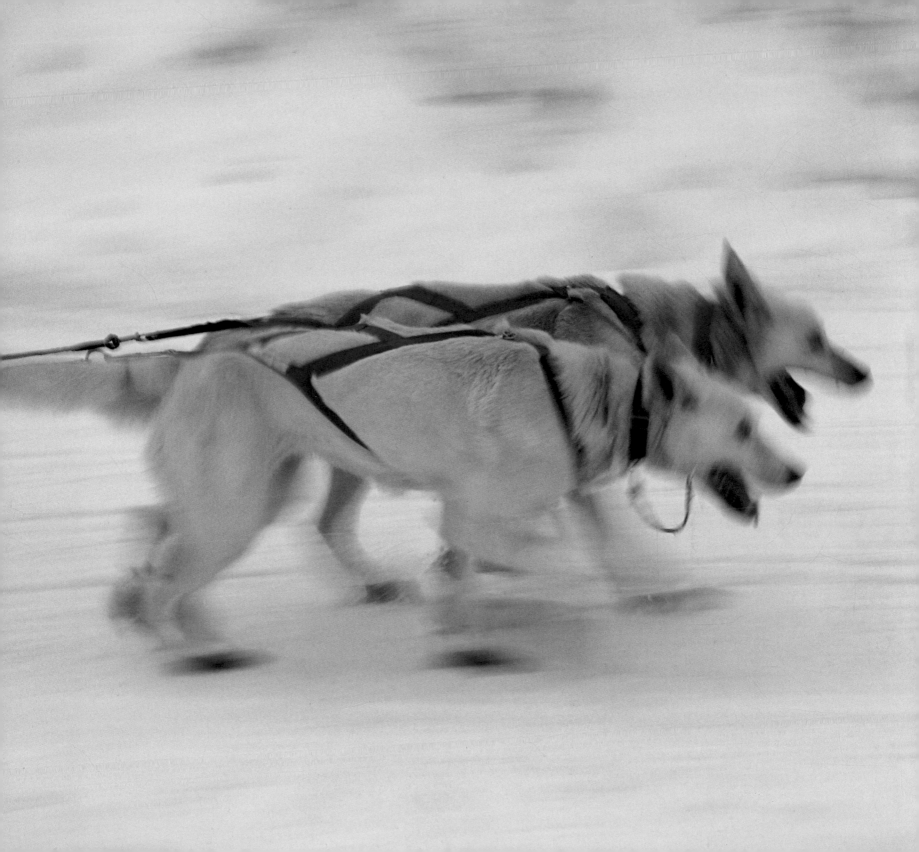

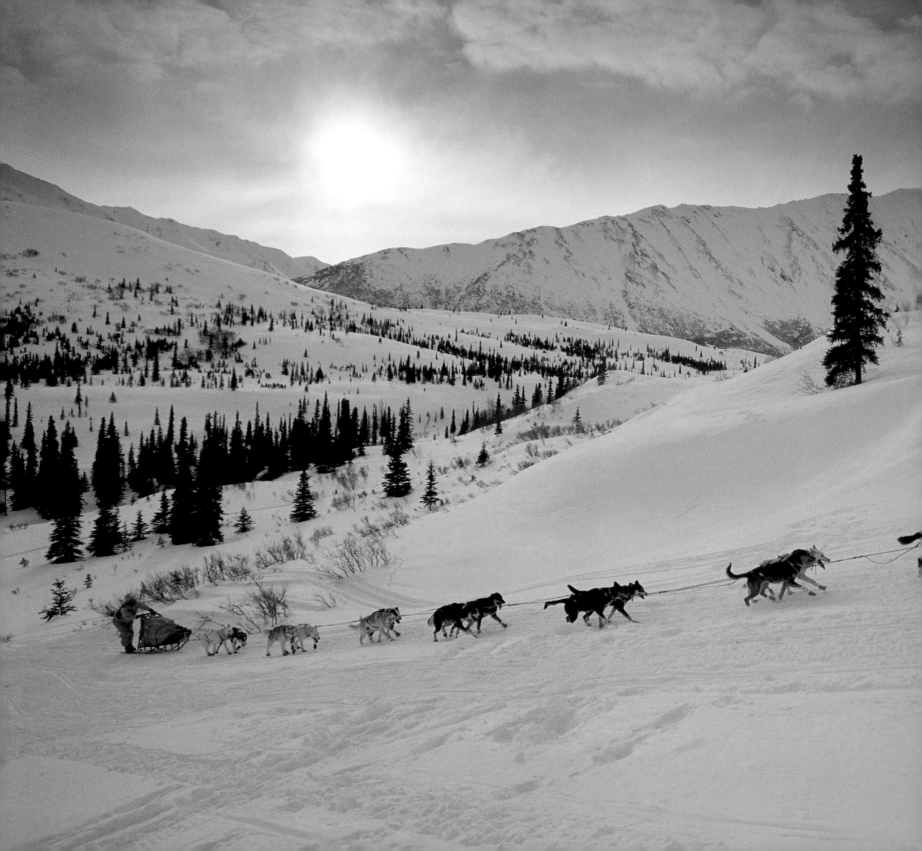

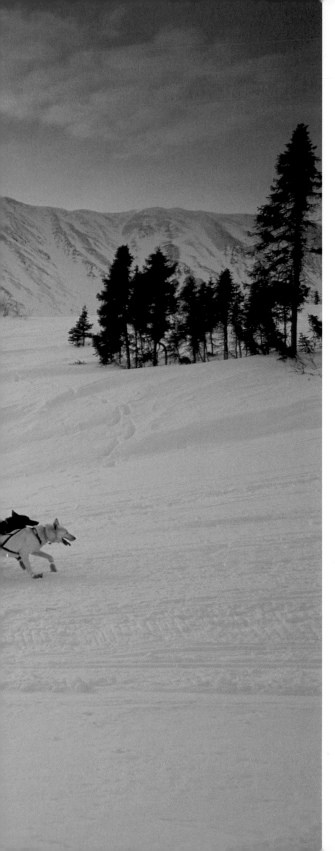

remember the negative experience." (That's exactly what had happened to Herbie Nayokpuk in 1982, when horrendous weather forced him to retreat to Shaktoolik.)

For two and a half hours, Riddles drove her team ahead, ploughing through blinding snow and onto the sea ice. Stakes marking the trail were the dogs' only guide. Finally, with darkness setting in, Riddles made camp to keep from getting lost. It was impossible to determine the team's location. Only one thing was certain: There was no place to take shelter.

For the dogs, this presented no real problem. They curled up, their tails across their faces, and were quickly buried by snow, which added further insulation to their fur coats. But for Riddles, the hardest and most frightening part of her 24-hour crossing was about to begin. She had to change out of her wet outer clothing before climbing inside the sleeping bag. "It was a real effort. I had to take off my fur parka and almost got frostbit hands doing that. Then I realized I had to take off my snow-pants too. So I had to go through the whole process again. Finally I got into my sleeping bag. I knew that as long as I had warm, dry clothing, I'd be OK."

Still, there was fear. Riddles was scared of frostbite, scared of hypothermia, scared of freezing to death. "You'd have to be stupid if you weren't scared in those conditions," she said. "It was probably the most dangerous position I've ever been in. But fear helps keep things in proper perspective. And I just kept telling myself, if you win the race it's worth it."

Riddles bundled herself as well as possible. She pulled over her fur-lined parka hood, and when her neckwarmer froze, she used dog booties as facewarmers. She stayed in her sleeping bag for ten hours or perhaps longer, until there was enough daylight to travel. After a breakfast of seal oil and Norwegian chocolate, she resumed the trek.

From the camping spot, it was another 45 to 50 miles to Koyuk. Riddles stopped the team occasionally to get her bearings. Finally, just as darkness was again approaching, she spotted the village. After being mobbed by its residents, she officially checked in at 5:13 p.m. Libby's gamble had worked. Now only 171 miles from Nome, she was more than six hours ahead of her nearest competitors. Dewey Halverson narrowed her lead in those final miles. But the musher who'd saved Susan Butcher's team from the moose finished two and a half hours behind Libby Riddles, as

she, and not Butcher, became the first woman to win the Iditarod. Her time of 18 days and 20 minutes was the slowest for a winner since Jerry Riley in 1976.

Through her gamble and her ensuing victory, Riddles became the star of the Iditarod show, Alaska's "first lady of mushing." In a matter of days, she'd gone from unknown to nationally known. Along the way, she blazed new trails for the Iditarod's publicity-hungry organizers while earning accolades and honors no male musher had ever before received. Riddles would run the Iditarod three more times, but she never again challenged for the title. In her last appearance, in 1995, she traveled with the back-of-the-packers. Yet she, as much as anyone, helped to raise the Iditarod's profile and make it an internationally acclaimed event.

By mushing into the national spotlight, Riddles made 1985 "the year of the woman." She also drew attention away from the earlier organizational snafus in what was perhaps the stormiest and messiest Iditarod race ever.

For the first time ever, Iditarod officials ordered an official "freeze," turning the Last Great Race into the Last Great Wait. Race marshal Donna Gentry halted the race at Rainy Pass, in the foothills of the Alaska Range, because stormy weather had prevented the Iditarod's volunteer pilots from delivering dog food to the next two checkpoints. (Mushers are required to get their food to Anchorage a couple of weeks before the Iditarod so that it can be flown to checkpoints along the trail.) Gentry decided that the absence of food at checkpoints farther up the trail, combined with poor weather and marginal trail conditions, presented a significant threat to teams. So she held up the race until delivery was confirmed.

Iditarod front-runners and tail-enders are normally separated by more than a day's travel when they reach Rainy Pass Lodge, 224 trail miles from Anchorage on the shores of Puntilla Lake. With a steady stream of teams coming into and going out of the checkpoint, there are never more than a dozen or so present at a given time. But the 1985 race stoppage enabled back-of-the-packers to catch up with the leaders, and eventually the entire field gathered at the lodge. With 58 mushers and 806 dogs waiting for a series of storms to end, it didn't take long for the mushers' food supplies to be exhausted.

A food crisis was averted, however, thanks to a couple of airborne mercy missions. Though stormy weather kept Iditarod planes from flying across the Alaska Range,

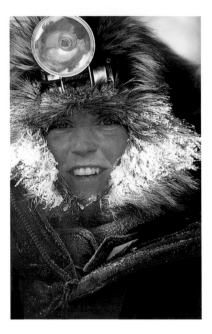

ABOVE *The frosted face of Lori Townsend is all smiles despite a cold run from McGrath to Tokotna in 1997.*

RIGHT *Diana Dronenburg, now Diana Moroney, keeps her sled from tipping on the side hill trail in the upper Dalzell Gorge in 1993. Side hills are tricky for mushers to keep the sled from falling or from hitting trees. Diana shows what it takes to avoid those pitfalls.*

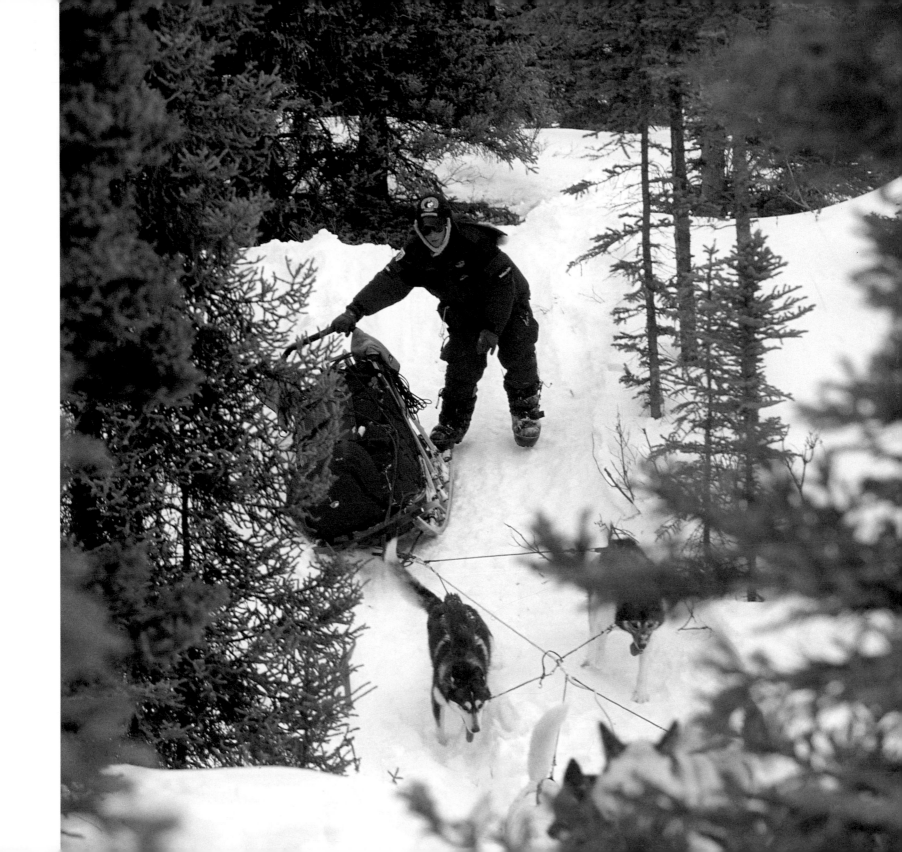

several Anchorage-based pilots were able to land on Puntilla Lake. First, about 3,000 pounds of dog food was delivered. Then a surprise gift from the people of Anchorage was dropped off: In response to a plea from the Iditarod Trail Committee, the public had donated more than two tons of people food, including everything from beefsteaks to military C rations.

As the freeze dragged on, racers expressed mixed emotions about their enforced wait. "Rainy Pass is probably the most ideal place on the trail to wait, if you have to," said Vern Halter, a mushing attorney from Moose Creek. "We've got a warm, dry place to stay [one of the lodge buildings was designated a 'mushers' cabin']. And now we have food for ourselves and the dogs. Plus the people in charge of this place [Robin and Bucky Winkley] have done just an excellent job making things comfortable for us. On the other hand, we've only gone 200 miles and it's been nearly a week. We've got almost 1,000 to go. That's kind of depressing. Everybody's antsy, but what can you do? All you can do is wait."

Finally, after three days, the dog food reached its destination, Gentry lifted the freeze, allowing the mushers to resume their trek to Nome. But again they were halted by storms and insufficient food supplies. Mushers were spread from McGrath to Ophir—43 miles of trail—when Gentry ordered a second freeze. It didn't last nearly as long, but it was much more complex to manage, given the presence of mushers at three different checkpoints. The two stoppages had many mushers howling mad at race organizers, and the Iditarod's reputation seemed certain to take a nasty hit—until Libby Riddles mushed into history.

For all her frustrations and sorrows in dealing with her dogs' deaths and watching Riddles become a darling of both the media and the public, Susan Butcher refused to give up her dream. "I knew after the first Iditarod that I had the ability and the knowledge to win," she said following the 1985 race. "It's a matter of getting the dogs and having things go right. It's only a matter of time."

The time was finally right in 1986. Running a "hodgepodge" team that included only six Iditarod veterans, Butcher outraced Joe Garnie to win one of the most memorable duels in Iditarod history, their teams racing neck and neck down the homestretch.

Both competitors, in their own ways, were sentimental favorites. Much of Alaska

Replacement sleds are lined up at the checkpoint in McGrath. McGrath is the closest major hub after mushers cross the infamous Farewell Burn, known to take its toll on sleds.

was rooting for Butcher to complete a comeback after the devastating losses to her team in 1985. Garnie, meanwhile, was trying to duplicate the feat of his partner Libby Riddles, who one year earlier had raced into Iditarod lore with her fairy-tale victory. If he won, the Riddles-Garnie kennel would be the first to capture back-to-back Iditarods since Swenson's victories in '81 and '82. Even more impressive, Garnie would symbolize the hopes and dreams of all small-kennel owners by upsetting a musher who had devoted her life to dog racing and turned it into a major, year-round business. The mayor of Teller, Garnie was especially popular in Northwest Alaska. Like Riddles, he was a resident of the region. He was also an Eskimo and thus could become the first Native winner since Jerry Riley a decade earlier.

Finally, there was the matter of Garnie's never-give-up persistence. He'd put himself in a position to win despite bad luck earlier in the race. Twice his team had gotten off the trail. He'd lost a few hours the first night of the race, and then made a wrong turn between McGrath and Takotna, a mistake that cost him the lead as well as another four hours of time. He'd also busted a couple of sleds. "It's to the point where I'm beyond shock when something like this happens," he said. Fortunately, both times Garnie was able to borrow another sled and stay in the chase.

From Unalakleet to Safety, no more than a few minutes separated Butcher and Garnie as they arrived and departed village checkpoints along the Bering Sea coast. Almost always within sight, they closely watched each other's teams, trying to gauge their relative strengths. After they reached White Mountain—77 miles from Nome— only four minutes apart, both thought Butcher had the edge. "I don't know about speed. I think my team can keep up with anybody's. But as far as being tired, there's no question Susan's has had more rest," Garnie said.

After taking their mandatory layover at White Mountain, the teams pushed on to Safety, where Butcher owned a nine-minute lead. But as both mushers had anticipated, Garnie's come-from-way-behind push had forced his team to use up its reserves. Over the final 22 miles Butcher pulled away, winning the 1986 Iditarod by more than 55 minutes. "It's a relief to win and get it over with," she admitted. "Now I don't have to worry about it anymore."

Propelled by her duel with Garnie, Butcher won her first title in record-breaking time. Not only had she stepped out of Swenson's shadow, she'd crushed his speed

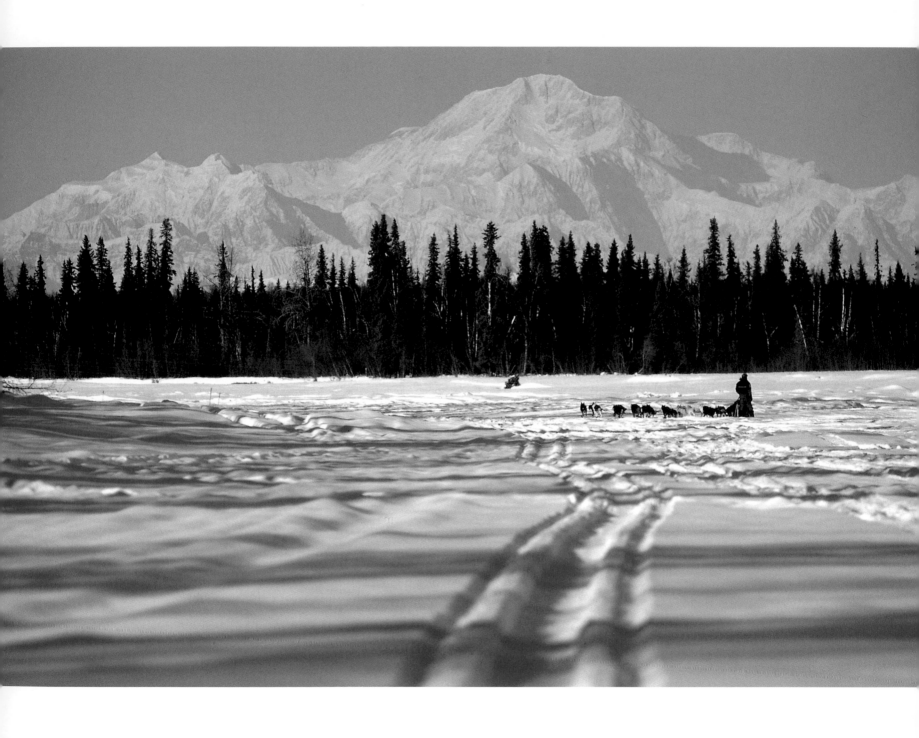

record by more than 17½ hours. In the process, she became the first racer to finish the race in under 12 days.

That victory seemed to make all the difference. Butcher suddenly replaced Swenson as "the musher to beat." After years of Susan chasing Rick, the roles reversed. From 1986 through 1990, she won four of five Iditarods, including an unprecedented three straight (1986–8). The only musher to disrupt her streak was Nenana's Joe Runyan in 1989, and that year Susan placed second. No musher, including Swenson, had ever put together such a dominating string of finishes. Much of the credit for that streak must be given to Granite, Butcher's main leader for three of her four victories.

Replacing Rick Swenson's Andy as Alaska's most famous living canine, Granite had been born into the kennel owned by Joe Redington, Sr. On one of her frequent visits to the kennel, Butcher noticed the skinny, scroungy-looking dog. She asked Joe Sr. about the two-year-old male, and Redington offered him for free. Once described by Butcher as "a mellow dog who's friends with all the other dogs," Granite would also prove to have the heart and drive of a champion, while showing again that looks don't mean everything.

Victories alone didn't measure Butcher's domination. By 1990 she had trimmed the Iditarod's speed record to just over 11 days, while posting three of the four fastest times in race history. As the decade ended, she had unquestionably usurped the title of world's best long-distance musher. Even Swenson once admitted, albeit in the heat of battle, "The rest of us are just in a different class."

Butcher's reign, combined with Riddles's dramatic win in 1985, captivated people around the country and added immensely to the Iditarod's appeal. Here was a sports event where women could indeed compete with men—and defeat them handily. The streak of female domination also led to a new, informal state motto: "Alaska, where men are men and women win the Iditarod."

The changing of the championship guard caused a rift, at least temporarily, in what had once been a close friendship. During the summer of 1985, Butcher said the Susan-vs.-Rick rivalry was "all blown out of proportion by the press. Rick is just about my best friend. It's just that when we're racing, we have a hard time being around each other. We're both so competitive, it's tough to be real buddy-buddy during the

GEAR

Race rules require that mushers carry several pieces of gear:

- a cold-weather sleeping bag, weighing a minimum of five pounds.
- an ax that has a handle at least 22 inches long and a head weighing at least 1¾ pounds
- a pair of snowshoes with bindings, each shoe at least 252 square inches in size
- eight booties for each dog, either on the dogs' feet or carried in the sled
- one operational cook stove and pot capable of boiling at least three gallons of water
- a veterinarian notebook, to be presented to the veterinarian at each checkpoint
- promotional material provided by the race committee.

Drivers are also required to send "an adequate amount of food" to each checkpoint, for the dogs and for themselves. Mushers don't always feed themselves the most nutritional food, but rarely will they skimp on their dogs' dietary needs. Iditarod dogs may burn up to 11,000 calories per day, so the wise racer feeds them high-energy foods. Nutritional advances are widely recognized as one of the biggest factors in the improved performance and reduced loss of dogs between early Iditarods and today's race to Nome.

Traditional dry dog food doesn't do the job, so mushers depend on specially formulated, high-quality commercial mixes that blend meats, fats, bone meal, and vitamins. Many often supplement the commercial foods with lamb, chicken, beef, fish, liver, seal, or beaver, as well as eggs, chicken fat or lard, and various types of vegetable oils. The key, mushers say, is a diet that's rich in easily digestible meats and fats. Another trend is the increased use of freeze-dried meals because they are unaffected by repeated freezing and thawing, are easy to prepare, and minimize the chance of bacterial contamination. While racing, dogs usually are fed three or four main meals per day as well as several snacks.

Equally important is adequate hydration. "We have learned when, where, and how to water the dogs, before they become dehydrated and exhausted," says veteran DeeDee Jonrowe. Often, a meat-and-fat-rich broth is made; it may also include electrolytes that help satisfy the dogs' appetites and replenish nutrients they've lost. Musher Jerry Austin says dogs' trail drinks can be "like Gatorade for a basketball player."

Though the need for extra food and survival gear is clear, dog booties can be just as critical to a team's well-being, particularly where the trail is hard and icy. Intended to protect the dogs' feet from cuts and abrasions, booties are usually made from synthetics such as polypropylene or fleece because those materials are flexible, breathable, and quick to dry.

The process of booting dogs is one of a musher's least favorite tasks. Hands bundled in mittens or thick gloves don't have nearly enough dexterity to pull on the boots and fasten the velcro straps, so it usually becomes a job for bare hands—which can be tedious and often painful, particularly when temperatures fall into the minus range.

Because they're made of soft material, booties don't last long. They get chewed apart, fall off, or simply wear out after many miles of trail pounding. During the Iditarod, a driver may go through 1,500 booties. At a cost of 50 cents or more per bootie, that's a sizable investment. Despite the aggravations and the cost, most mushers take the time to properly boot their dogs when conditions call for it. Bill Chisholm, a veteran dog driver from Two Rivers, Alaska, once explained: "Twenty minutes here, 20 minutes there, it eats you up. But for what those dogs do for us, day in and day out, it's a delight [to care for their feet]. All my dogs are my buddies. They kind of like it when I put their shoes on."

A strange piece of mandatory gear is the promotional material, also known as the "official Iditarod cachet." A small package weighing up to five pounds, the cachet is filled with envelopes, to be postmarked in Nome. Symbolic of the mail that mushers delivered along the Iditarod Trail during the early 1900s, it has been a race tradition since 1974. Envelopes delivered by the top two finishers are auctioned off at the post-race banquet to raise money for the race; others are sold throughout the year.

The mandatory gear is just a small portion of what mushers carry on the sleds. Other necessities include a stove-cooker and fuel, extra clothing

and boots, a headlamp and batteries, first-aid kits, and repair equipment—just about anything you'd take on a ten-day to two-week winter camping trip, with the notable exception of a tent. Most mushers simply curl up inside their sled bags to sleep, though some carry a bivy sack.

Packing the sled is a difficult balancing act but one that becomes considerably easier with experience. The key is to go as light as possible without scrimping on critical items. Every pound of unused gear will needlessly add to the dogs' burden. On the other hand, too much "weight shaving" can lead to disaster. For the 1990 race, Lesley Ann Monk made a dubious packing decision: She left the starting line with only one pair of boots, which weren't waterproof. Less than 100 miles from Anchorage, Monk suffered the consequences. Caught in overflow, she soaked her boots. With her feet wet and cold, the British racer chose not to risk frostbite. Frustrated and humbled, she drove to the nearest checkpoint and dropped out of the race.

Not everything is hauled by sled. Prior to the race, food is flown to checkpoints. Many mushers will also ship out extra booties, headlamps, batteries, tools, and sled parts. Some will even have extra sleds waiting at strategic sites (no more than two may be shipped beyond Wasilla); for instance, a fast, lightweight model may be delivered to Unalakleet for the final 270-mile dash to Nome.

Iditarod. But afterward, we're back to being good friends." As evidence of their friendship, Butcher even chose Swenson as her "bridesmaid" when she married Dave Monson in 1985, and Swenson's wife Kathy baked the wedding cake.

But during the late 1980s, the onetime neighbors became separated by physical as well as emotional distance. Swenson moved from Eureka to Two Rivers, located much closer to Fairbanks, and the two bickered publicly. Some suggested that Swenson couldn't stand Butcher's success or her favored image with the public and press. Rick and Susan tended to shrug off their strained relationship, however, saying it was only natural they'd be cool to each other, given their competitive makeups.

In 1991 their relationship took another curious turn. The intensity of their rivalry had perhaps been never greater, as each attempted to be the first Iditarod musher to win a fifth championship. At Elim, only 101 miles from Nome, Butcher was in first place, an hour ahead of Swenson, and appeared to own an insurmountable lead. But in a classic example of Yogi Berra's famous line "It ain't over 'till it's over," a Bering Sea storm turned things upside down, in one of the most stunning endings ever to an Iditarod race.

Butcher was the first to drive her team into the blizzard, followed by Swenson, then Joe Runyan, Tim Osmar (son of 1984 champion Dean Osmar), and Martin Buser. Butcher didn't travel far before getting stopped by whiteout conditions, and Swenson caught his rival only 6 miles out of White Mountain. For a while they traveled together, taking turns in front while searching for trail markers. But eventually their teams got separated by curtains of blowing snow. Alone again, Butcher chose to retreat, expecting Swenson to do the same. Runyan and Osmar too returned to White Mountain. Unaware that the other teams had turned back, Swenson led his team slowly toward Nome. After hours of miserably harsh walking through fierce winds and blinding snow, he reached a shelter cabin in the Topkok Hills. While he was there, a snowmachiner arrived. Shocked to see Swenson, he reported Butcher's retreat.

Uncertain whether anyone else might be pursuing him, Swenson waited at the cabin only until his team was rested, then plunged back into the storm to continue his slow and painfully cold push toward Nome. Competitively, his decision proved to be a wise one; only two hours after Swenson's departure, Martin Buser arrived at the same cabin.

Born in Switzerland, Buser was a veteran of seven previous Iditarods and a top-ten

finisher in the four previous races, including a personal-best third-place showing in 1988. He, like Swenson, had thrown caution to the winds and gone for broke, realizing this might be his best chance to win. Dressed in a white wind suit that he called his "stealth gear," Buser pushed hard, hoping his team might catch Swenson unaware.

As the hours passed, worries grew about both mushers. They could easily lose the trail, get sidetracked, take a wrong turn. Once lost, they might not be found for days if the storm persisted. How long could they survive in such numbing cold, with limited food and fuel? Joe May's warning that "somebody's going to buy it in this race" echoed through the blizzard. Would Swenson be the one to "buy it"? Or Buser? Or both?

Concerns eased when Swenson reached Safety, followed a couple of hours later by Buser. Nine years after his fourth win, Swenson triumphantly drove his team into

Susan Butcher, shown here leaving the restart line in 1983 from Settler's Bay in Wasilla.

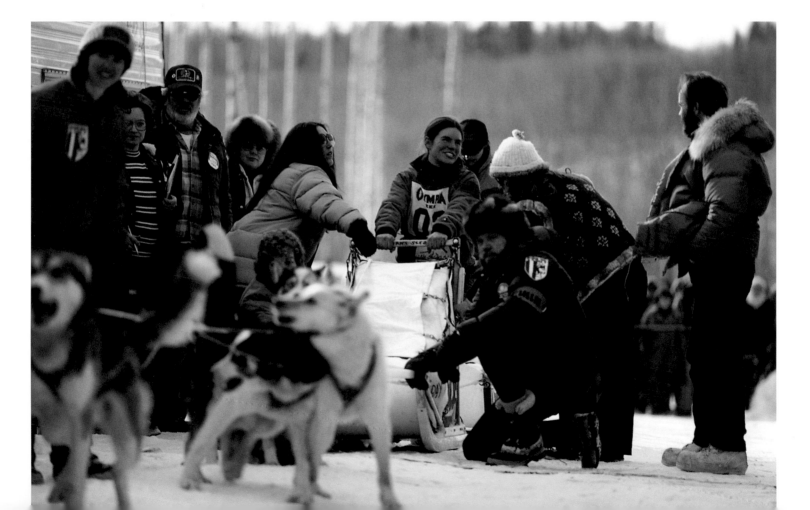

Nome to claim his fifth crown in the slowest winning time since Riddles's 18-day saga six years earlier—12 days, 16 hours, 34 minutes.

At the finish line, Swenson jokingly commented, "Maybe [Butcher] has gotten soft after she got a few victories under her belt. She'll have to win six if she wants to be top dog now." Yet he went on to say, "We've known each other a long time. I have a lot of respect for Susan."

Butcher's disappointment was understandable. After leading most of the race, she had to settle for third. Asked about her reaction to Swenson's win, she told reporters, "I'm very, very, very happy for Rick. As a friend watching a friend win, I feel terrific. But as a four-time winner watching another four-time winner take a fifth—when in every other circumstance the race was mine—I don't feel good about it." Upon reaching Nome, Butcher hugged Swenson in front of television cameras and presented him with a bottle of champagne.

Undeniably the world's best musher, Rick Swenson is the only five-time champion of the Iditarod.

No one suspected it then, but 1991 marked the passing of an era: Susan Butcher's reign was coming to a close. Her teams would continue to rank among the Iditarod's top contenders for a few more years, but her championship streak had run its course.

The end of the Iditarod's second decade would thus mark a significant changing of the guard. Swenson and Butcher, who in turns had dominated the race for 15 years, would give way in the 1990s to a trio of new champions. The first of those was Martin Buser.

Buser's path to Iditarod stardom began in Europe, when as a Swiss teenager he became fascinated by sled dogs. Moving from Zurich to Big Lake, Alaska, in the late '70s, he worked initially with the Siberian huskies of Earl and Natalie Norris. Running Siberians as an Iditarod rookie, he placed 22nd in 1980; the following year his team finished 19th. Then came a five-year hiatus, as Buser experimented with a new breeding program, in which he incorporated the sprint-dog lines of such fabled Alaskan mushers as Gareth Wright and George Attla. The program began to pay dividends in 1987, when Buser cracked the top ten with his new line of mixed-breed Alaskan huskies. That was one critical turning point. The other was 1991.

Buoyed by his runner-up finish that year—and particularly his team's hard-fought passage through the coastal blizzard—Buser entered the 1992 Iditarod with new

confidence in his dogs. They had proven themselves to be both fast and tough, able to cope with the harshest sort of late-winter weather Alaska might toss their way.

Battling deep snow for much of the 1992 race's first 300 miles, the front-running pack moved slowly until they reached the Interior. Buser stayed within striking distance of the leaders until the Yukon River, then made his move. Upon reaching the coast, Buser owned a six-hour lead over the nearest competitor, Susan Butcher. Refusing to concede, Butcher and her team narrowed the margin to three hours at Koyuk, 123 miles from Nome. But by the time they reached Front Street, Buser's dogs had widened their lead to more than ten hours. Led by D2, Dave, and Tyrone, they also shattered Butcher's two-year-old speed record by more than six hours—a remarkable feat, given heavy snowfalls early in the race. For the first time, an Iditarod team posted a sub-11-day time: 10 days, 19 hours, 17 minutes.

Among the keys to this record-setting victory: happy dogs. "I work on keeping my attitude and the dogs' attitude as positive as possible," Buser explained. "Happy dogs perform better and make racing more fun. When it stops being fun, I'll quit."

Though Buser's victory portended changes in the Iditarod's uppermost ranks, it also continued a disconcerting trend that had begun with Swenson and been carried on by the likes of Butcher, Rick Mackey, and Joe Runyan: the dominance of full-time professional mushers who live along the road system. Since Emmitt Peters's victory in 1975, only one rural village musher—Libby Riddles in 1985—had captured an Iditarod title.

Since the early 1980s, it had become harder and harder for rural mushers to compete for the championship—or even a share of the purse—and most Native Alaskan racers also lived in "the bush." Peters was among those to discover this hard truth. From 1975 to 1985, he'd never finished lower than 19th, and six times he'd placed in the top five. After four years away, the Yukon Fox had returned in 1990 but could place no better than 41st out of 61 finishers. Once a champion, he'd plummeted to middle-of-the-pack status. While passing through the Ruby checkpoint (which was also his home that year), Peters admitted it was the low point of his racing career.

"It's kind of hard to sit back and watch the big boys get away. But I've got to face it," he said with some sadness. "I won with seven dogs, but that was back in the '70s. There's a different quality of teams now. My dogs are too big. Too slow. You've got to have greyhound dogs now. You've got to have speed."

An unidentifiable volunteer braves a fierce wind chill to direct traffic during the Wasilla restart in 1999. Volunteers such as this are truly the unsung heroes of Iditarod, as the race literally would not be able to function without them.

Having money—and corporate sponsorships—also helps. All other things being equal, it's more expensive for rural mushers to compete in the Iditarod because dog food and racing gear used in the Iditarod must be shipped to Anchorage and food must then be reshipped to checkpoints. That's a major expense for rural residents living off the road system, far from town. Yet mushers living in the bush also find it much more difficult to attract sponsors, to help pay the bills. To complicate matters further, rural mushers who must hunt, trap, and fish for their living cannot spend as much time training dogs or breeding them. Their kennels—and thus their talent pools—are much smaller than those of full-time racers, who might have 70 to 150 dogs to pick from.

Anvik's Ken Chase saw signs of "a separation" into haves and have-nots even in the late 1970s. An Athabascan Indian, Chase was one of the Iditarod's pioneering mushers; he ran every race from 1973 to 1983, and through 1979 he routinely finished in the top 20, with a personal best of fourth in 1978. He did this while maintaining a kennel of 14 or 15 trapline dogs. As more and more "roadside" racers began to build large kennels and devote increased time to training and year-round dog care, their separation from rural mushers widened into an almost insurmountable gulf.

"It was frustrating," Chase admits. "A village guy like me simply couldn't make a living running dogs full time. You started to see a lot of village racers dropping out; they couldn't afford to compete in the Iditarod any more."

In 1974, nearly half the top 20 finishers were rural Native mushers, including the top four placers. From the mid-1980s through the early 1990s, Inupiat Joe Garnie was the only Native Alaskan to consistently crack the top 20. In 1991, not one Native entrant shared in the Iditarod's winnings; a year later, Garnie barely did.

In the end, it all came down to economics. Martin Buser earned $51,600 for his 1992 victory, more than the entire purse had been in 1973. As the stakes increased, so did the price of competing. "Money is what changed things," says Jerry Austin of the tiny rural village St. Michael. "It become more and more expensive and time consuming for someone to compete. I'm not saying that's necessarily a bad thing. It almost seems like the natural progression of a sport."

In that progression, rural Native villagers had been left behind.

Susan Butcher and Rick Swenson hug on stage during the award ceremony in Nome at the end of the 1989 race. Rick had just told the crowd that he wanted to call a "truce" to what many knew was a feud between the two.

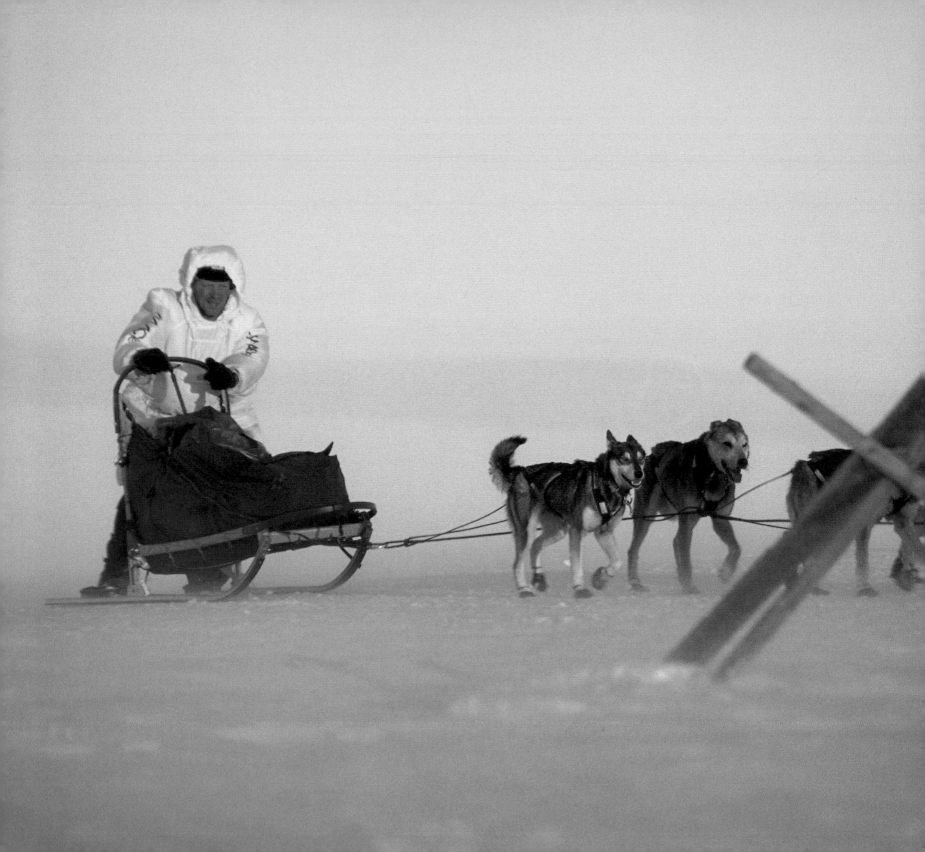

PUSHING THE ENVELOPE

LEFT *Paul Gebhart is bundled in his warmest gear and wind break as he braves a 30 mile an hour wind and crests the top of "Little McKinley," between Elim and Golovin on the Bering Sea coast to take second place in the 2000 race.*

ABOVE *Dr Jim Lanier's dogs run down the trail in the 1999 race. They are wearing coats made of cool, white, sun-reflective cotton which prevent overheating by reflecting the warm sun rays off the dogs' darker fur.*

By the start of its third decade, the Iditarod Trail Sled Dog Race had evolved radically. No longer an adventure into the unknown, it was now a highly competitive event involving dogs bred as much for speed as for long-distance stamina. Both front-runners and rear-enders were traveling ever faster across Alaska, thanks to improved trail conditions, year-round training regimens, and nutritional and technological advances. Weather, too, favored the mushers and dogs, with a string of relatively mild and storm-free runs, at least for the lead pack. A 20-day march through the wilderness in its earliest years for even the fastest teams, the Iditarod would become a 9-day race before the decade had ended, an unimaginable time just ten years earlier. Even the slowest teams were now reaching Nome in well under 20 days. In the 2000 Iditarod, for instance, last-place finisher Fedor Konyukhov posted a time of 15 days, 5 hours, 44 minutes—a time that would have been good enough to win six of the first thirteen Iditarods.

Many present and former racers say the Iditarod's quickened pace begins with the trail itself. "It's a race track now; a highway," says Wasilla resident Lavon Barve, who ran his 14th and last Iditarod in 1997, with a personal best of third in 1990. "The trail

is well marked from end to end, and it's groomed and hard-packed. You don't see teams searching for the trail, or wallowing around in the snow like we used to."

Denali Park's Jeff King compares the trail's improvement to that of the Alaska Highway: "Back in 1956, getting to Alaska from Seattle was a week-long project. Now you can do it in one and a half days. Same with the Iditarod. Our 'road' is smoother and firmer, so it's easier on the teams. And many of the obstacles have been eliminated; for instance, now there are bridges across many of the creeks that used to be a real problem."

A hard, fast, and reliable trail has made it possible for racers to breed and train their dogs for long-distance speed. Lots of attention has been given to the "modern" sled dogs bred by King, Martin Buser, and other top contenders. Yet some mushers who've raced in all three decades insist Iditarod dogs aren't much different now than in the earliest races, except for how they're being trained. "The basic build of the dogs is the same," says Bill Cotter of Nenana, who's competed in more than a dozen Iditarods including the 1975 and 2001 races. "Look at some of the guys who ran in the early races: George Attla, Isaac Okleasik, Joee Redington (son of Joe Redington, Sr.), Dick Mackey were all people who'd competed in sprint races. Their fastest dogs were just as fast as those of today. There just weren't as many of them. What's different is how the dogs are being trained. It's become much more specialized."

King agrees that depth of talent is the biggest difference in team performance. And that's where breeding comes into play. As the overall quality of dogs has improved, so have team speeds. King estimates that speeds are 10 to 15 percent faster now than in his rookie year, 1981. Though hardly noticeable to the average mushing fan it's "a quantum leap" when projected over 1,100 miles of trail.

Technology, too, has made a difference. Lighter sleds, reliable headlamps, more efficient cooking equipment, lightweight clothing and gear, freeze-dried foods, and longer-lasting, easy-to-change booties have all eased musher's work loads. At the same time, racers have become more efficient when feeding, resting, and caring for their dogs. Just as important as the advanced technology, if not more so, is improved nutrition. Using a blend of fatty foods and oils, mushers now feed their dogs high-calorie diets that make them, as DeeDee Jonrowe puts it, "highly-fueled racing machines" that run faster, longer.

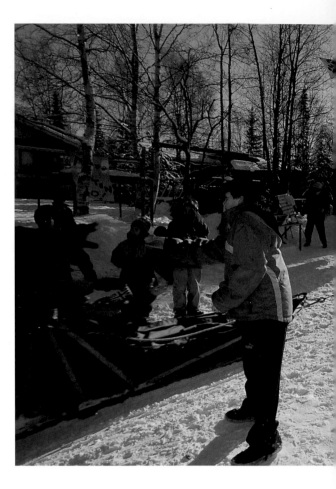

Gunnar Knapp blows his trumpet to signal another musher arriving at the unofficial "muffin checkpoint" at Mile 4 in Anchorage, where the trail runs right behind the Knapp's home. The family has an annual ritual of greeting each passing musher with a hot muffin.

The end result of all these variables: ever faster and more efficient teams. And, barring major storms—which can disrupt the best-laid plans and strategies—ever quicker passages across Alaska.

Given the enormous advances over the past 10 to 15 years—in gear, racing technology, trail grooming, communication links along the trail, veterinary care, dog breeding and training—there's little question that today's Iditarod is a safer race for both dogs and mushers. Yet any team traveling 1,100 miles across Alaska in winter may still face an array of potentially deadly dangers. And racers still get into trouble. As veteran race manager Jack Niggemyer told a reporter in the late 1990s, "Every year I've had to institute three or four searches for mushers." In some of those instances, mushers wouldn't have survived without others' help. Case in point: Bob Ernisse.

An Iditarod rookie from Anchorage, Ernisse in 1992 got caught in a Norton Sound coastal ground blizzard while passing through the area locally known as the Solomon Blow Hole. Hindered by near-zero visibility, fierce gales, wind-chill temperatures to minus 50 degrees or colder, and tangled dogs, Ernisse and two other mushers stopped for the night. Exhausted, chilled, and wearing wet outer layers, Ernisse had to be stripped down to his polypropylene long johns and helped into his sled by Bob Hickel and Debbie Corral. Unfortunately, the zippers on both his sleeping bag and his sled bag were partly frozen, making it impossible to completely protect Ernisse from the wind and snow. After a long and bitterly cold night, he woke the next morning and tried to get on his feet—but couldn't. "I needed to get some more layers on, but I couldn't do anything," he said later. "My hands were frozen. But what scared me most was that I couldn't even stand."

Fearing for his life, Ernisse shouted to Hickel, 25 feet away. In 50-mph winds, Hickel helped Ernisse into his (mostly frozen) outer layers, a grueling process that took more than an hour. As they were finishing, a local musher named Robin Thomas happened to come by. Thomas carried Ernisse to the Safety checkpoint; from there he was rushed by motor vehicle to Nome's hospital and treated for severe hypothermia and frostbitten hands. Afterward, Ernisse had no doubts: "Bob saved my life. If he hadn't helped me, I don't know . . . "

Other recent incidents emphasize the ever-present dangers, both known and

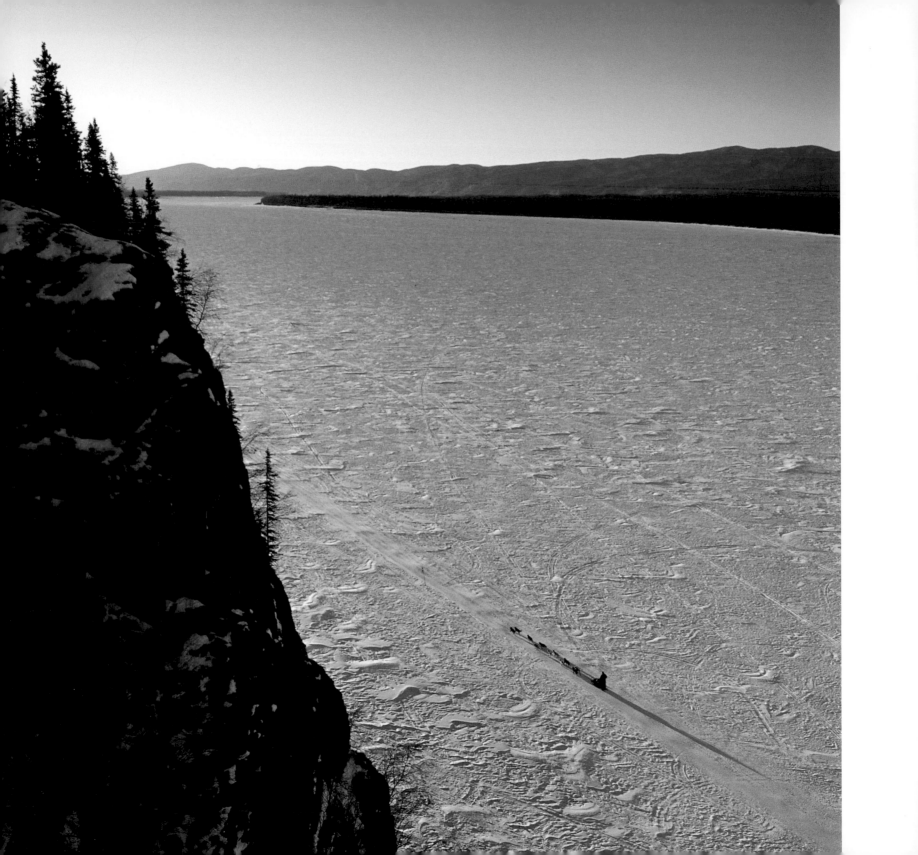

unsuspected. In the mid-1990s, Chugiak physician Beth Baker lost her bearings during a coastal storm and ended up on the sea ice miles from the marked inland trail, where, after a difficult night, she eventually was spotted by a plane and rescued by snowmachiners. She, like Ernisse, suffered frostbitten hands. That same year, five mushers were nearly asphyxiated while resting early in the race inside an airtight tent along the trail.

There are lots of stories out there, some of which have escaped public attention. The more you hear, the more you realize how remarkable it is that no one has died while racing the Iditarod. Even in this high-tech era of ever-faster races, you begin to wonder—like some of the longtime veterans—whether it's only a matter of time.

At the same time it was speeding up, the Iditarod, in its third decade, was becoming ever more competitive. Racers and officials now routinely agreed that 30 or more teams were capable of finishing in the top 20 and that between 10 and 15 entrants were potential winners. Perhaps. But if the Iditarod's talent pool was in fact deepening and broadening, only an elite few would ascend to the race throne. Three mushers would dominate this third decade of mushing: Martin Buser, Jeff King, and Doug Swingley. By the end of the decade, Swingley would build a string of victories that challenged Swenson and Butcher's status as the most dominant racers in Iditarod history. Buser had already shown he had the right stuff, outdueling four-time champion Susan Butcher to win the 1992 race. Nineteen ninety-three would be King's turn.

King had come north from California in 1975 to find adventure. Settling near Denali National Park, he quickly carved out a living that is the stuff of Alaska legend: a trapper, self-employed plumber, contractor, "art critic," chief of the McKinley Volunteer Fire Department—and, eventually, champion musher. He began running dogs and building a kennel soon after his arrival, at first using the dogs primarily for work: running a trapline and hauling freight. But his motivations quickly changed after he placed third in a 140-mile race.

By 1981, King was ready to try the Iditarod. His 28th-place finish, though decent for a rookie, garnered no special attention. He then took a decade-long break from the Iditarod, but continued to race and build his kennel; by 1991, he'd won several races, including the 1989 Yukon Quest. Returning to the Iditarod, he placed 12th. In 1992,

LEFT *Linwood Fiedler runs on the Yukon River shortly after leaving the village of Ruby. The Yukon is the longest river in Alaska.*

ABOVE *Jeff King, at sunset in Tokotna in 2001.*

he jumped to sixth. King had now joined the ranks of top contenders. But as the 1993 race began, he still hadn't attained "musher to beat" status.

King hung with the lead pack from day one, but he didn't gain special notice until reaching the ghost town of Iditarod, 566 miles from the start. Pulling ahead of Buser, the defending champion, King won the race's halfway prize, $3,000 in silver nuggets. He then scoffed at a legendary Iditarod jinx: in 20 years, only one musher—Dean . Osmar, in 1984—had captured the midway prize and gone on to win the race.

Halfway to Nome, the race leaders—a group that included King, Buser, Butcher, Rick Swenson, Rick Mackey, and DeeDee Jonrowe—were on record pace. Clear and calm skies continued to bless them as they reached the Yukon River. But on their run up the Yukon, unseasonably warm weather began to slow the pace.

As the race reached Unalakleet, the lead pack had shrunk to three: King, Jonrowe, Mackey. Over the next 184 miles, King and Jonrowe steadily increased their advantage over Mackey. Surprisingly, the Iditarod had become a two-team affair involving mushers who'd never finished higher than fourth (Jonrowe's previous best, in 1989).

That Jonrowe would be challenging for the victory was nothing less than remarkable. The veteran musher from Willow had entered her 11th Iditarod with a banged-up body: a damaged left knee required a brace, and her right hand was still tender from recent surgery, sometimes making it difficult for her to grip the sled handle. Knowing the limits imposed by her injuries, Jonrowe aimed only for a top-ten finish. But once the race began, she pushed aside her pain and remained at or near the front of the pack throughout the entire race.

At White Mountain, with 77 miles to go, King owned a seven-minute lead over Jonrowe. After the mandatory rest stop, he readied his team—now down to a dozen of his strongest, most reliable dogs—for the stretch run. But before leaving, he walked over to his rival, gave her a hug, and said, "See you in Nome." Shortly after, Jonrowe renewed her chase.

Toward Nome they drove, always within sight of each other: King's team unable to pull away, Jonrowe's never quite able to catch up. In the final miles, again blessed by clear skies and calm, cold weather, King's dogs proved just a bit stronger. Led by Kitty and Herbie, his team slowly but steadily widened its advantage, finally crossing the Front Street finish line 31½ minutes ahead of Jonrowe's—the fourth-closest Iditarod finish ever.

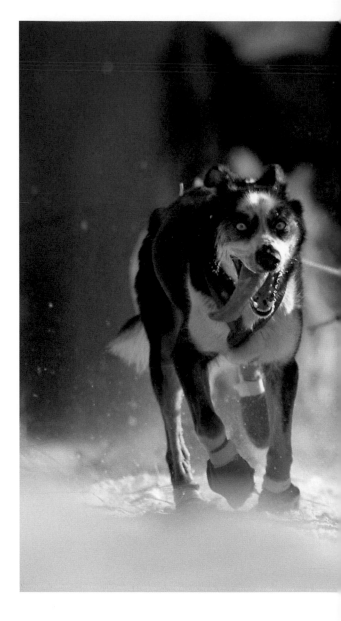

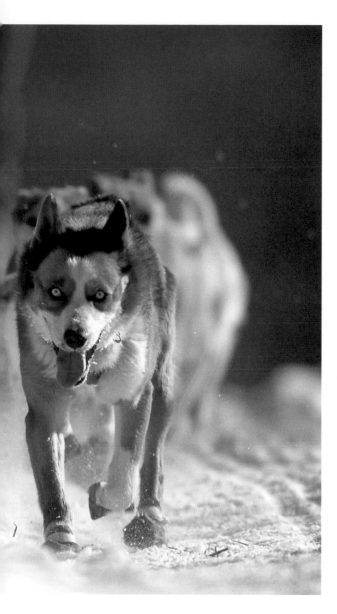

King's 12:30 a.m. arrival marked the end of a near-perfect ride into the record books. His time of 10 days, 15 hours, 38 minutes sliced more than 3½ hours off Buser's year-old speed record. (Jonrowe and Mackey also beat that record.) For his efforts, King earned $50,000 and the title of champion. Jonrowe was already a crowd favorite, and her perseverance in the face of nagging injuries earned her the Most Inspirational Musher Award and the respect of race fans everywhere.

King's reign, and his speed record, would last only a year. After settling for sixth place in 1993, Martin Buser rebounded in '94 with his second title in three years and yet another record-breaking run to Nome. Buser's winning time of 10 days, 13 hours, 2 minutes trimmed nearly 2½ hours off King's one-year-old mark. With the Iditarod's record time falling for the third straight year, everyone associated with the race—mushers, officials, media, and fans—openly wondered: How low can it go? Nine days? Eight? Buser, for one, had no doubts: "I think it can be done faster," he said after crossing the finish line. "A lot faster."

Buser had reason to be confident. He'd set a new record despite an unusual—and unscheduled—25-hour "layover" at the start of the race. Lack of snow in Anchorage and Wasilla forced organizers to reshape the Saturday start into a ceremonial affair. By tradition, full teams had always raced 20 miles from Anchorage to Eagle River Saturday morning and then had been transported by truck to Wasilla for an afternoon restart. But 1994's 58 entrants were allowed to harness only six dogs and run them only 15 blocks through downtown Anchorage. Then they had to wait for a revamped Sunday restart in Willow, about 70 miles north. All that time, the race clock was ticking, with about 25 hours added to each team's time by the restart.

Once more blessed by ideal racing conditions—a hard-packed trail and mostly calm, clear weather—Buser outraced 1978 champion Rick Mackey to join Swenson and Butcher as the only mushers to win the Iditarod more than once. For his part, Swenson finished fourth, marking the 19th straight time he'd cracked the top ten. No one else comes close. Butcher, meanwhile, dropped to 10th, her lowest finish (not counting the 1985 scratch) since her rookie year of 1978, when she'd placed 19th. But what really ruined her race was the death of a dog from a heart attack—the only dog to die in the 1994 Iditarod.

After her dog's death, Butcher seriously considered dropping out, but finally

decided to run the best race possible, given the circumstances. At the awards banquet following the race, Butcher announced she was quitting the Iditarod. Maybe for a year or two. Maybe forever. Without immediately explaining why, the four-time champion simply said that she and husband David Monson were "ready to explore life beyond this race." Later, she confided her desire to begin raising a family. Fourteen months later she would give birth to a daughter, Margarethe. She and Monson still run a kennel, but Butcher has remained in "retirement."

Though only one dog died in 1994, even that was too many for some Iditarod critics. Not since the race's earliest years had animal-rights groups so vehemently protested the treatment of Iditarod dogs as in the early to mid-1990s. The Iditarod's most vocal enemy was the Washington, D.C.–based Humane Society of the United States. The HSUS made its stance abundantly clear: In a perfect world there would be no Iditarod race.

Led by David Wills, its vice president for investigations, the Humane Society threatened to organize boycotts of the Iditarod's corporate sponsors and successfully lobbied race organizers to change several rules. Under pressure, the Iditarod Trail Committee during the mid-1990s increased the mandatory rest time for dogs; reduced maximum team sizes from 20 to 16 dogs; required straw for every dog to use while resting at each checkpoint; and instituted new and harsher penalties for any mushers whose dogs died along the trail, no matter what the reason. In 1993 the HSUS was also given a seat on the ITC and veto power over the choice of the race's chief veterinarian. Many Alaskans angrily protested these concessions, arguing that race organizers were coddling an enemy whose ultimate goal was to end the event.

As the Humane Society ratcheted up the pressure, several of the Iditarod's key sponsors dropped their support, and a national television network decided not to renew its contract. With the race's future in jeopardy, new executive director Stan Hooley and ITC president Matt Desalernos (himself a musher) began a successful campaign to enlist in-state sponsors and also began a membership drive that doubled the ranks of paying Iditarod supporters. Officials also won the legislature's permission to run a fund-raising lottery. And they began a hugely popular "Iditaride" program.

The Iditarod's strained relationship with the HSUS abruptly ended when Wills,

PAGE 114/115 *"Margaret" and "Blue," lead dogs leased to Max Hall by Doug Swingley, head down the trail on the start day of the Iditarod in 1999.*

BELOW *Doug Swingley poses with his lead dogs "Stormy" and "Peppy" shortly after completing his fourth win and third in a row in 2001.*

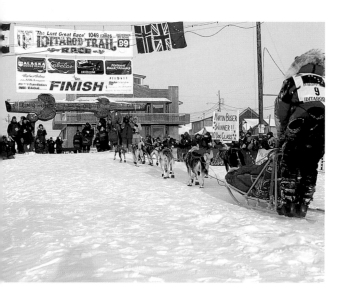

Martin Buser is about to cross under the famous burled arch finish line in Nome in 1999. This would be the last year any mushers would cross under the original burled arch built and donated in 1975 by Red Fox Olsen. In the summer of 1999 the arch fell apart from dry rot and was replaced before the next Iditarod by another donated burled arch.

interviewed on national TV, again condemned the race after Butcher's dog died. (Butcher, ironically, had been touted as the ideal role model for mushers before that death.) Not only did the HSUS lose its seat on the board, it also lost all influence on how the race is run.

Controversies over dog deaths didn't end there, however. In 1995 race organizers were widely criticized, even in Alaska, when they delayed reporting a dog death. Again under fire, the ITC enacted a new "dead dog rule." With limited exceptions, mushers would automatically be removed from the race if one or more of their dogs died, even if the death were beyond the driver's control.

As fate would have it, Rick Swenson was the first musher to be "withdrawn" under the new rule. Less than one full day into the 1996 race, Swenson pulled into the Skwentna checkpoint with a dead dog—the first he had ever lost in 21 years of running the Iditarod. A three-year-old female, she had died as the team was slogging through a long stretch of overflow on the Yentna River. Upon learning details of the death, race officials told Swenson he must withdraw, based on their interpretation of Rule 18, the new dead dog rule. The decision was extremely unpopular with both mushers and the public. Fans sent bundles of letters and jammed Iditarod phone lines in protest. Racers, meanwhile, voted Swenson Most Inspirational Musher at the Iditarod's post-race banquet. Swenson would eventually appeal the withdrawal, and a special board reversed the ruling. Vindicated, Swenson nevertheless swore he would never again enter the Iditarod. To many Alaskans' delight, he changed his mind after a year's absence and finished 11th in 1998.

The Swenson incident prompted race organizers to change the rule on dog deaths yet again. The "rule on expired dogs" now stipulates that mushers will not be penalized if the cause of death cannot be determined; is due to circumstances, trail conditions, or some other force beyond the musher's control; or is from some unpreventable or previously undiagnosed medical condition.

As if Butcher's retirement, the Humane Society's attacks, and Swenson's removal weren't enough to shake things up, the tumultuous 1990s marked the unprecedented ascendance of—shudder—an Outside musher to Iditarod prominence.

Montanan Doug Swingley served immediate notice of his talents and desire in

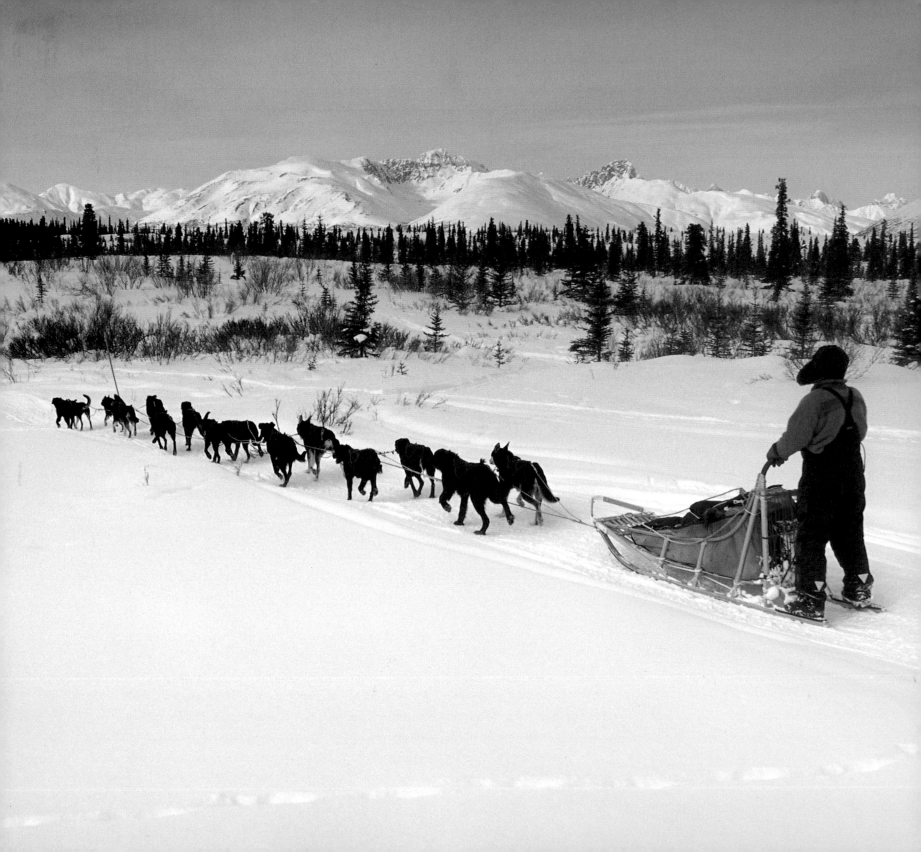

LEFT *1976 champion Jerry Riley of Nenana runs his team during the 2000 race along the trail nearing the Rainy Pass checkpoint, the Alaska Range in the background. Part Alaskan Native, Riley ran his first race in 1974 and continues to run today.*

ABOVE *Ramy Brooks is son of champion sprint musher Roxy Wright and a grandson of the legendary musher Gareth Wright.*

1992, with a ninth-place finish—the best rookie performance since Harry Sutherland took third in 1976. Not bad for a musher who didn't begin racing, or building a competitive kennel, until 1989. His first team, he once recalled, was "a mishmash of dogs," some of them from the pound.

Both during and after his rookie race, Swingley made one point very clear: he wasn't in the Iditarod to be a top-ten finisher. He planned to win the thing, and the sooner the better. Ninth place was both disappointing and encouraging.

Swingley rose steadily in the standings—from ninth, to seventh, to sixth. But in 1995, as media analysts, race fans, and other Iditarod "experts" engaged in their usual pre-race prognostications, few mentioned him as a serious threat to unseat Buser. Swingley, after all, was an Outsider. And no non-Alaskan had ever won the Iditarod; in fact, none had come close since Larry "Cowboy" Smith finished third in 1983. Many race aficionados believed it would never happen.

Swingley, however, didn't give a hoot for the prevailing wisdom. Leaving the Anchorage starting line, he felt sure this would be his year. Turns out he—and not the experts—was right. Not only did Swingley win the Iditarod, he absolutely shattered its speed record, chopping nearly a day and a half off Buser's year-old mark with a time of 9 days, 2 hours, 42 minutes. Part of the difference could be attributed to a change in the race structure that year: Mushers were timed from Wasilla, not from Anchorage as in previous years. But even without that advantage, Swingley's Montana dogs would have slashed the record. For the first time ever, a team had averaged 10 miles per hour over the length of the race.

Swingley made his move early. He challenged prevailing wisdom by driving his team all the way to Iditarod, the race's midway point, before taking his 24-hour layover. Others questioned the Montana musher's strategy, given the unseasonably warm weather, which is harder on the dogs, because they're more likely to overheat. "To me, it's still not time to be racing," said Rick Swenson, as usual one of the favorites to win. "If they want to burn out their dogs, that's fine with me."

Swingley's team was running fast and strong, however, so he saw no reason to take his 24-hour stop earlier. And because Iditarod is a ghost town with few distractions, his dogs would be sure to get a good rest there. "This was my 'A' plan," he told reporters. "My dogs will be fresher going up the Yukon."

Race history seemed to favor the contenders who'd hung back. Only twice in 22 previous Iditarods had the halfway winners gone on to victory. And only once—in 1975, when Emmitt Peters won the race—had an eventual champion driven his team so many miles before taking the mandatory 24-hour layover. But as Swingley told the press, "Championships are based on certain things; mine is based on making Rick eat his words."

All eyes now focused on Swingley. Fans and racers alike wondered whether he'd be caught and passed—as had happened in 1992, when he and 1989 crown-holder Joe Runyan had tried a similar strategy. The duo had pushed all the way to Ruby (653 miles from Anchorage) before taking their 24. Runyan eventually scratched, while Swingley faded to 20th before surging back to 9th. The general consensus was that they'd driven their dogs too far, pushed them too hard, before taking their mandatory rest.

This time Swingley's team stayed in front, sparked by its leader, Elmer. He reached the Bering Sea coast—only 261 miles from Nome—with a three-hour lead. As his team moved down the coast at a record-setting pace, it became clear that only a coastal storm or a grave tactical error could stop him. But the weather continued to be an ally. Under clear skies, on hard-packed and well-marked trails, the Montana team continued its march into the Iditarod record books. At 42 minutes past noon on March 14, Doug Swingley's dogs forever silenced those who'd claimed an Outsider couldn't win the Iditarod.

Alaskan Native musher Johnny Baker of Kotzebue.

With a swagger—some called it arrogance—that reminded many people of Swenson in his earlier, dominant days, Swingley boldly predicted that his team would be the one to beat for years to come. After all, he'd won with a young group of dogs, just entering their prime. Barring some calamity, his teams should only get better. But Swingley's brash talk was muted in 1996, as Jeff King dethroned the Outsider to win his second Iditarod title. The victory was especially sweet to locals, who interpreted Swingley's bravado as arrogance. Greeted in Nome by thousands of cheering fans, King told the boisterous gathering, "It's nice to have the trophy back in Alaska." The crowd roared its agreement.

For the first time in five years, no speed records were set. Still, it was clear that speed, every bit as much as endurance, stamina, and dog care, remained the name of

the Iditarod game. King's finishing team of seven dogs reached Nome after 9 days, 5 hours, 43 minutes on the trail, the second-fastest time ever. Swingley didn't exactly turn in a shabby performance either; his dogs posted the third-fastest time in Iditarod history, 9:8:31.

Both runner-up Swingley and third-place finisher Buser credited King with a smart race. King, they said, had been patient and not driven his team too hard early on, when Swingley and Buser had pushed the pace. King agreed. "I really had to step back," he told a reporter, "and say 'I've got to run my own race.' " Perhaps because of

Martin Buser's team screams down the trail just a few miles into the 1999 race after leaving the Willow Restart.

that early decision, King's team remained the strongest down the stretch, while Buser's and Swingley's teams faded.

King, Swingley, and Buser would again sweep the top three spots in 1997, but in reverse order. Buser posted his third Iditarod victory, one more than King. Now clearly among the Iditarod's all-time elite, he moved a notch closer to Butcher's and Swenson's victory totals.

Paced by co-leaders Blondie and Fearless, Buser's team completed the 1,161-mile journey in 9 days, 8 hours, 30 minutes—a personal best and the third-fastest time in race history. The Big Lake musher stormed into the lead as the Iditarod reached the Yukon River and never looked back. As usual, he maintained an upbeat attitude throughout the race, often whistling, singing, or chattering happily with his dogs, whom he called "my kids." After reaching Nome, he stressed to reporters, "It's really about the dogs. I'm just the lucky guy who gets to ride the runners."

Had Buser established an Iditarod dynasty? Not yet. Or at least not in the same way that Swenson and Butcher had during their reign at the top. Buser's three wins were spread over six years. And both King and Swingley had shown equal, if not greater, dominance in their victories. Instead of one preeminent musher, the Iditarod now had three. Consider the evidence: In the six races between 1992 and 1997, Buser, King, and Swingley had accounted for every victory, three runner-up finishes, and three thirds. If you subtract the retired Butcher (runner-up in '92), only Jonrowe and Mackey had seriously challenged for the crown since 1992.

Any remaining doubts that this trio stood a notch above the Iditarod's other contenders were answered in the next four races. First King would match Buser's three-win total with a victory in 1998. As she had five years earlier, Jonrowe came close to beating King, but her team once more came up short, this time by just under three hours.

Next it was Swingley's turn. And he would prove himself to be a huge step above all other racers as the twentieth century gave way to the twenty-first. After runner-up finishes in 1996 and '97, and a sub-par ninth-place showing in '98, the Montanan cruised to wins in 1999, 2000, and 2001, thus joining Swenson and Butcher as the only racers to own at least four Iditarod titles. Elite company indeed. Swingley also tied Butcher's remarkable string of three straight championships, a mark that few experts thought would ever be matched.

During the Anchorage ceremonial start day, rookie musher Sam Maxwell takes a break to allow his "Iditarider," a participant in the "Make a Wish" program, the thrill of running the dogs. Sam's son Jake drives the second sled and carries Sam's good friend and sponsor, Bill Kramer of Industrial Roofing. Sam is the only person in recent Iditarod history to be a volunteer pilot for many years, then a musher, and later a member of the board of directors.

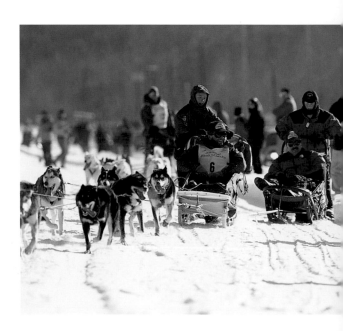

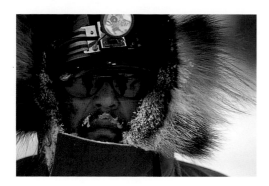

ABOVE *Alaskan Native musher
Mike Williams always mushes with the
"Sobriety" banner.*

PAGE 124/125 *A marvelous sign made of
driftwood welcomes mushers to the Inupiat
Eskimo village of Koyuk in 2000. The 58-
mile trail between Shaktoolik and Koyuk
travels mostly over the flat and barren
Norton Sound. In order to mark a trail each
year, villagers cut holes in the ice and put in
spruce trees every few hundred feet. It was
here in 1985 that Libby Riddles crossed in a
blinding blizzard, with only those spruce
tree markers to show her the trail.*

Though Swenson had earned a reputation for winning the close ones, Swingley's victories were runaways. His winning margins: 6 hours, 2 minutes in 1995; 8 hours, 40 minutes in 1999; 5 hours, 6 minutes in 2000; and 8 hours, 3 minutes in 2001. And as if that weren't impressive enough, Swingley's team set a new Iditarod speed record in 2000, as it came within an hour of the nine-day barrier. The new mark: 9 days, 58 minutes.

Since Buser's breakthrough win in 1992, ten Iditarod championships had been split three ways. This three-part supremacy—and Swingley's emergence as the musher to beat—inevitably raised questions. If the Iditarod's field of contenders was becoming ever deeper and more competitive, as the "experts" insisted, why were Swingley, Buser, and King the only ones to win? And why had Swingley emerged as an unbeatable force?

Swingley, for one, points to desire and commitment: "Jeff, Martin, and I are all extremely motivated guys. We're all extremely competitive, and hate to lose. We're also professionals; we've arranged our lives and paid our dues, so that we're able to commit the time and effort it takes to building a championship team. The breakthrough is once you learn what it takes to win. Look at Swenson. I still consider him a threat, because he knows how to win."

Innovation is another key element. "If you look at the Iditarod's winners, going all the way back, nearly everyone was an innovator in some way," Swingley notes. "It might be in breeding, technology, or race strategy. To get to the top, you have to be constantly searching for new and better ways to do things."

Swingley's record win raised another, familiar question: How much faster can teams go? "We don't really know what the limit is," says Buser. "We're not quite there yet."

Swingley agrees. "I think someday you'll see a seven-and-a-half to eight-day race."

Mushers emphasize that dog speed is only part of the equation. Over the years, drivers have become more efficient when they rest their dogs, which cuts down on their cumulative time. Some racers are also gradually shaving the amount of time dogs are given to rest. By the late 1990s, most competitive Iditarod mushers were routinely running a "6-on, 6-off" schedule: six hours of racing, six hours of rest. Swingley believes the necessary rest for dogs can be shaved by a quarter- to half-hour per stop, and maybe more. But it has to be done in small increments. Over the course of the race, that could amount to a day's saving. There's also the question of how much racers

can push themselves. "How much more can mushers take?" Swingley wonders. "How little sleep can we operate on? There's definitely some point of diminishing returns."

While the "big three" maintained their collective grasp on the Iditarod's top spot throughout the race's third decade, significant changes were occurring lower in the standings during the mid- to late '90s. Perhaps the most welcomed shift was the return of competitive Native mushers to the Iditarod. Mike Williams of Akiak, Ramy Brooks of Fairbanks, and John Baker of Kotzebue spearheaded this small but notable resurgence. After a string of six years in which only one Native Alaskan or none finished among the Iditarod's money winners, Brooks (8th), Baker (11th), and Williams (18th) all cracked the top 20 in 1997. Not since 1983 had so many Native teams earned prize money. And not since Inupiat racer Joe Garnie finished second, third, and fourth during the mid- to late '80s, have Native mushers performed to the level of Brooks and Baker.

Among the youngest of the Iditarod's present-day contenders—he turned 33 in 2001—Brooks comes from a line of championship mushers. Both his grandfather, Gareth Wright, and his mother, Roxy Wright-Champaine, were among the premier "sprint" racers of their generations, with numerous titles between them. Part Athabascan, Brooks spent his early years along the Yukon River and then moved with his family to Fairbanks. A sled ride with Rick Swenson in the early 1980s sparked his interest in the Iditarod. A decade later, he made his own impressive debut: 17th place, good for rookie-of-the-year honors. Brooks has competed in the race six times since, with a personal-best fourth-place showing in 2000—the top performance by a Native racer since Garnie was fourth in 1988. He also captured the thousand-mile Yukon Quest in 1999, to show he knows how to win.

Baker too has been pegged as a musher to watch. An Inupiat Eskimo and a lifelong resident of Northwest Alaska, he recalls that "growing up in rural Alaska, we were either playing basketball or mushing dogs. I took a turn at basketball and even won a couple of gold medals in the Eskimo/Indian Olympics. . . . Now we're going for the gold in the Iditarod."

Baker didn't have gold on his mind in 1996, however. Though a lifelong musher, he'd only recently begun to race sled dogs. He entered the Iditarod as a 32-year-old

rookie, intending to run it one time for the adventure and then get on with other things. "I didn't believe I could be competitive," he says. "But by the end of the race, I was telling myself, 'Heck, I can win this thing someday.' " Although he's been up and down in the race standings, Baker's fifth-place finish in 1998 (in only his third Iditarod), followed by eighth place in 1999 and sixth in 2001, showed his ability to compete with the Iditarod's best.

Also worthy of special mention in this Native renaissance is Jerry Riley. In 2001, at the ripe old mushing age of 64, the 1976 champion and two-time runner-up startled competitors and fans alike by finishing eighth, his best performance since placing fourth in 1979. Though he's admittedly mellowed with age, Riley clearly retains his burning competitive drive—and he's regained the respect of all those associated with the Iditarod.

The success of Brooks, Baker, and Riley doesn't surprise Mike Williams, a Yupik musher and lifelong resident of Akiak, a tiny village in southwest Alaska. "The dogs are in the villages. They're here," he says. "I just don't see a problem putting together a world-class caliber team—except for the money." Williams remembers how he idolized the Native racers who starred in the early Iditarods. Fired by their heroics, he pledged to someday follow in their tracks. Nearly two decades later, at age 39, he became an Iditarod rookie.

Williams finished the 1992 Iditarod near the rear of the pack, in 44th place. But speed wasn't as important to him as the journey. And the opportunity to promote healthy lifestyles, sobriety, and educational opportunities for rural Native Alaskans.

In succeeding years, Williams became a sort of Iditarod evangelist, and his message helped to spark the Native revival of the mid- to late 1990s. He, as much as anyone, continues to push a message of hope: Rural mushers can compete at the very highest levels of mushing, if they're given financial backing like the professionals who live along the road system. Again, it comes down to money. Williams calls it "a shame that top mushers like Joe Garnie can't afford to compete." He and others have pressed Native corporations and their subsidiaries to level the playing field with sponsorships.

Williams, Baker, and others wholeheartedly believe this: Someday, soon, a rural Eskimo or Athabascan musher will join pioneering racers Carl Huntington, Emmitt Peters, and Jerry Riley in the Iditarod's circle of champions.

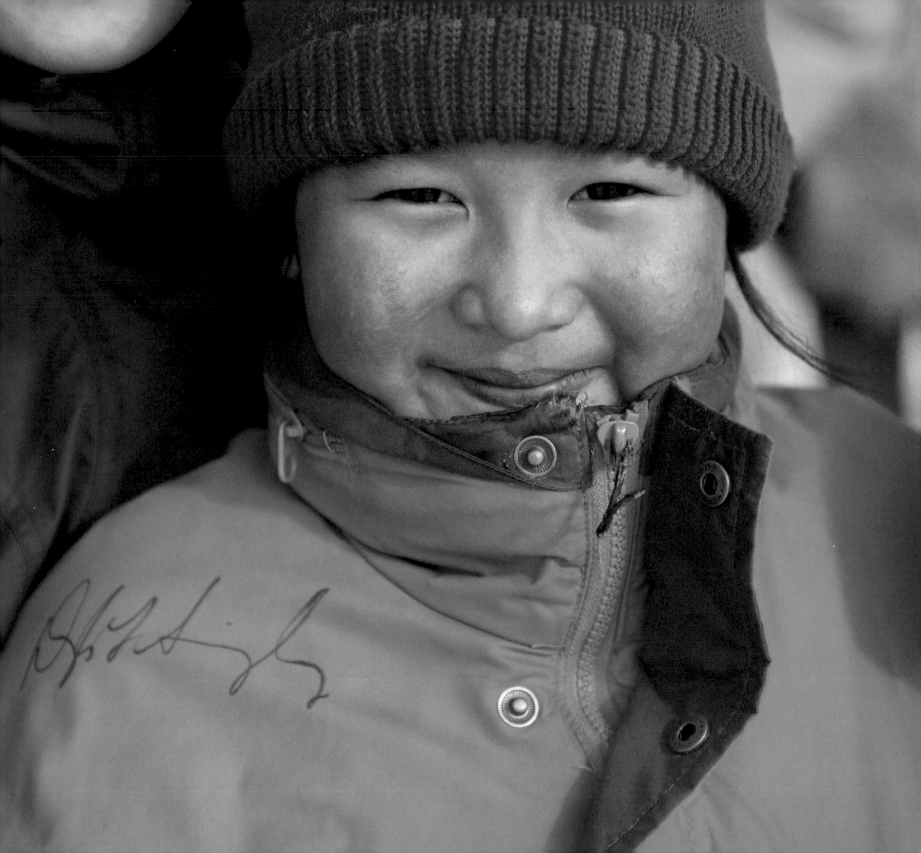

LOOKING TO THE FUTURE

LEFT *A young girl from Shaktoolik displays the fresh autograph of 2001 winner Doug Swingley on the shoulder of her jacket.*

ABOVE *An Iditarod sled dog howls as it waits in the Nome dog lot for transport back home.*

As the Iditarod approaches the end of its third decade and the start of its fourth, the race's future seems bright indeed. Once a stubborn and visionary musher's impossible dream, the Great Race to Nome has become an integral part of the "Alaska mystique." From its controversial beginnings, the Iditarod has grown into—and figures to remain—the world's richest and most famous sled dog race, attracting entrants, and media attention, from around the globe. Not so long ago, the best mushers in the world competed in Alaska's shorter "speed" events; nowadays, and into the foreseeable future, they are and will be Iditarod racers.

Gazing into the future is always a risky proposition, but certain educated guesses and speculations can be made. The most certain seems this: Unlike most other major sports events, the Iditarod field will continue to feature a captivating blend of professional athletes intent on championships and monetary rewards, and those who race solely for the adventure, camaraderie, and personal challenge. While champions and top contenders get most of the headlines, the back-of-the-packers are also heroes of a sort, inspirational in their efforts to take a dog team more than 1,000 miles across the Alaska wilderness. Often, the tail-end teams face even

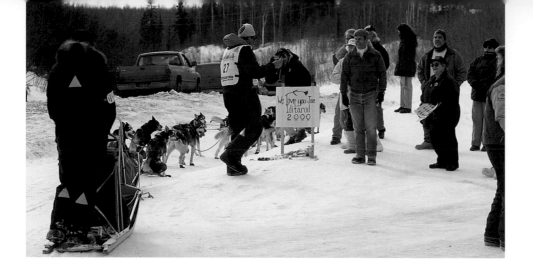

harsher trail conditions and weather than the fast-moving front-runners.

It also seems likely that a select few mushers will continue to dominate the winner's circle. First Rick Swenson, then Susan Butcher, and now Doug Swingley have built dynasties that have defined the first three decades. Even as the field grows more competitive, it seems harder than ever to take that final giant step into the winner's circle. Since 1986, an elite half-dozen mushers (Susan Butcher, Joe Runyan, Rick Swenson, Martin Buser, Jeff King, Doug Swingley) have accounted for all 16 titles and 10 second-place finishes. During that same span, only five other mushers have finished as high as second: Joe Garnie, Rick Mackey, DeeDee Jonrowe, Paul Gebhardt, Linwood Fiedler. And of that group, only Jonrowe has repeatedly finished near the top.

Not since 1985, when Libby Riddles stunned the world, has a relative unknown upset the favorites and reached Nome in first place. Though the days of a surprise winner seem a thing of the past, we can always hope for another Riddles or Dean Osmar or Dick Wilmarth. Still, what seems more likely is that before the fourth decade of the Iditarod ends, the Outsider from Montana will surpass Swenson as its winningest racer.

We can also be assured that race technology, dog nutrition and care, trail standards, and musher strategies will continue to improve. As they do, the Iditarod's speed record will almost certainly fall. The sport's premier racers all proclaim that an 8½-day or even an 8-day race is possible. Since Martin Buser broke the 11-day barrier in 1992, teams have sliced nearly 43 hours from that once unimaginable speed record, and some say another 12 to 24 hours can be trimmed.

There's another question on many Alaskans' minds. When, if ever, will a Native racer return to the winner's circle, ending a championship drought that now exceeds a quarter

LEFT Roy Monk stops at the foot of the Redington driveway in Knik on the restart day in 2000 and gives a carnation to Joe's widow, Vi. In honor of Joe's recent passing all the mushers in the 2000 race carried a carnation from the restart in Wasilla and lay it down or gave it to Vi as they mushed past the Redington home.

BELOW Rick Mackey signals "# 1" to the spectators along Fourth Avenue at the start of the 2001 race.

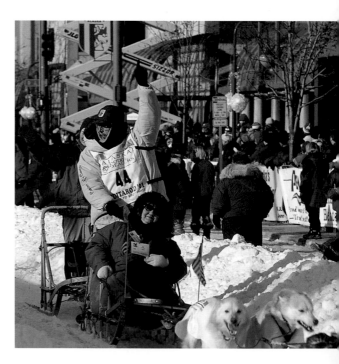

After the 2000 race, Doug Swingley happily accepts his first-place prize-winning check from Terry Kipp of National Bank of Alaska, an Iditarod presenting sponsor. Presenting sponsors donate a minimum of $150,000 to support the race each year.

century? Some of the Iditarod's brightest new stars are Native mushers, most notably John Baker and Ramy Brooks. But will they have the dedication, drive, and sponsorship to move from top contender to champion? Or is there someone else out there, still an unknown, who will someday follow in the sled dog tracks of Carl Huntington, Emmitt Peters, Jerry Riley? As Mike Williams says, "You've got to believe."

Two more things seem certain. First, some small number of dogs will continue to die in the race, despite the best care of mushers and veterinarians. Veterinarians say you can take any group of 1,000 or more dogs and monitor them for ten days to two weeks, and the odds are great that one or more will die, whether in the city or in the wilderness. Second, animal-rights groups will continue to attack the Iditarod as an unethical, evil thing. Nonetheless, the race will continue to prosper as long as the well-being of the dogs remains the Iditarod's top priority.

Contemporary Alaska is in many ways a land divided, split into countless factions by emotionally explosive issues that range from subsistence rights to resource development, federal management of parklands and forests, Native sovereignty, fisheries allocations, wildlife management, urban-vs.-rural politics, and education. But for two weeks in March, give or take a few days, the divisions miraculously dissolve. Residents throughout the state are united by their passion for this unique sporting event, which transcends athletic competition. From its ceremonial start in Anchorage until the final dog team has crossed the finish line in Nome, the Iditarod Trail Sled Dog Race is given center stage. Although the divisions will probably never disappear, the Iditarod will continue to help bridge the many differences that divide Alaskans.

The Iditarod will also continue to renew the primal bond between humans and dogs, and to pit competitors not only against each other but also against wilderness trials and sometimes brutal winter weather. Above all, perhaps, this "Last Great Race" will continue to celebrate the adventurous spirit associated with America's Last Frontier. As Joe Redington, Sr., explained back in the late 1970s: "I would like to say something on what makes you run the Iditarod. I think it's a certain type of person that wants to explore. . . . My dad, when he was 14 years old, rode a horse into the Oklahoma Territory, looking for something. I don't know what. But you're looking for something different, and the Iditarod is the last place you can prove to yourself that you've got something your forefathers had."

NOTES

Much of the material in the text, especially quotes from Iditarod racers, was gathered by the author over a period of years as a reporter with *The Anchorage Times* or was taken from newspaper accounts of the race. Several mushers were also interviewed by phone during research for this book. Other important sources for the sections on the Iditarod Trail's history and early races are described below.

THE IDITAROD'S ROOTS

The Bureau of Land Management carried out an Iditarod Trail Oral History Project in 1980–81. Taped interviews were conducted with old-timers who lived along the trail, mushers who ran in the 1925 diphtheria serum run, mail carriers, and other persons closely connected with the trail at various times. The tapes are available at many Alaska libraries. Some information given in this chapter, such as Pete Curran, Bill McCarty, and Edgar Kalland's remarks, is taken from the BLM tapes.

THE ALL-ALASKA SWEEPSTAKES

The main source for Scotty Allan's story was Shannon Garst's *Scotty Allan, King of the Dog Team Drivers* (1946). Other information on issues such as treatment of dogs can be found in Esther Birdsall Darling's 1916 booklet *The Great Dog Races of Nome*.

THE RACE FOR LIFE

The primary source of information for the 1925 serum run was Kenneth Ungermann's 1963 book *The Race to Nome*. The relay sequence list and related text discussion given here are slightly different from those in Ungermann's book and are based on more recent information provided by Edgar Kalland in a 1980 interview, conducted as part of the BLM's Iditarod Trail Oral History Project.

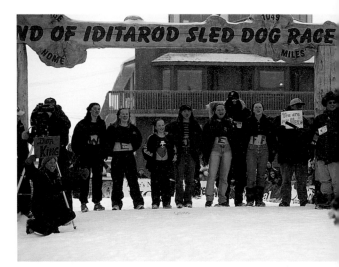

The Nome finish line has been the site of many strange happenings, such as weddings, proposals, and more. As Jeff King arrives here in 2001, his three daughters and other Junior Iditarod girls welcome him with a painted sign on their bellies. On the left is Donna Gates, Jeff's wife.

BIBLIOGRAPHY

Weeks prior to the race, volunteers weigh a musher's drop bags, which will end up at the more than twenty checkpoints along the trail.

Anchorage Daily News and *The Anchorage Times,* miscellaneous staff and Associated Press reports from 1973 through 2001.

Bowers, Don. *Back of the Pack: An Iditarod Rookie Musher's Alaska Pilgrimage to Nome.* Anchorage: 1998.

Brown, Tricia. *Iditarod Country: Exploring the Route of the Last Great Race.* Kenmore, WA: Epicenter Press, 1998.

Bureau of Land Management. *Iditarod Trail Oral History Project* (tapes). Anchorage: U.S. Department of the Interior, 1980–81.

Bureau of Land Management. *The Iditarod National Historic Trail, Seward to Nome Route. A Comprehensive Management Plan.* Anchorage: U.S. Department of the Interior, 1986.

Cadwallader, Charles Lee. *Reminiscences of the Iditarod Trail.* [No publisher or date.]

Cellura, Dominique. *Travelers of the Cold: Sled Dogs of the Far North.* Bothell, WA: Alaska Northwest Books, 1990.

Coppinger, Lorna. *The World of Sled Dogs, From Siberia to Sport Racing.* New York: Howell Book House, 1982.

Darling, Esther Birdsall. *The Great Dog Races of Nome, Official Souvenir History* (1916). Knik, AK: Iditarod Trail Committee, 1969.

———. *Baldy of Nome.* Philadelphia: Penn Publishing Co., 1916.

Dogs of the North. Anchorage: Alaska Geographic Society, 1987.

Freedman, Lewis. *Father of the Iditarod: The Joe Redington Story.* Fairbanks: Epicenter Press, 1999.

———. *Iditarod Classics: Tales of the Trail from Men and Women Who Race Across Alaska.* Fairbanks: Epicenter Press, 1992.

———. *Iditarod Silver.* Fairbanks: Epicenter Press, 1997.

Freedman, Lewis and Jonrowe, DeeDee. *Iditarod Dreams: A Year in the Life of Alaskan Sled Dog Racer DeeDee Jonrowe.* Fairbanks: Epicenter Press, 1995.

Garst, Shannon. *Scotty Allan, King of the Dog Team Drivers.* New York: Julian Messner, 1946.

Hart, Betsy. *The History of Ruby, Alaska, "The Gem of the Yukon."* Anchorage: National Bilingual Materials Development Center, University of Alaska, 1981.

Heacox, Kim. *Iditarod Spirit.* Portland, OR: Graphic Arts Center Publishing Co., 1991.

Hood, Mary. *A Fan's Guide to the Iditarod.* Loveland, CO: Alpine, 1996.

Iditarod Press Packet. Wasilla, AK: Iditarod Trail Committee, 2000 and 2001.

Jones, Tim. *The Last Great Race.* Seattle: Madrona Publishers, 1982.

Mattson, Ted. *Adventures of the Iditarod Air Force: True Stories About the Pilots Who Fly for Alaska's Famous Sled Dog Race.* Fairbanks: Epicenter Press, 1997.

Nielsen, Nicki J. *The Iditarod Women on the Trail.* Anchorage: Wolfdog Publications, 1986.

O'Donoghue, Brian. *My Lead Dog Was a Lesbian: Mushing Across Alaska in the Iditarod, the World's Most Grueling Race.* New York: Vintage Books, 1996.

Page, Dorothy. *Iditarod Trail Annual,* Anchorage to Nome Race, 1974 to 1986 editions.

Paulsen, Gary. *Winterdance: The Fine Madness of Running the Iditarod.* San Diego, CA: Harcourt Brace, 1995.

Richer, Elizabeth M. *Seppala: Alaska Dog Driver.* Boston, MA: Little, Brown & Co., 1930.

Riddles, Libby, and Tim Jones. *The Race Across Alaska.* Harrisburg, PA: Stackpole Books, 1988.

Shields, Mary. *Sled Dog Trails.* Anchorage: Alaska Northwest Books, 1984.

Stuck, Hudson. *Ten Thousand Miles with a Dog Sled* (1914). Lincoln, NE: University of Nebraska Press, 1988.

Ungermann, Kenneth A. *The Race to Nome.* New York: Harper & Row, 1963.

Vaudrin, Bill. *Racing Alaskan Sled Dogs.* Anchorage: Alaska Northwest Publishing Co., 1976.

Wendt, Ron. *Alaska Dog Mushing Guide.* Anchorage: Alaska/Yukon Publications, 1987.

Wickersham, James. *Old Yukon Tales, Trails and Trials.* Washington, D.C.: Washington Law Book Co., 1938.

INDEX

DEDICATION

I dedicate this book to the memory of my father, Edward William Sherwonit; and to the memories of Joe Redington, Sr., and Dorothy Page, without whom there would be no Iditarod race.
—*Bill Sherwonit*

I'd like to dedicate this book to the late Joe Redington, Sr., whose vision and dedication to this great race is the only reason it exists today. And to my wife, Joan, who is my best friend and always an encourager, along with our children, Ben and Hannah.
—*Jeff Schultz*

Text copyright ©2002 by Bill Sherwonit
Photographs copyright ©2002 by Jeff Schultz
All rights reserved. No portion of this book may be reproduced or utilized in any form, or by any electronic, mechanical, or other means without the prior written permission of the publisher.

Published by Sasquatch Books, Seattle
Printed in China
Distributed in Canada by Raincoast Books, Ltd.
07 06 05 5 4 3 2

Cover design: Kate Basart
Interior design: Jane Jeszeck
Copy editor: Alice Smith

Photo Credits: All photographs by Jeff Schultz, except the following: Alaska State Library: page 2 (Basil C. Clemons; PCA 68-89). Anchorage Museum of History and Art: pages 3 above (B65-18-218), 5 (B91-25-64), 6, 11 (B65-18-597), 12–13 (B65-18-590), 16 (B91-25-14), 17 (B65-18-591), 19 (B75-134-232). Glenbow Archives, Calgary, Canada: page 4 (NC-1-133). MSCUA, University of Washington Libraries: pages X (Mesler 28a), 3 right (Hegg 1218), 7 (Nowell 4694), 8 (Lomen Brothers 1206), 14 (Nowell 76), 20–21 (Hegg 1465).

Iditarod® and The Last Great Race® are registered trademarks of Iditarod Trail Committee, Inc.

Library of Congress Cataloging-in-Publication Data

Sherwonit, Bill, 1950-
 Iditarod : the great race to Nome / text by Bill Sherwonit ; photographs by Jeff Schultz.
 p. cm.
 Rev. ed. of: Iditarod / photography by Jeff Schultz ; text by Bill Sherwonit. c1991.
 Includes bibliographical references (p.).
 ISBN 1-57061-291-9
 1. Iditarod Trail Sled Dog Race, Alaska. I. Schultz, Jeff. Iditarod. II. Title.

SF440.15 .S38 2002
789.8'3'09798--dc21 2001049020

Sasquatch Books
119 South Main Street, Suite 400
Seattle, WA 98104
(206) 467-4300
www.SasquatchBooks.com
custserv@SasquatchBooks.com